THE UNIVERSITY OF
WINCHESTER

Martial Rose Library
Tel: 01962 827306

30 SEP 2013

To be returned on or before the day marked above, subject to recall.

TWO
ARTISTS
ONE
EXPRESSION

DOUBLE
ACT

MARK
GISBOURNE

EDITED BY
ULF
MEYER ZU KUEINGDORF

PRESTEL

MUNICH · BERLIN · LONDON · NEW YORK

"But as our work began to occupy a greater part of our time, the collaboration began to influence our entire way of living. Today I cannot imagine being with someone with whom I couldn't discuss a project over breakfast. It's such a luxury to have a life companion who has a natural interest in what you are saying; it would be terrible to sit there with your morning coffee and your brain exploding with some new ideas and then hearing only the reply, 'Oh, really? Interesting!.'"

MICHAEL ELMGREEN, 'Taking Place', 2001, p. 37

○ ELMGREEN & DRAGSET, **Powerless Structures, Fig. 146 - Elevated Gallery**, 2001, Courtesy Galerie Klosterfelde

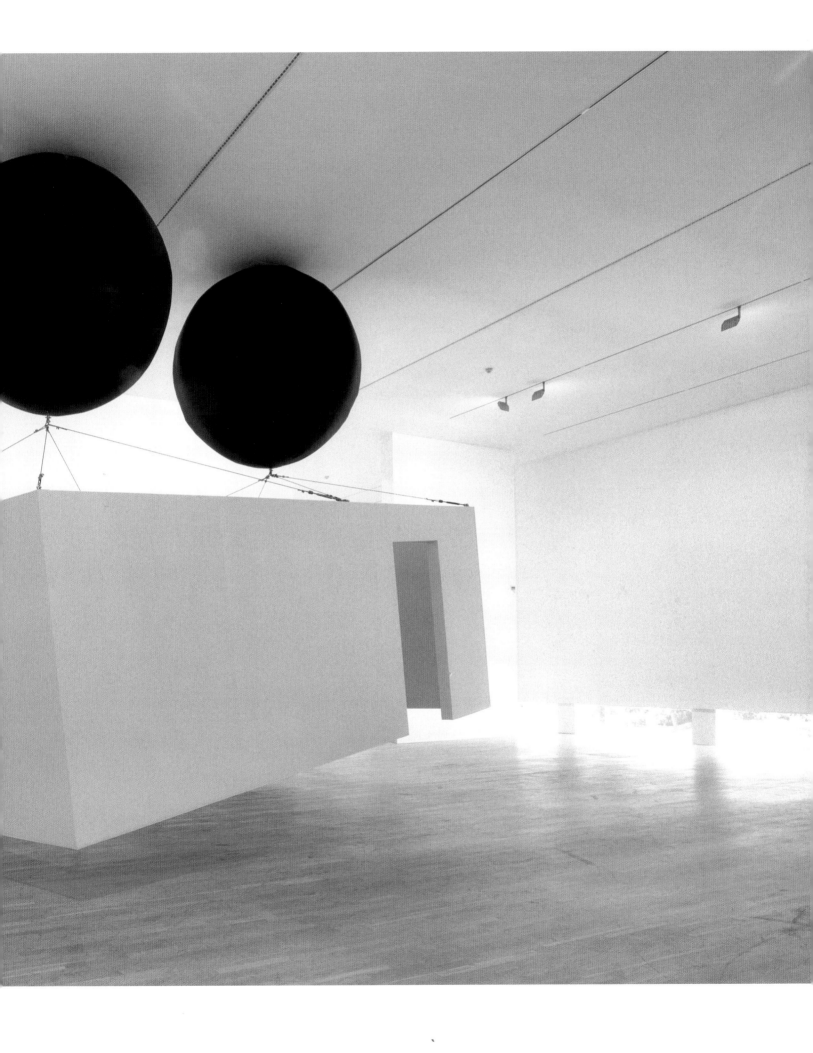

TWO ARTISTS ONE EXPRESSION
DOUBLE ACT

*JAKE & DINOS CHAPMAN, **Painting for Pleasure and Profit: A piece of site-specific performance-based body art in oil, canvas and wood.** 2006, Mixed media, Dimensions variable, Photo: Stephen White, Courtesy Jay Jopling/White Cube (London)*

MULTIPLE AUTHORSHIP

CLEGG & GUTTMANN

Abstract: *Multiple authorship is a strategy in the perpetual battle of the avant-garde against pseudo-expressionism. Positing as its author a group of individuals, the work of art is thereby provided with a 'built in' defence against the pervasive habit of being seen as an expression of an individual soul.*

Many artists – perhaps even the majority – see their life-work as an inward journey, a voyage to a mysterious self. Superficially, they paint and draw the faces and bodies of humans and beasts, misty cities by the sea and, occasionally, inanimate objects, saddled with the task of being a reminder of the inevitability of death and decay. That, however, is not the *real* point; the herds of animals, the vegetables and minerals that appear on canvas are but a means to an end, traces in the sand, left by an individual soul that has been disrobed in periodic instalments. Artists have no need to justify the choice of subject matter for their artwork; they have the right to pick and choose according to their inclinations. The figures found in their works are valuable only as 'objective correlatives' to the inner feelings of the soul. That is what modern artists mean when they speak of their work as an *expression* and what is here referred to as *pseudo-expressionism*.

It is not surprising that pseudo-expressionist art developed towards abstraction. The last constraints on the choices available to artists are removed when they no longer need to subordinate their canvases to the demands of natural forms and thus become completely free to proceed in any way they please. Abstraction, in other words, guarantees the greatest artistic freedom; for this reason, abstract painting is widely considered the apotheosis of self-expression attained through subjective choice.

*

The notion that behind each human individual lies a coherent soul that expresses itself when it indulges in idiosyncratic choices is – by no means only – an artistic conceit. The same idea provides the moral metaphysics of *supply-side economics*. Consumer society entails the metaphysical belief that self-realisation is, simply, the ability to make seemingly arbitrary choices.

Beliefs about objective facts do not provide an occasion for self-expression. Choosing in favour of this or that cereal, by contrast, or blue instead of yellow as the colour of the season, presumably requires the soul to 'listen to its inner voice' and thereby exercise its talents for self-expression; subjective choice is the path to self-knowledge – the *sine qua non* of self-realisation.

Every individual, moreover, has a *right* to self-realisation, which imposes a *duty* on the state

to ascertain an uninterrupted supply of things to choose from, to guarantee a variety of objects of *consumption*; in doing so, it assures the *potential* of self-realisation. *Actual* realisation, by contrast, is presumed to be an *individual* achievement; the state is not duty-bound to facilitate demand or help individuals *realise* their choices.

*

In the best possible scenario, the choices of the past remain wrapped for a while in the depths of the cupboard or the secret vaults of a foreign bank, awaiting discovery. They do not do so in vain. The eminent museums of our times often display them – as portraits of the great individual souls that expressed themselves – amassing them and attaining glorious self-realisation through their discriminating purchases. Exhibitions celebrate the astute choice of artworks or antiquities over time as do hats and evening gowns acquired for special occasions, decade after decade; even in such cases newspaper critics wax poetical about the 'style' or 'intelligence' revealed as a consequence. Collecting things of any kind is widely considered another means of self-expression and a path to self-realisation.

*

The idea that the œuvre of the modern artist is meant to reveal the movements of a worthy individual soul developed gradually. It started as an anti-naturalist tendency; warnings were issued that art was not a representation of the objective world and, generally, the mind had no way to ascertain the veracity of its representations. Naturalism – the belief that human impressions were copies of nature – was deemed naïve; pseudo-expressionism, which opposed it, started as a *critical* position.

In the 1880s, Europe was already brimming with critical types – full-bearded youths who fortified the sour brew of Schopenhauer with powerful doses of Nietzsche's electrifying nihilism. The two had much in common: both philosophers believed nothing in consciousness was external and real except, perhaps, the colours and sounds the senses reveal. They also agreed that casting sensations as independently existing objects could only reflect the machinations of an active *will*. In reality, there were no trees and houses below or heavenly stars above. All the kindred beings we know and love are artificial constructions of the mind.

For Schopenhauer, the blindness of the will was a source of constant melancholy. He resigned to the life of a Buddhist who knew that, despite his best efforts, his foot might inadvertently crush a living ant. His bushy-browed erstwhile follower, by contrast, had little sympathy for such faint-hearted, cosmic compassion. Pessimistic and critical subjectivism was transformed in his hands into raging, irrational ego-mania.

*

The next phase was *aestheticism*. The nihilist dandy reasoned that the absence of any objective values made *him* responsible for making his own subjective world as beautiful and exciting as possible. Accepting appearances, as such, is indeed an aesthetic disposition. In Greek, 'aesthetics' means, literally, the study of appearances. That marked a new stage of the revolt;

the critical empiricist turned self-centred and then recast himself as an aesthete. The aesthete relishes the subjectivity of the constructions, indulging, without shame, the same idiosyncratic preferences that hypocrites mask or conceal. The aesthete, in other words, is the quintessential pseudo-expressionist.

Aestheticism is the constant or zero of modern thinking. Ever since the 1880s, modern metropolitan culture has been dominated by the cult of beauty, youth and style. Blasé types know well that the objects of their devotion were shallow and temporary – distinct only in terms of appearance. They shrug off such accusations with the retort: "What else is there to admire? The only purpose in life is the collection of beautiful moments, forming them into a beautiful chain, kept in the memory – a portrait of the soul."

*

Modernism proper started in the 1890s as a movement against the aesthetic nihilism of the dandies. It was conceived of as an anti-decadent youth culture that vowed to be the voice of the voiceless. That was the beginning of *expressionism* as the term was *originally* understood.

The expressionist painter channeled through his work the horrors of *reality*. He maintained a state of complete receptivity to the social environment, placing himself in the midst of the roaring insanity of modern life, absorbing in his own body and soul the impacts of its forces on his person and delivering them further to others through his paintings. In order to be a *clear channel,* the expressionist artist had to put his own ego aside and avoid all manner of cognitive self-indulgence.

The first generation of French Expressionists included Georges Braque, Henri Matisse, Maurice de Vlaminck and Maurice Denis. De Vlaminck, like the 'individual' anarchists he admired, said that "the suffering of the masses must not remain unheard." It was *their* anguish and pain and not his own that the painter was expressing; the original expressionists had no intention of using their paintings as a means of *self*-expression.

*

Ever since its inception as an expressionist movement, modernism alternated between an undercurrent of decadent and nihilistic, cognitive self-indulgence and a corrective, avant-garde counter-tendency aimed at voicing a voiceless experience. The avant-garde work of art channelled to the viewers ignored or 'repressed' reality, thereby expanding their 'hearing' capacity – namely, their social consciousness and cognitive horizons. Even abstract art can be reinterpreted in this manner as a means for the expansion of consciousness. The spiritual art of Wassily Kandinsky, for example, was as much a channel of non-material forces made visible through his abstract paintings.

The avant-garde demanded from its viewer the same qualities as those expected from an artist: selfless receptivity and openness. They, too, must set aside preference and idiosyncrasy and try to let the work channel its contents to them.

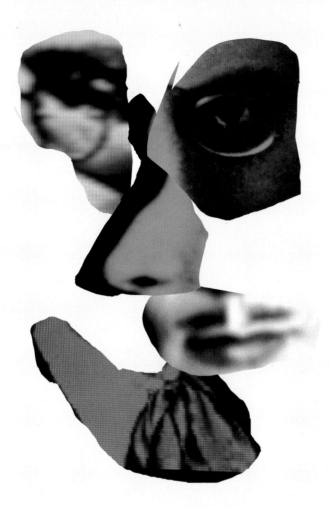

Accordingly, the avant-garde work is *not* a voyage to the wonderful individual soul of the artist but one that expands consciousness, revealing a threateningly unfamiliar world.

The current period is one dominated by supply-side economics and its experiential corollary or cognitive self-indulgence. Ours is another 'gilded age', when many voices remain unheard and most artists have little or no interest in channelling anyone else but themselves through their works.

Habits die hard and even artists who see things 'the avant-garde way' have a hard time convincing the viewer to look at their works differently, in terms other than as voyages to the artists' soul. In order to succeed on their own terms, these artists must devise *immanent* methods to produce art that preempts the pseudo-expressionist habit, thereby forcing the viewer to see things differently.

One immanent strategy – one of many invented in the 1970s – is embodied in *multiple authorship; a work of art that posits more than one individual as its author cannot be interpreted as a journey to an individual soul.*

*

Lest there be any mistake about it, let us state at the outset that no single strategy guarantees any work of art absolute immunity from cognitive persecution. Historically speaking, the producers of works with multiple authorship proved just as likely as others to be construed as artistic *brands*. Even when it is impossible for it to be considered as a means for individual expression, the work of art with multiple authorship may still be viewed as a *collectible* – an object-of-collection.

The only means available to the avant-garde artist to convince the pseudo-expressionist viewer to regard his work differently are those immanent to his trend: his work must channel an experience of a new type, expanding it and altering the nature of its cognitive routines. Only works with such capabilities can hope to coax viewers to review their habits and prejudices.

CLEGG & GUTTMANN, June 2007

*○ CLEGG & GUTTMANN, **Ideational Construct #4**, Left Eye: K. Liebknecht, Right Eye: J. Heartfield, Nose: H. Hoech, Mouth: K. Weill, Neck: H. Höch, Photograph mounted on aluminium, 175 x 117 cm, with wood pedestal: 35 x 75 x 50 cm, Courtesy Georg Kargl Fine Arts, Vienna*

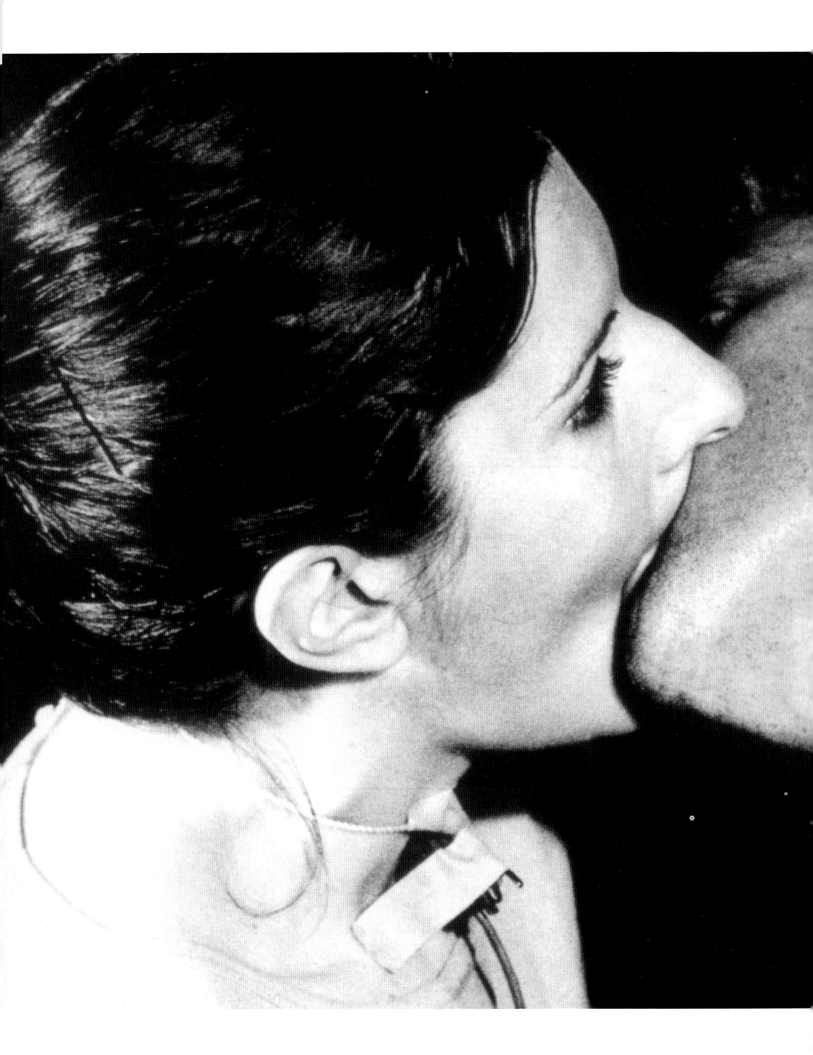

○ MARINA ABRAMOVIC/ULAY,
Breathing in/Breathing out,
April 1977, Student Cultural Center,
Belgrade, 19 min., performance,
Courtesy of the artists

This book is called *Double Act* and if you immediately think of **Laurel and Hardy, Morecambe and Wise, Flanagan and Allen, or George Burns and Gracie Allen, then it is all to the good.** The term originated in the music hall and popular theatre in which double acts, or comedy duos, played each other off for laughs. Later the idea was transferred to television. The most important principle, however, is that of mutuality and creative dependency – the straight man cannot work or fulfil his aims without the funny man and vice versa. However, the double-act artists in this book are not comedians – far from it. Although some might be amused by the idea, others might just as easily be offended. What they share with the term 'double act' is a sense of two people using but one expression. One art work emerges, but one that has been thought through and achieved through collaboration.

Distinctions need to be made between what constitutes an artist double act and artist couples, who may at times collaborate but still retain their singular artistic autonomy. Regardless of their personal relationships (brothers, sisters, lovers, friends), the double-act artists have chosen – and here the emphasis is on 'have chosen' – to sublimate the pursuit of a singular subjectivity in a shared endeavour. Hence it serves little purpose to establish which element belongs to which artist in the art works realised, and to do so mitigates against the intentions of the double-act artists themselves.

However, this description speaks to psychological motives, and it is the radical nature of the contemporary practitioners in this book that they work outside the stereotypes of individuality in their creative visions. In a certain sense, too, they challenge the conventions of art history that would seek to categorise and attribute specific parts to each artist. This does not mean that their work is not immediately recognisable or does not possess certain striking and particular characteristics. Neither,

We are kneeling face to face,
pressing our mouths together.
Our noses are blocked with cigarette filters.

Ulay
I am breathing in oxygen.
I am breathing out carbon dioxide.

Marina Abramovic
I am breathing in carbon dioxide.
I am breathing out carbon dioxide.

Ulay
I am breathing in carbon dioxide.
I am breathing out carbon dioxide.

MARINA ABRAMOVIC/ULAY, *Breathing in/ Breathing out*, April 1977, Student Cultural Center, Belgrade, 19 min., performance

of course, does it mean that the artists involved are not without their own strong, individual personalities.

It is a long established cliché in the visual arts that creative endeavours are the product of a singular vision. There have nonetheless always been movements of the like-minded and, at times, manifest examples of collaboration, both large and small, using either workshops, ateliers, factories, manifestoes, or a whole array of alternative collective strategies. Indeed, art history spends much of its time reconstructing the Medieval, Renaissance, or Baroque studios, the role of masters and assistants, and historical art workshop practices in general. This notwithstanding, all is generally subsumed beneath the singularity of the master's name, the singular visionary who affords the style and the stamp of individual authenticity. Since the Romantic Age and with the demise of large traditional artist workshops – Rubens, for example, in the seventeenth century may have had up to a hundred assistants – and the coming of art schools and academies which replaced the former master-assistant model, the idea of a unique and singular artistic voice has become ever more pronounced. The emergent nineteenth century avant-garde position – and one should always remember art history is a discipline born of the nineteenth century – particularly in the 'art for art's sake' camp, privileges the singularity of each individual contribution. No matter how collaborative a particular art movement may have been, modern art history segments and dissects the inner workings of group identities in order to generate individual specificities. In other words, to pin down who did what, and uses both intellectual and material analyses to individuate each member of an artistic movement, though this has never been so pronounced among the other leading arts, music, theatre, film and dance, where collaboration is a necessary commonplace. This said, the extraction of individuals in terms of their creative intervention, has just as readily been highlighted: the composer, the instrumentalist, the actor, the film director and so on.

As we live in an age of visual arts celebrity, the attachment of a unique sense of singularity to an individual artist has become all-consuming, as seen for instance in Warhol exhibitions and Picasso shows. Countless exhibitions take place in public spaces and museums that give particular prominence to the names of individual artists, frequently allied of course to the publicity, or 'bums-on-seats' effect, that the named artist is able to generate. In the last thirty years or so, this point of view has been progressively challenged by a new phenomenon. We find it increasingly common that two artists work together, but wish to sublimate their singular identity into a shared expression. They are artists who wish to subsume the 'I' for the 'we' and, in so doing, try in some measure to undermine and refocus the nature of, and our attitudes

towards, what constitutes singular subjectivity. That this may be part of the post avant-garde, something other writers have termed post-modernity or late capitalism, is neither here nor there. Artists usually do not sit around speculating as to whether they are post-modern or late capitalists as such. Alhough it is equally true that, today, they are clearly aware of the value of money and develop distinct strategies and aims for their success. The myth of the solitary angst-ridden artist is precisely – and probably always was – nothing but a myth.

This book concentrates on double acts of the last twenty-five years. It does not claim to be fully comprehensive, focussing primarily on fourteen established pairs of artists who emerged during that time. On occasions, comparative material from other double-act artists is also included. This introductory chapter provides a background to subsequent developments, and looks – albeit only briefly – at some of the precursors of this phenomenon, those artists whose beginnings date from the 1960s and '70s. These include Gilbert & George, Ulay and Abramovic, Komar & Melamid and Bernd and Hilla Becher. In doing so, access can be gained to the potential creativity of double acts that have been followed by subsequent generations. We will find no abstract painters and no overly existential clichés – though this does not mean that existential phenomena were not addressed in other ways. Abstract forms of artistic production have predominantly been singular fixations on the relation of the subject or the object and overwhelmingly subjective in their interpretation. Be they geometric or lyrical, they have pursued either the metaphysical (spiritual) ideas at one end of the spectrum, and/or the phenomenological or conceptual

object at the other. Certain characteristics and questions immediately emerge as regards double acts: what benefits can arise from two people working as a single expressive unit? How does the relationship of two individuals alter and shape the development of a work? What other intentions become apparent as a result of there being two people? What form does such collaboration take and how does it manifest itself in the art work? Are there distinguishable boundaries within the double contributions and are they relevant? What is meant by an implied mutuality of intention?

In nearly forty years of working together, the art of Gilbert & George has always remained local.[1] In this respect one is reminded perhaps of Renaissance artists such as Tintoretto (1518–94), who scarcely ever left Venice, but whose works in retrospect have similarly achieved a near universal appeal. Conversely, and in the same time period, Bernd and Hilla Becher scoured the Western world in pursuit of obsolete domestic architecture and industrial infrastructures to record in their taxonomic photographic works. What can be assumed from these examples is that the doubled identity of expression is clearly not manifested or restricted to a specific place or topic. The obvious Britishness of Gilbert & George's East London subject matter at the same time stands in contrast to the Bechers' German photographic history with its interest in classification, echoing as it does earlier physiognomic and social precedents – as distinct from architectural ones – in the photography of August Sander (1876–1964).

The recent major Gilbert & George retrospective at the Tate Modern in London and the Haus der Kunst in Munich is a

○ GILBERT & GEORGE, **Gin and Tonic**, 1973, 71 x 42 cm, Private collection, Courtesy Sonnabend Gallery, © the artist. GILBERT & GEORGE at Tate Modern, 15 February - 7 May 2007 (section 30 (i) and (ii) of the Copyright, Designs and Patents Act 1988)

○ GILBERT & GEORGE, **Singing sculpture**, 20th anniversary, 1991, Presented at Sonnabend Gallery, New York, 1991

○ **GILBERT & GEORGE in their London home**, 1987, Photo © Derry Moore. GILBERT & GEORGE, Major exhibition, Haus der Kunst, Munich, 11 June – 9 September 2007

summation of double-act endeavours, particularly as they are portrayed in all but a few of their works.[2] The fact that they are so readily identifiable indicates in some measure how they see themselves as both the subject and object of the art they create.

This was apparent from the beginning in their living or singing sculpture performances such as *Underneath the Arches* (1969),[3] the title of which derives from the song of a music hall comedy double act, Flanagan and Allen (Bud Flanagan the lyricist was born less than a hundred metres away from their house in nearby Hanbury Street), and became their signature tune.[4] Indeed, we might find a clue as to the sublimating of individual identity in further songs by Flanagan and Allen like *Let's be Buddies* or *Two Very Ordinary People,* since Gilbert & George often assert how normal – or better still, how 'conventional' – they are, always ignoring or dismissing questions that are directed to their relationship. The style and delivery of music hall

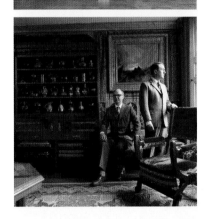

songs is something with which they might concur; a binary verse and verse chorus structure, one singing the melodic part, and the other the harmonies. Though they trained as sculptors at St Martin's School of Art, London, where they first met in 1967, the general rubric of their work has always been art and life, or rather life as it is lived which has become the basis for art. The large-scale, nature-based wall-size drawings in charcoal on paper of 1970, and even their triptych paintings of 1971, were and still are always described as sculptures. It is paradoxical that these fundamentally urban beings should first reveal themselves in the context of nature: "We look at nature for comparisons with human states: fruiting, flowering, death, the skeleton, they're all human states."[5] From 1971 they moved into photography as their primary medium.

Gilbert & George have always lived against the grain of the art world and were never particularly interested in the clichés and lifestyle of Swinging London in the 1960s. Though, visually, one might be tempted at times to see their works in

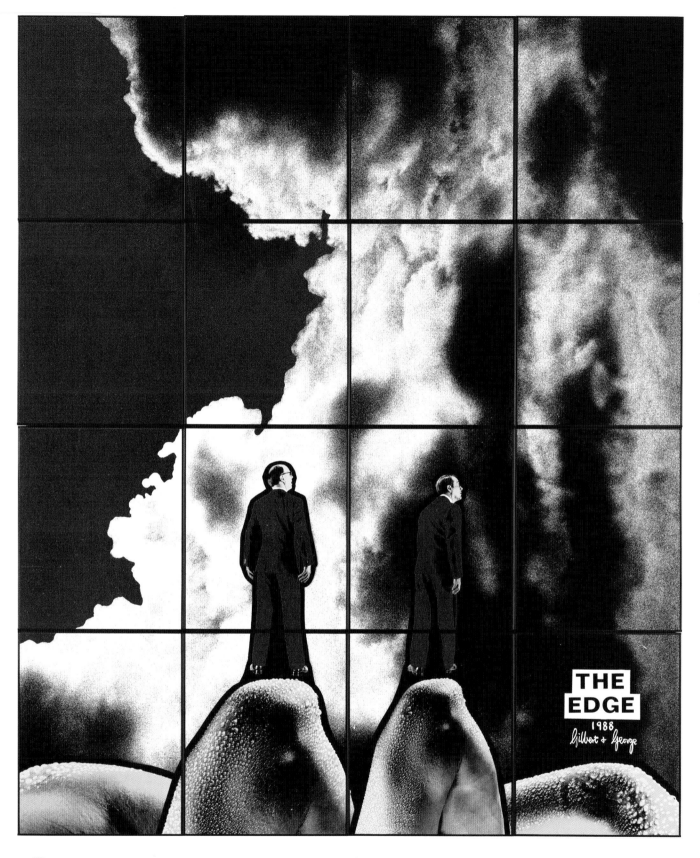

GILBERT & GEORGE

You have made your work together for about twenty-five years now. Why did you decide to work in this way?

George: We didn't. No decision. We always say it was something that came over us. We were already doing it in a way before we realised.

Do you think as one artist or two?

Gilbert: Two people make one artist.

George: We think that we are an artist.

Gilbert: Two visions make one vision.

George: A family is made up of people who have different views on different subjects but there is always a family feeling or a family direction - as well as the individual - where they share a common ground in going forward.

Would it be pointless to make your work individually?

Gilbert: I think it would be totally impossible. It would finish us. I mean, it is totally impossible. I think I would be totally lost. It would be like cutting the legs of the 'Singing Sculpture'.

relation to British Pop culture, their own lifestyle was that of outsiders, far away from the Jagger-Land of Notting Hill Gate, the King's Road and Chelsea. Situating themselves in run-down Fournier Street, just off Brick Lane, Whitechapel (formerly the poor Jewish area of London), went against everything that constituted Carnaby Street and the florid fashions of Soho culture. The standard three or four-buttoned suit has always been their attire of choice. The subject matter of their early black and white photo-pieces, up until 1974, with their ciphers of local history, hints of monarchism and the swastika, went totally against the '60s and early '70s spirit of leftist revolt and hippyism. From 1974 the primary grid structure emerged, having first being used in their *Cherry Blossom* series, and the pattern of producing works in thematic serialisation began. Mapping the immediate physical environment in its material, social and cultural terms became the basis for their art; almost everything of their subsequent production is derived from the immediacy of London's East End. Whether it is their own physical ejaculations as in *Coming* (1975), or street graffiti as in *Are You Angry or Are You Boring?* (1977) and *The Penis* (1978), or the series on their house *Dusty Corners* (1975), everything stems from what they know and see in their daily lives. The most human element is the familiar, the things we do and the things we see around us every day. The works of the second half of the 1970s were all in black and white with the singular

◐ GILBERT & GEORGE, **The Edge,** 1988, 242 x 202 cm,
© the artist, Courtesy Jay Jopling / White Cube, London,
GILBERT & GEORGE, Major exhibition, Haus der Kunst,
Munich, 11 June – 9 September 2007

GILBERT & GEORGE: Interview with Andrew Wilson,
first published in 'Journal of Contemporary Art', vol. 6, no. 2,
Winter 1993. Published in the book 'The Words of Gilbert &
George', Thames and Hudson Ltd., London in association with
Violette Editions, 1997

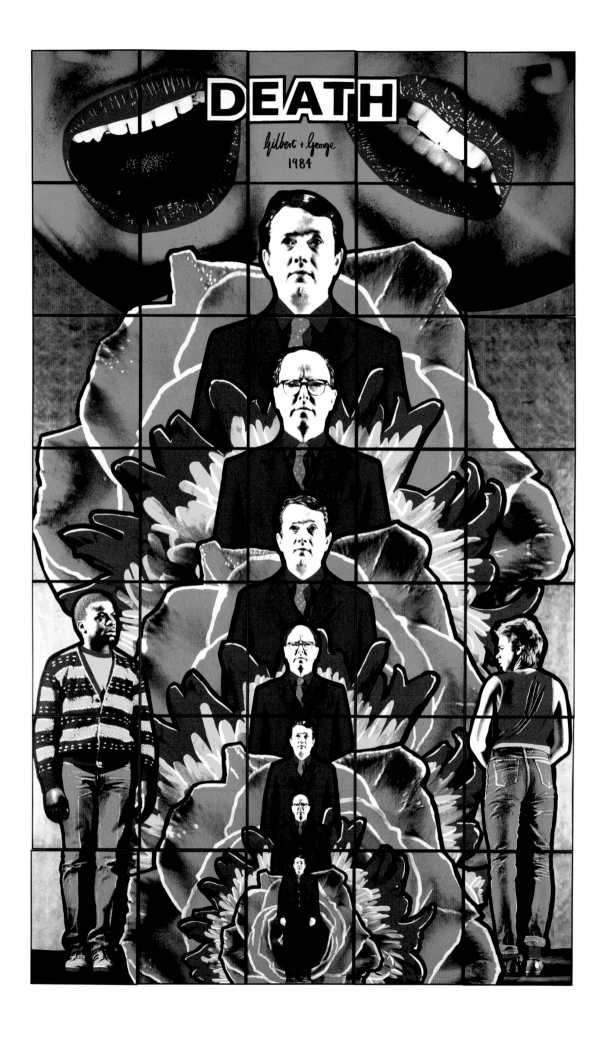

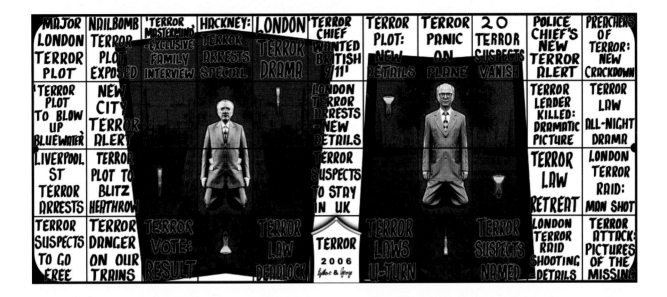

addition of hand-coloured red: "For years we saw only red in front of our eyes... Red in political terms... Misery."[6] The fact that red and black are the colours of anarchism and are strongly associated with the British punk generation of the late '70s is not coincidental. That they have always claimed that they were not in any sense punk artists, is just another of their assertions of being against the grain, opposing the conceptual 1970s end-of-art ideas. It would be disingenuous to state that they were not aware of this, and their subject matter meshes completely with the contents of such films as Derek Jarman's famous *Jubilee* (1979), the same year that Margaret Thatcher came to power. Since 1980, the thematic series have continued in ever greater colourful elaboration, always as

art-for-all: "We want Our Art to speak across the barriers of knowledge, directly to People about their Life and not about their knowledge of art."[7]

What had started as a strategy became a standardised approach in the case of Gilbert & George. This has not been without its advantages, as their use of photography worked deliberately against the idea of creating individually identifiable art. It freed them of individual subjectivity and one is unable to ascertain who did what in the context of their production. Mutuality of intention is manifested by the fact that there is always a co-equal presence in everything they do, and if they disagree on things it is never exposed to public scrutiny. This does not mean that their works have not been

◊ *GILBERT & GEORGE, **Death from Death Hope Life Fear**, 1984, 423 x 252 cm, Tate Britain, © the artist. GILBERT & GEORGE at Tate Modern, 15 February - 7 May 2007 (section 30 (i) and (ii) of the Copyright, Designs and Patents Act 1988)*

◊ *GILBERT & GEORGE, **Six Bomb Pictures 2006, Terror 2006**, 2006, 336 x 775 cm, Courtesy Jay Jopling/ White Cube, London, © the artist. GILBERT & GEORGE at Tate Modern, 15 February - 7 May 2007 (section 30 (i) and (ii)*

KOMAR & MELAMID

extremely prescient and a touchstone in social and cultural terms. Their interest in youth culture and adolescence, AIDS and sexually transmitted diseases, the functions of the human body, in transgression and taboos (as in their Shit Paintings), and in God, religion and death has always made their art engage directly with the perennial certainties of life. Gilbert & George are in most respects non-ideological social realists, with a small 's' and a small 'r', and it is in this tangential way that their art abuts that of the Russian artists Komar & Melamid, the distinction being that Soviet Russian ideology offered nothing like the same freedom and possibilities of an open society's material and discursive mobility.

The art work of Komar & Melamid in the 1970s was, however, decisively different in many respects, not least because it was a dissident art and more conceptually driven. Its use of strategy and media (inverting propaganda) became an extended subversion of the immediate Soviet political system in which it operated.[8] Later, following their departure from the Soviet Union for Israel in 1977, and their move to New York in 1978, it embraced a sense of dissidence in retrospect, deeply embedded in memory, history and nostalgia. The two artists first met in the morgue at the Institute of Physical Culture, Moscow, in 1963, as students at the Stroganov Institute of Art and Design from which they graduated in 1967. Their training was classically academic and pre-modernist,

hence the anatomy studies at the morgue. They came from families that were part of the Soviet professional classes although both were Jewish and constantly made aware of it, and it remains un-clear whether this was the reason why they were blocked from becoming full members of the Moscow Union of Artists. Instead, they were allowed to become members of the Graphic Artists' Organisation. While they only worked together sporadically, they kept in contact up until 1972 and ceased working together in 2003. In the interim both married and had children. The evolution into a double act was gradual, but had taken shape by the time they worked together at a children's camp near Moscow in 1972. The director of the camp pointed out a buried concrete bust of Stalin and explained that busts that were too large to destroy were buried all over the Soviet Union.[9] Stalin had all but disappeared in Komar & Melamid's early childhood, his personality cult having been erased under Krushchev

○ KOMAR & MELAMID, **Colour Writing: Ideological Abstraction No. 1** uses a colour code to spell out Article 129 of the Russian constitution. The original code was lost when the painting was transported from the Soviet Union; this palette is a later version with a similar code. Each tube of paint is assigned a letter of the alphabet. Below: 1974, Oil on canvas, 210 x 99 cm, Courtesy Ronald and Frayda Feldmann

○ KOMAR & MELAMID, **Double Self-Portrait as Young Pioneers**, 1982-1983 (from Nostalgic Socialist Realism series), Oil on canvas, 180 x 127 cm, Courtesy Martin Sklar

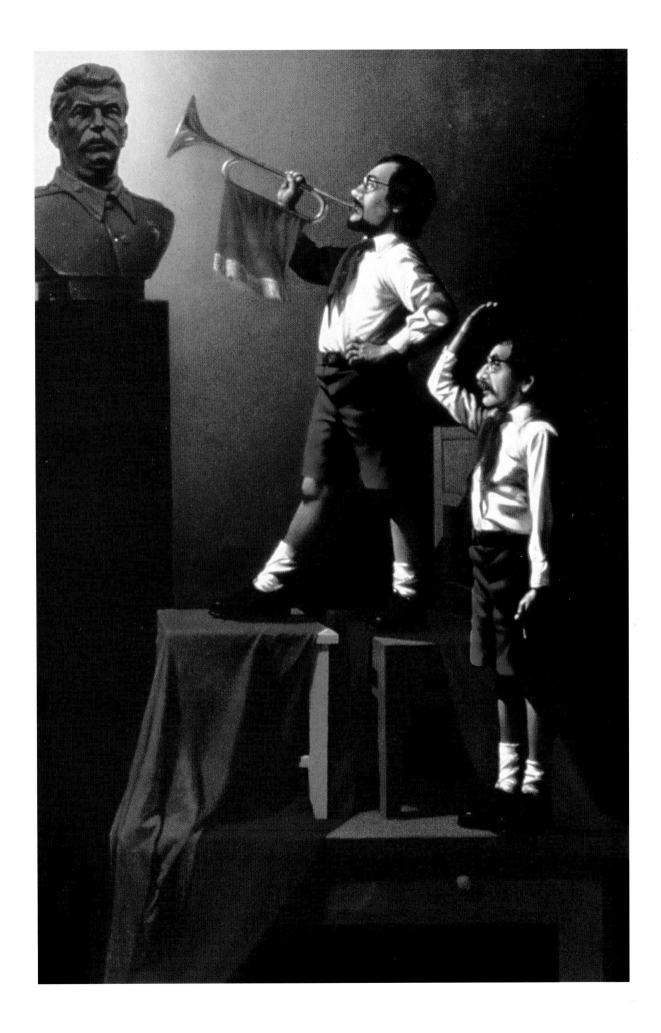

of national paternalism. From this situation, what emerged was what they called their 'Sots' art, a fusion of Socialist art with Pop art, the distinction being that what was an engagement with consumer abundance in the West stood in direct contrast to material shortages in the Communist system. What was the domain and media means of corporate or mass advertising in the West, was the sole prerogative of State propaganda in the Soviet Union. The dissident and hidden nature of their early production, their ironic *Paradise* environmental installation in a Moscow apartment in 1973, contained sculpted figures (including a suspended Prometheus who dripped a red liquid), light fixtures, pseudo-landscapes, toy soldiers and instruments of war smothering a Buddha. In addition, a Soviet radio blared out, creating and mirroring in microcosm the sense of State claustrophobia they were then experiencing. 1974 saw their involvement in the 'Bulldozer' exhibition in Beljaevo, on the outskirts of Moscow, organised by Oscar Rabin. The show was literally bulldozed and all the works destroyed. The early Sots Art series inverted the vocabulary and meaning of Soviet official culture, as in their canvas *Laika Cigarette Box* (1972). Laika, a dog sent into outer space on an early Sputnik, died and became something of a national Soviet hero. Whereas in the West artists like Warhol appropriated and celebrated icons of consumer culture such as Coca-Cola bottles, Brillo boxes, etc., Komar & Melamid subverted State icons and their propagandist conventions. Their first *Double Self-Portrait* (1973) was based on an earlier double portrait of Lenin and Stalin (©1950). The work, part of the Bulldozer exhibit, was later recreated. Parodies of Soviet banners and popular

(Party Secretary of the Communist Party from 1953–64), but nevertheless Stalin exerted an important influence on their subsequent work. The theme of childhood recollection and the persistence of memory or nostalgia, has always been positively affirmed by the artists: "Through Stalin Art," said Komar "we were able to recreate our childhood." This was not because they were not aware of the monstrous tyranny Stalin had perpetrated on the Soviet people, but because he helped them access the lost certainties of their childhood and an age

○ KOMAR & MELAMID, **Stalin With Hitler's Remains**, 1985-86 (from Anarchistic Synthesian series) mixed media, 2 panels, 213 x 152 cm overall, Courtesy Robert M. Kaye

○ KOMAR & MELAMID, **Ronald Reagan as a Centaur**, 1981, Oil on canvas, 230 x 160 cm, Courtesy Judy and Michel Steinhardt

propaganda were similarly subverted, as in *Onward to the Victory of Communism* (1972, signed Komar & Melamid).

Unlike Gilbert & George, whose work tends to be literal, the context of Komar & Melamid necessarily made their work more conceptual. They even added fictional written biographies and pictorial identities of non-existent artists, as in the work *Nikolai Buchamov* (1973), comprising sixty small panels, or the fictional, mid-eighteenth century painter (deemed abstract) ironically called Apelles Ziablov. These more conceptual ideas would be extended later after they reached, first Israel, then New York, in works like *Performance: Canine Art (Teaching a Dog to Draw)* (1978). The Soviet promotion of science and technology was also subject to parody and subversion by Komar & Melamid. The state addiction to systems was frequently questioned as in their *Translation of Article 129 of the Constitution of the R.S.F.S.R* (1974), in which the freedom of speech, press, assembly and demonstration were proposed, and each letter was translated into paint tube colours, rendering it incomprehensible unless one knew the code – a reflection of a reality that was being ignored in the Soviet Union at that time. Objects and performance also played their part as in the *Catalogue of Superobjects – Supercomfort for Superpeople* series of works (1976). The artists' experience of Western art at this time was largely restricted to magazine reproductions, but it should not be thought that they were particularly enamoured of its virtues – they remain in many respects ambivalent towards it even to this day. Their works *Post-Art No. 1 (Warhol)* and *Post-Art No.2 (Lichtenstein)* were paintings of a badly charred Warhol Campbell's soup can and a burnt fragment of a Lichtenstein comic strip.[10]

Komar & Melamid's style in 1972–77 was deliberately pluralistic, conforming where necessary to the given needs of the idea at hand. A subsequent use of the convention of academic history painting became more predominant at the time they were leaving the Soviet Union – it was, after all, the official style of Social Realist painting. Not surprisingly, it conforms to Komar & Melamid's later confession of intentional nostalgia and in retrospect to their period as dissidents. Its use by the artists is a complex idea linked to their philosophy of dark painting and subsequent temporal accretions to which a painting should be exposed.[11] The temporal element in painting has strong roots in the tradition of icon painting in Russia. In a work like *Double Self-Portrait* (1977), painted at the time of departure from the Soviet Union, the artists could well pass for monks as in, perhaps, a seventeenth-century painting by Zurburán, rather than twentieth-century men. Visually, Komar & Melamid's use of history painting and traditional methods always gives a sense of an uncertain period of execution. It is their subject matter that contextualises them and, for this reason, they detest the idea of contemporary cleaning and

restoration. Their most well-known paintings in the Nostalgic Social Realism Series (1982/3), Scenes for the Future (1983/4) and the Anarchistic Synthesism Series (1985/86) are devoted to their strange relationship with Soviet and Russian history painting and, not least of all, with the 'Red Tsar' Stalin, who is repeatedly depicted. Perhaps a painting like *The Origin of Socialist Realism* (1982) is about something else, regardless of its numerous Renaissance and Baroque iconographic and literary references which any first-year art history student could spot. Is it the ironic melodrama that history painting creates when seen in retrospect? Or is it about paternalism and the male ego? Whether it is the *Portrait of Hitler or Robert Reagan as a Centaur* (1981), or *Stalin with Hitler's Remains* (1986) they may have far less to do with actual history than we might suppose. They seem to suggest that history is always the product of a collective iconic repetition.

The coming together of Komar & Melamid as a double act in 1972 is best understood as a like-mindedness united through the forced circumstance of political and ethnic discrimination. Since their amicable parting in 2003, the circumstance seemingly no longer applies. Their shared identity as dissident artists largely dissolved with the end of the Soviet Union, as the grounds for what they initially criticized were no longer present. In they last twenty years, in what they call their 'Transtate' reality, such satirical critique as

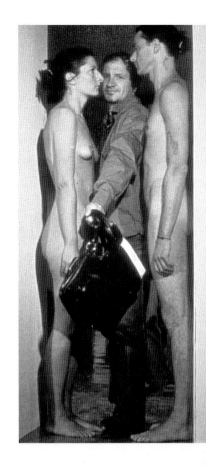

exists in their works has been turned against America – a country which they see today as having repressive tendencies analogous to the former Soviet Union.

In the case of Ulay and Abramovic we can be more circumspect. In the twelve years between 1976 and 1988, the two artists came together as a double act in a conceptual and performance-based relationship.[12] The actual extended character of their relationship as a couple was an accepted fact, but never specifically placed in the foreground. As far as their performances were concerned, they claimed they were in pursuit of universal dualism in which the limits of their bodies were to become part of a shared but transformed identity: "Giving up your ego and working with someone who maintains a very ego-based personality is an unusual thing to do. That was the thing to shake out: to reduce our egos to our personalities."[13] The performance works can be divided into five categories: the *Relation Work* (1976–80), *That Self* (1980), *Nightsea Crossing* (1981–87), *Modus Vivendi* (1981–87) and *The Lovers – The Great Wall Walk* (1988). At the same time

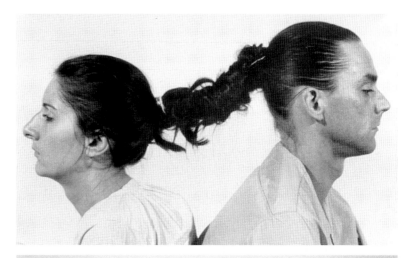

the performance works of Ulay and Abramovic operate on the interface of ethics and aesthetics, East and West, and what might be called the anthropology of human relations.[14]

The *Relation Work* is, more than anything else, an example of a mutuality of shared intentions, expressed by either immobility or activity. In *Relation in Time* (October, 1977), they sat with their backs to each other with their hair tied together for sixteen immobile hours before the audience came in – after which time they remained in the same position for another hour. In *Imponderabilia* (June, 1977): "We stood naked in the main entrance of the museum. The public entering the museum had to pass sideways through the small space between us. Each person had to choose which one of us to face." The performance lasted ninety minutes. Conversely, in action relations such as *Workrelation* (September 1978), Ulay and Abramovic performed heavy physical work, carrying the same bricks in buckets backwards and forwards to seemingly no real end or purpose. The performance lasted either two, three or eight hours, depending on the location where it took place. In *The Brink* (April, 1979), at the third Biennale in Sydney, Ulay (the psuedonym used by Frank Uwe Laysiepen) walked along the top of a wall while Marina Abramovic moved along the line of the shadow it cast. The performance lasted four-and-a-half hours, until the shadow diffused with the passage of the sun. Or, again, in *AAA-AAA:* "We are facing each other, both producing a continuous vocal sound. We slowly build up the tension, our faces coming closer together until we are screaming into each other's mouths,"[15] a work not unrelated to *Breathing In – Breathing Out* (April, 1977), where their mouths

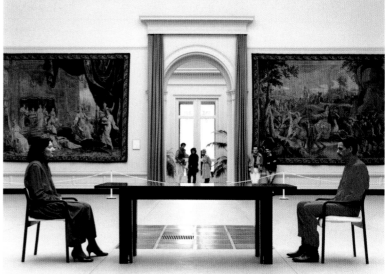

were pressed together and they inhaled and exhaled each others carbon dioxide. The performance lasted nineteen minutes.

The social-anthropological content of their performances became more pronounced after 1980, though the relational contents remained. It may have been presaged in some way by their work *Communist Body – Capitalist Body* (November, 1979). Two tables and place settings were presented side by side, one with the more elegant Capitalist contents such as napkins, porcelain, champagne glasses and silver cutlery. The other had enamel cups, toilet paper and aluminium knives and forks. The two artists slept on a mattress covered by a white sheet and red blanket. On another table were their birth certificates, one from Capitalist West Germany, the other from Communist Yugoslavia. Psychological experiments in hypnosis followed, their aim being "to explore the subconscious". The issue of physical contact and emotional dependency was extensively explored in performances such as *Rest Energy* (January/August, 1980) where, with a tensioned longbow, Ulay held the taut string and arrow while Abramovic, leaning backwards, had the arc of the bow in her hand. The arrow was pointed at her heart. The work *Nightsea Crossing* (1981–87) was performed in many locations around the world, sometimes with other participants including a Tibetan monk or simply an independent observer. The essence was that the two artists sat across a table from one another, motionless, and without speaking or eating. This performance could in some instances last for days. A whole series of works under the general heading *Modus Vivendi* (Ways of Living, 1981–87) also took place worldwide and incorporated other figures, extending the anthropological discourse of cultural relativism into one of relational inclusion. It was a general feature of the 1970s' end-of-art, end-of-painting argumentation, that a sincere and truthful art found its roots in the life of living cultures and not simply in the artifice of formal art making as an end in itself.

The conclusion of the Ulay and Abramovic collaboration came with their project *The Lovers – The Great Wall Walk* (March–June, 1988), in which they walked the whole length of the Great Wall of China from opposite directions; the implication being that at each moment they were getting closer to one another. They eventually met after ninety days at Er Lang Shan, in Shen Mu, Shaanxi province. While their period as a double act exemplified their status as lovers and the intense human desire to become (in and through their performance works) empathically closer to one another, in the end it was no longer sustainable. Ulay claims to "have no particular reason for our separation. After twelve years something happened. We couldn't hold on to our ideology to become 'one', to experience the union of man and woman, which had been the reason why we were so close together and why we were moving so strongly in the same direction."

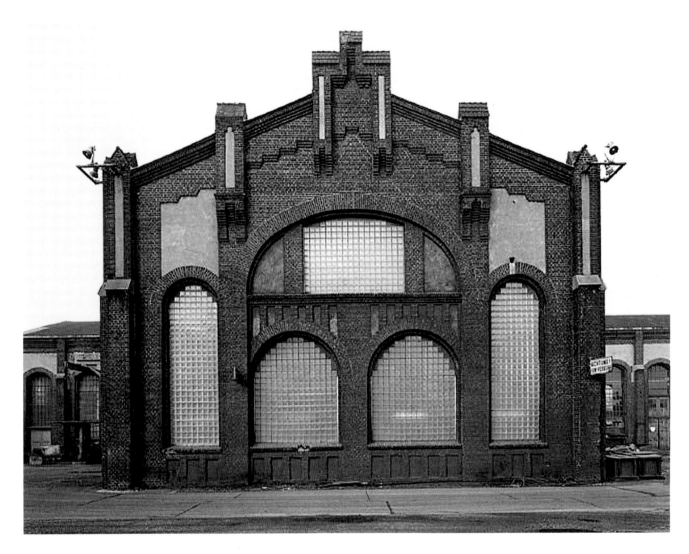

BERND AND HILLA BECHER

Conversely, Abramovic argued: "It was not so much a mutual decision as a simultaneous desire to break up. I had to leave this bond and Ulay wanted to get out from his side."[16] Abramovic has further extended her explanations by reflecting upon a general phenomenon of the 1980s, as being a time when artists wanted to return to their studios.

On the face of it, any consideration of Bernd and Hilla Becher is far less fraught with the apparent intensity of the Ulay/Abramovic relationship. Until Bernd Becher's death in June 2007, the Bechers were a married couple who shared the same intellectual and black-and-white photographic interests. This said, their work was no less complex for all that. Bernd

"No, there's no division of labour where one of us always takes on the same aspect or phase of a work. Each of us does everything, sometimes one of us does this bit, and the other that bit, and the next time it's the other way round. So actually, for us, it makes no difference who provided the impetus for any particular work. And frequently we even completely forget about it until the films are developed and we look at the proofs."

Becher became Professor of Photography at the Düsseldorf Art Academy, although in reality he and Hilla Becher always operated as a team and could not easily be separated.[17] Their work fostered a generation of students that became a unique historical School of Photography in itself (Candida Höfer, Thomas Struth, Thomas Ruff and Andreas Gursky, to mention but a few). Bernd and Hilla met at the Düsseldorf Academy, where they had both studied painting, and married in 1961. However, back in 1959, they had both started documenting the rapidly disappearing earlier forms of industrial architecture. Today, the 1960s have come to be seen in retrospect as the moment when older forms of production and capitalism were beginning to be displaced by the consumer society – a period which some Marxist theorists call Late Capitalism.[18] From their first exhibition in 1963, in Siegen, Germany, they immediately revealed a commitment to taxonomy and to bringing together similarities of shape and design found in earlier domestic or industrial typological infrastructures. This took place first of all in Germany and then, as they travelled extensively in the 1960s and '70s, across the Western World. It is for this reason that many projects had a long gestation, for example *Fördertüme, Deutschland, England, Frankreich* (Mineshafts, Germany, England, France, 1968–97). There is the same accuracy of approach and endeavour whether recording industry-related historical dwellings as in *Fachwerkhäuser, Industriegebiete, Deutschland* (Half-timbered Buildings, Industrial Estates, Germany, 1959–76) or industrial objects like *Gasbehälter, Deutschland* (Gasometers, Germany, 1983–92).

Their working practice, from which they never deviated, was always to take black-and-white photographs with a large-format camera, capturing their motifs from many viewpoints. For the presentation of their photographs, a standardised and balanced viewpoint was subsequently established. This meant on occasions that they had to adopt certain eye lines that were not immediately possible, with or without cropping the photograph – a method that has been both challenged and debated. An extremely formal and schematic system was

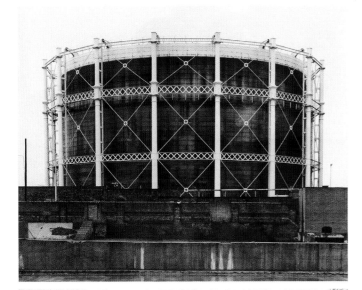

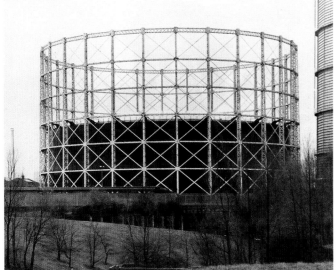

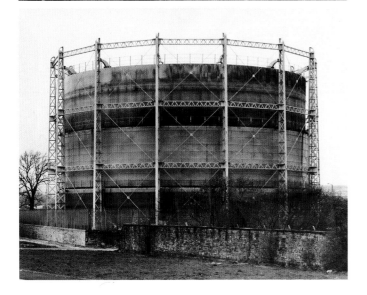

established, presenting the images in a rigid grid formation, not unlike that used by Gilbert & George and, later, more freely by Komar & Melamid. While adopting the grid, a classical trope of modernism, the long period of each project's gestation suggested a synchronous sense of time which might equally be read as touching upon the anti-diachronic aspects associated with the post-modern. In formal terms it was also a logical compliment to the grid-like configurations found in many of the domestic and industrial constructions. The presence of humans, the actual engineers and/or builders of these industrial edifices, are not (or very rarely) seen but remain hidden, only 'visible' through their ongoing industrial tabulations. Single images as presentations, such as in *Kalköfen, Brielle, NL* (Lime Kiln, Brielle, Netherlands, 1968), or *Kalköfen, Hönnetal, Sauerland, D* (Lime Kiln, Hönnetal, Sauerland, Germany, 1996) sometimes take on qualities that make them appear as singular works of industrial sculpture. Though not without precedent, such industrial buildings were often photographed in Germany in the 1920s (another period of great German taxonomic interest). However, such projects had never been so systematically undertaken as the recording approach and method applied by Bernd and Hilla Becher. One might also think of other German typological photographers such as Karl Blossfeldt (1865–1932) or August Sander, mentioned above. Not surprisingly there are obvious similarities with the Minimalist art of the 1960s, though it is for the most part arbitrary to force any analogies with artists such as Sol LeWitt, Carl Andre or Donald Judd. Their work is in fact probably closer to the 1960s revival of Malevich-like Constructivism, remembering that Blinky Palermo and Imi Knoebel were also studying in Düsseldorf

at the same time. Since what the Bechers systematically recorded is quite literally disappearing in front of our eyes, there is an inevitable sense of poignancy experienced when looking at their images. Though some have wished to see their work as a form of historical nostalgia and set it in a negative light, it nonetheless remains a startling accomplishment of aesthetic documentation. As a result the increasing re-use of pre-existent industrial architecture for other purposes has been deeply influenced by them. The Tate Modern in London, a former power station, and the Kuppermühle Museum für Moderne Kunst in Duisberg (both executed by Herzog and De Meuron) spring to mind, and there are numerous others.

It is clear therefore that motives for forming double acts vary considerably. For Gilbert & George it was a clearly defined and developmental strategy; for Komar & Melamid the consequence was formed by their dissident circumstances in the Soviet Union. In the case of Ulay and Abramovic, they were driven by a profound psycho-physiological and experimental relational need, and for the Bechers it was a mutual passion in photography and a fascination with their subject matter.

As precursors, the four double acts cited – there are, of course, many others such as Christo and Jeanne-Claude which might equally well have been used – touch upon many of the themes engaged with intensively and in many different ways by subsequent generations. If a double act in the 1960s and '70s was unusual or appeared only occasionally, it became something of a phenomenon in the 1980s and '90s. It is these later artists that form the greater part of this book. Among the many themes they inherited from their immediate double-act precursors were performance, transgression, prohibition and taboo, gender and desire, war, crime, punishment, political and sexual anarchy, history, memory and nostalgia. There is no suggestion made here, however, that these subjects were not also the concerns of many artists pursuing a singular subjectivity. The chapters that follow are broad in character and never exclusive, since the content of the works produced is frequently of a similar nature and allows various interpretations of the different topics. That these have been arranged under certain chapter headings does not mean that the reader is not free to relocate them, either mentally or emotionally. What it supposes rather is that visual language today is so diverse in its possibilities that it cannot be limited arbitrarily by the temporal determinism of the written word. The dream of creating a formal visual semiotics has largely remained just that – a dream.

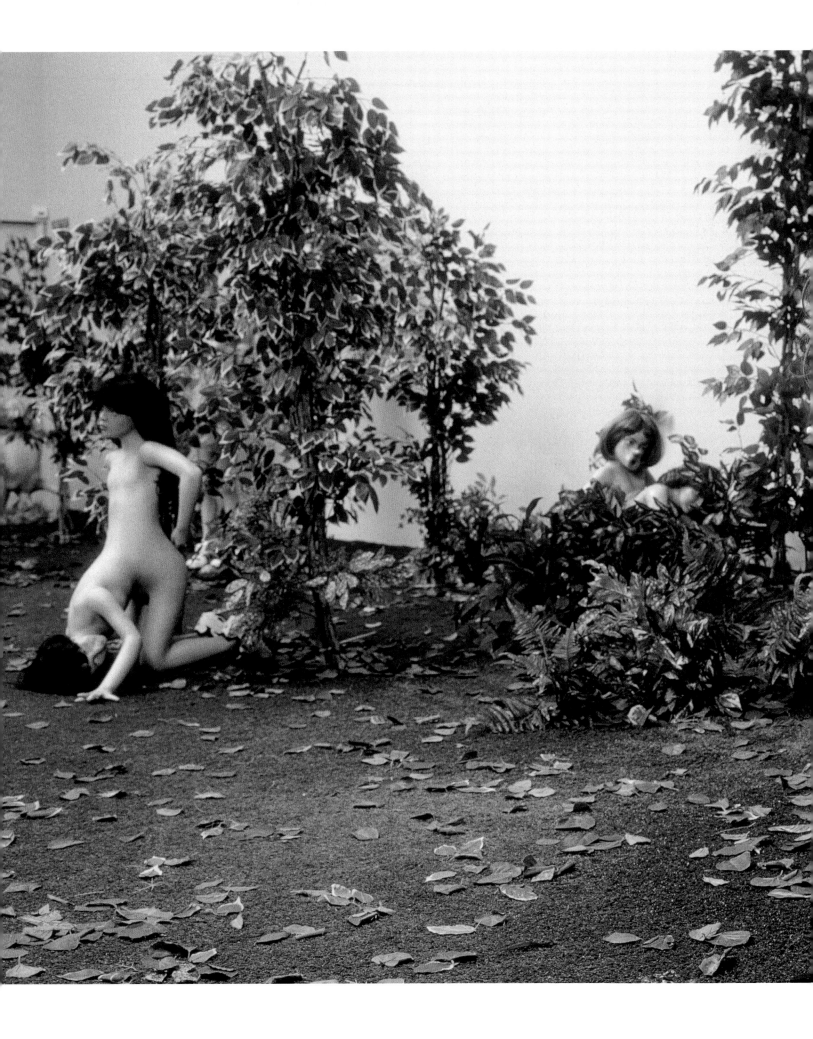

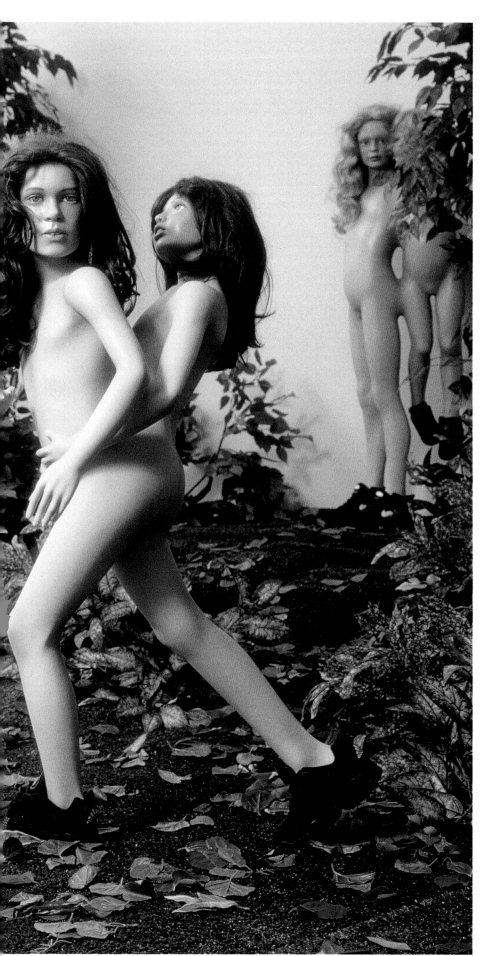

II=TRANSGRESSION PROHIBITION AND TABOO

The breaking of rules and conventions in the visual arts is common and part of their ongoing history. It takes many forms. When it happens with a double act, it spurns the immediacy of a singular subjectivity in favour of a strategy of intervention. A collaborative intervention requires discussion and shared

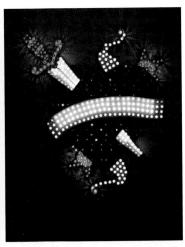

planning. Though it is self-evident that individual artists similarly break existing rules and conventions, they do so with a personal as opposed to a shared intention. A singular subjectivity stresses the sense of the 'I' as distinct from the 'we'. What emerges as a result is a collaborative space between singularity and plurality. Two minds are applied and operate in a relationship and the outcome is negotiated. But because the outcome manifests itself in a single expression, the negotiated contents of the work take on a sense of the 'hidden visible'. It

may well be the case that one participant is more theoretical and the other more practical. But in any event, in terms of the viewer's experience of the work produced, they are not visually separable. To pursue and access the two individual artists' (intentionally sublimated) subjectivities is fraught with psychological speculation. It requires that the viewer solicit contents that are *hors texte*. In the case of singularity it is problematic; in the case of duality even more so. For the viewer, as the French philosopher Jacques Derrida (1930–2004) stated, the 'we', through the very act of considering the structuralist invasion as an object "he would forget its meaning and would forget that what is at stake, first of all, is an adventure of vision, a conversion of the way of putting questions to any object posed before us …"[1] An implied mutuality of intention therefore further undercuts the immediacy of linguistic analysis to segregate the component intentions expressed or projected by the work. And, at the same time, it invariably goes against the intention of the artists who 'have chosen' the double act approach of sublimated identity.

Transgression, prohibition and taboo can take on many forms, either culturally, socially, politically, or sexually.

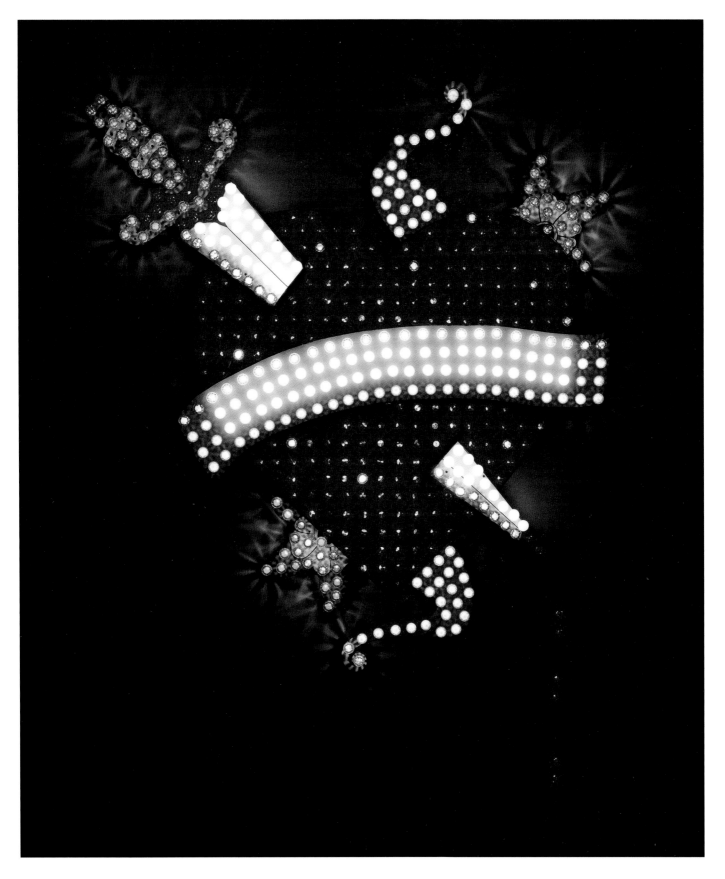

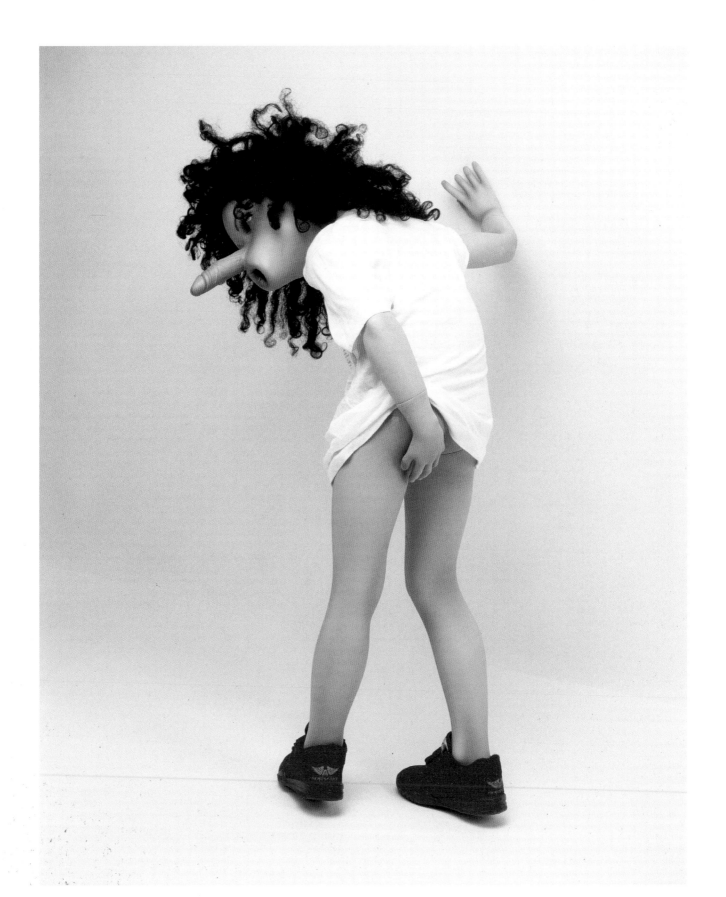

To transgress in the transitive is 'to go beyond or over (a limit or boundary); exceed or overstep.' In the intransitive it is 'to commit an offence by violating a law or command' – in the old fashioned sense quite literally 'to sin'. For the French writer Georges Bataille (1897–1962) it was linked to an anthropological 'ritual licence' and human sovereignty.[2] That is to say either as a necessary catharsis of our animal nature, or as a sacred and profane conflict between the 'natural given' and death.[3] In Bataille's view, it was invariably linked to sexuality and to violence, something he understood as vital to the general economy of 'expenditure' which he saw as central to human life.[4] In this respect the French theorist believed that transgression preceded the law and the taboo.[5] This definition does not extend itself by necessity to the breaking of social, political or institutional conventions (short of criminality). To prohibit simply means 'to prevent by authority' or 'prevent, and/or preclude', derived as it is in its etymological roots from 'in front' and 'to hold'. Thus prohibition stands in the sphere of the legislative and the moral. It is hardly surprising that the avant-garde is the front guard, advance guard or vanguard of the cultural realm. By extension, a taboo is "a prohibition, especially excluding something from use, approach or mention, because of its sacred or inviolable nature" leading to "a ban or an inhibition resulting from custom or emotional aversion," resulting in "an object, a word, or an act protected by such a prohibition."

While these characteristics are not prescribed they do inflect the work of the British artists Jake and Dinos Chapman, among others. In a contemporary context, however, their use of transgression may be simply described as the aesthetics of shock – a somewhat well-trodden path in the twentieth century. Hence to some extent Jake and Dinos' sculptures, paintings and installations take on something of the pantomime of excess. They gorge themselves on shock and aesthetic expenditure. It thus remains something of a contentious issue as to how, or in what way, their work can be fully assimilated. This status of ambiguity is an aspect of their works that they intentionally embrace. The intimacy of their working together as a double act is easily formed by the fact that they are brothers – though they did not initially train together, Dinos having studied at Ravensbourne College of Art and Jake at North East London Polytechnic. They came together shortly afterwards at the Royal College of Art on the master's programme (1988–90). In 1991, after a short period as assistants to Gilbert & George, who must surely have had an influence, they produced their first works together. As Dinos puts it: "We're only good enough to make one person's work. Our own work is crap."[6] From the outset their art immediately engaged with language-oriented expletives – or scatology – and scopophilia,[7] both being part of the aesthetics of transgression.[8] Dealing with excrement, sperm, vomit, urine, blood and decaying flesh, an early work

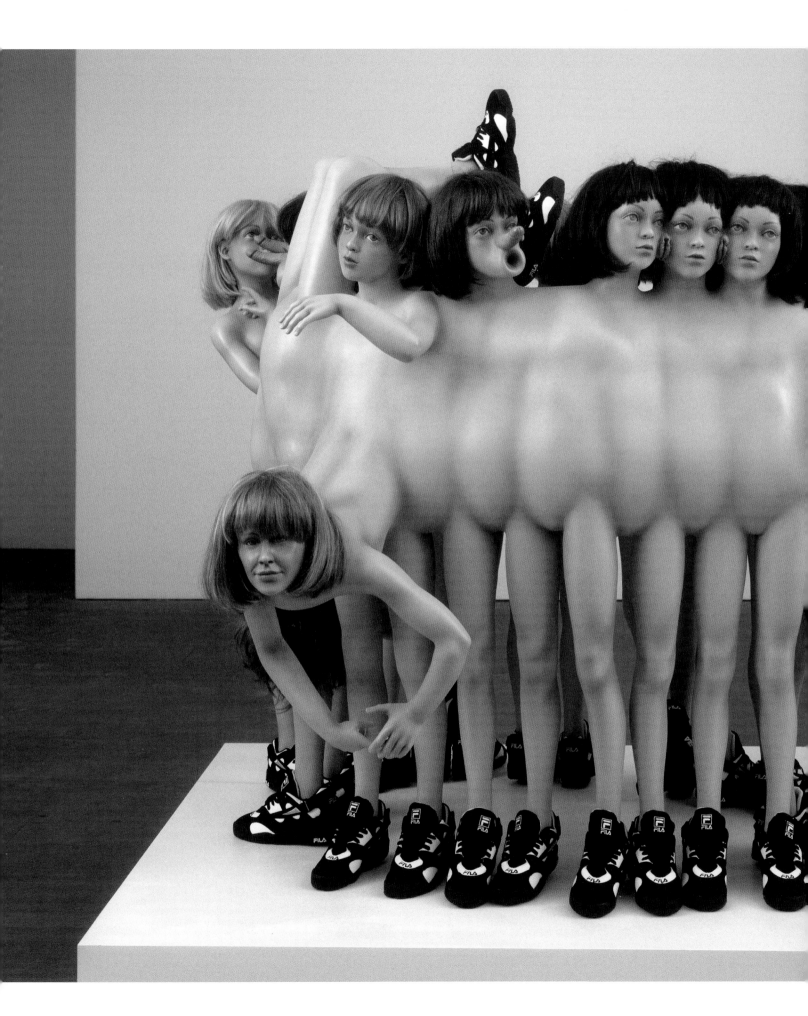

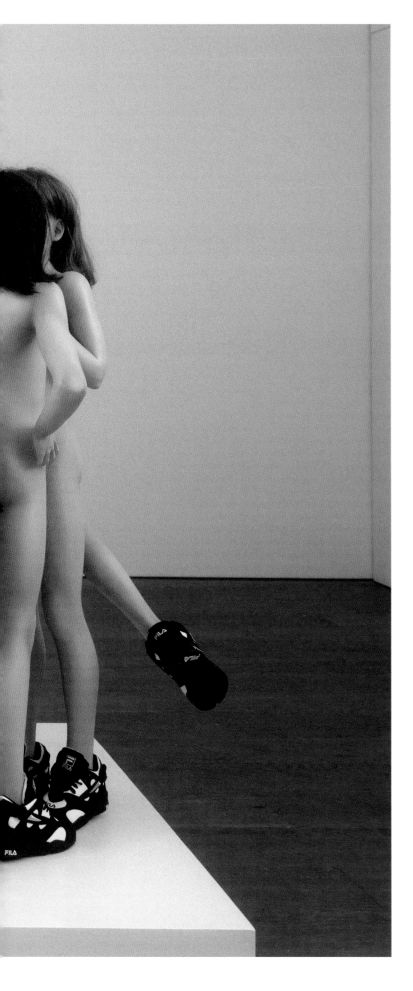

"Social status is defined by crime. Either you are an entrepreneurial criminal who is merely interested in the expansion of your own immediate local status, or you are a state criminal who abides by the judicial consensus and sanctions every economic, techno-hegemonic financial and military crime enacted on your behalf..."

like *We Are Artists* (1991) comprises a superimposed text on a hand-daubed, 'shit-like' wall with more than a hint of the lack of potty-training. The text begins: "We are sore-eyed scopophiliac oxymorons ..." – an immediate and abject attack on all forms of rational idealism in artistic practice. "We were interested in the convergence between filth and science."[9] Not only did excrement evoke the hidden content of the Sadean abject as part of the human psychological make-up, but directed the viewer to his/her irrational responses to it.[10] Body waste and fluids were a strong impulse in Jake and Dinos's early artistic development. In works like *Blood Shit and Semen* (1994), and *Little Death Machine (Castrated)* (1993), the former was a cube as a sculptural tableau, its affixed contents were fashioned toy soldiers, a brain, the mayhem

◖ *JAKE & DINOS CHAPMAN,* **Zygotic acceleration, biogenetic de-sublimated libidinal model,** *(enlarged x 1000), 1995, Mixed media, 150 x 180 x 140 cm, © the artist, Courtesy Jay Jopling/White Cube, London*

JAKE CHAPMAN, Holy Libel, 1997, Chap. 12, p. 28

of warfare comically intermixed with the aforementioned bodily ejections.[11] The use of a cube in not lost upon those with a formal or minimalist persuasion. The *Little Death Machine* was a synthetic brain being struck by a hammer, which then dispensed a semen-like fluid through a dildo-penis into an inverted brain as a receptacle. A hydraulic pun, perhaps, on the sex drive and the eternal repetition of coitus. The idea was reinforced in a smaller work called *Seething Id* (1994), in which a brain is set on a piece of artificial grass, and an incorporated penis in an early state of detumescence is located in between the frontal lobes of the left and right hemispheres. The drawings of the years up to 1997 are like extensions of thought and abject graffiti, including skulls, expletives, elements of planning and recapitulation and human desires. Reminiscent of the writings found on lavatory walls, they are decidedly different from the clandestine expressions of David Hockney in the early 1960s – coincidentally another Royal College protégé.

The most provocative aspect of Jake and Dinos Chapman's work, however, has been – and, for many, remains – the mannequin as a deferred object or fetish.[12] The artist's use of what are in essence adult and child shop dummies – with their mutation and deformation – was particularly disturbing in Britain in the early 1990s with the concern about paedophilia that was re-emerging at that time. But this said, they also mirrored a re-engagement with theories of mutation

in the popular science-fiction literature of the time.[13] The Chapmans' general interest in genetics and the mutating human (deferred onto a doll) formed a perverse strategy for undermining an obsessive attainment to rationalism. If evolution was the theory of the rationalists, then a Buffon-like natural history of devolutionary mutation could come in to play.[14] The wordplay in this context needs to be stressed. In any event, aberrant human deformity and abnormality had long been consigned by the rationalist scientist to formaldehyde or the test tube. It erred against the necessity of classification and taxonomy in biological science. In works *Fuck Face* and *Fuck Face (Athena)* (1994), two young child mannequins (such as you might see in a 'GAP Kids' shop window) have had their nose and mouth replaced by a Pinocchio-like erect penis and anal sphincter. The two, wearing trainers and T-shirts with a text from *We Are Artists,* a child's version of their adolescent elders, deliberately provoke. In their subsequent series called *Tragic Anatomies* (including *Forehead, Satyr, Two-Faced Cunt* and *Deaf Cunt*, 1996), the idea is extended to fusing together mannequin bodies, limbs, heads and sensory organs, the effect being a feeling as if one is at a freak show or in a nineteenth-century anatomy museum of physiological anomalies. This is even more exaggerated in *Zygotic acceleration biogenetic, de-sublimated libidinal model (enlarged x 1000)*, where a ring-a-roses union of numerous child dummies is morphed together.

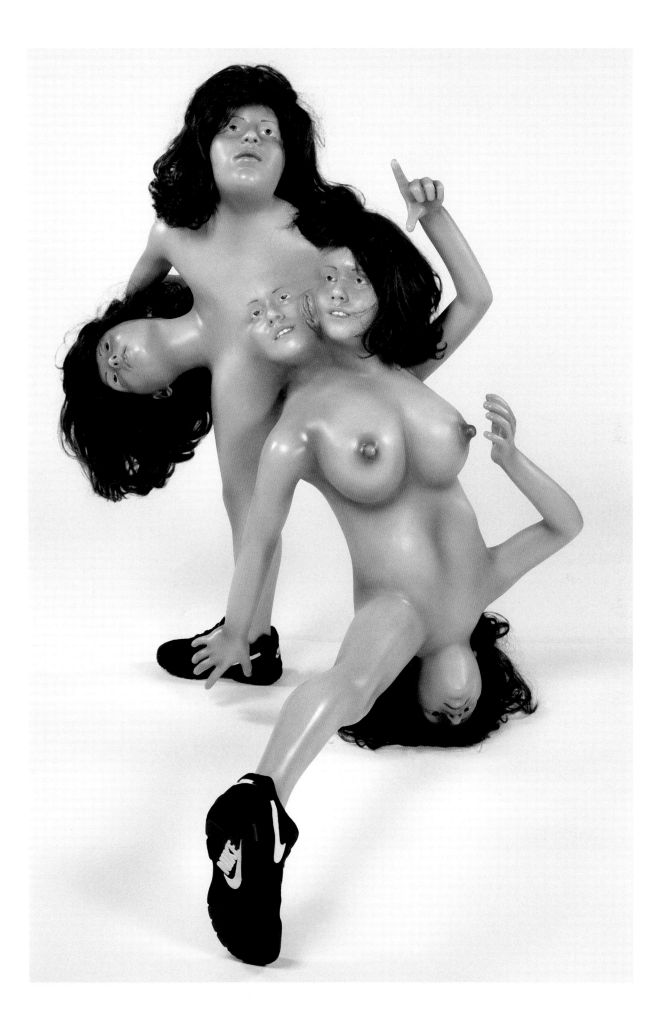

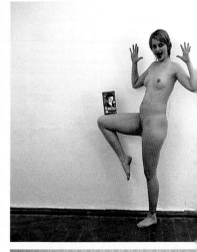

Jake and Dinos' love of scatological expletives and esoteric words in their titles also embraces their sense of delight in the transgressive sound of such words.[15] In what might be called a pseudo-sacrilegious use of bad language, they reveal how the mere sound of such words as 'fuck' and 'cunt' has the aural power to disturb the viewer. Such works, displayed in an Edenic, tinselled setting as *Kiss My Arse* (1996), or the synthetic forest installation of *Tragic Anatomies*, are less about lost innocence and more about an innocence that never was. The child is as libidinal and sexually charged as the adult, since everyone is the product of an interaction (in some form) of the penis and the vagina – whether for the direct purpose of procreation or as a chance outcome and extension of pleasure. This is made explicit in a video work *Bring Me The Head of Franco Toselli* (1995), the title no doubt being a pun on the film *Bring Me the Head of Alfred Garcia* (Sam Peckinpah, 1974) and their former Milan gallerist, where a porn-star pleasures herself with a decollated, penis-nosed head of a male shop dummy which – as with Bataille before them – links the strong relationship between sexuality, pleasure and violence.[16]

If this was the bad-boy side of their art (the amusing pantomime side alluded to earlier), the more serious side exposes all the human anxieties we have about excess sexual energy, violence and libido. It is not surprising that *Mummy and Daddy Chapman* (1993), as mannequin stand-ins for Mum and Dad, found their bodies covered with transgendered genitalia, Mum's body sprouting penises and vice versa, suggesting biological gender is a mixture of chromosomal chance and collaboration. However, throughout their early works (up until 1998) there is a strong psycho-analytical bias towards Freud and his interpreters.[17] Freud's theories of fetishism inform many aspects of this period of Jake and Dinos Chapman's works. But at the same time their mannequins are riven by a practical-theoretical equipoise – that is to say their scopophilic shock value as against their wider intellectual contents. There is a sense of impossible over-existence, not because they are in a true sense human by analogy, but because they exceed the limits of what a living human could be. They are quite literally excessive. Thus the experience for the viewer is polarised between amusement (erotic black humour – "just imagine if your nose were a penis") and disgust, between their fetishist quality as erotic differed objects and a sense of moral deviance.[18] Simultaneously, their interest in Goya's etchings *The Disasters Of War* (c. 1810–11) of 1995 – a recurrent theme throughout the Chapman's work – and in sexuality, oppression, violence, history, war and the despoiling of the human body (in short, torture) is discussed in another context later.

In contradistinction, the 'Blue Noses' acts of transgression are a form of anarchic parody. They are structured

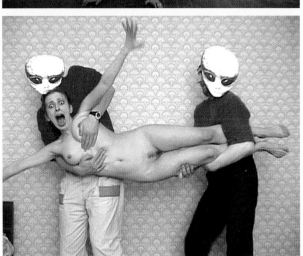

BLUE NOSES

as an intentional form of anti-art. If the Chapmans' use deferred and eroticised objects such as mannequins, Viacheslav Mizin and Alexander Shaburov (born in the provincial Russian cities of Novosibirsk and Ekaterinburg respectively) use their bodies and performances as a means of anarchic intervention. Like Russian, double-act Charlie Chaplins, the 'Blue Noses' see their art work as representing the little man in response to what they believe to be an elitist and pretentious art world. Hence their position is that of art-world spoilers, parodists of high art and its intellectual strategies. And, while it is common enough in the visual arts to bite the hand that feeds you, it still remains contentious as to whether videos of pranks, gags and self-deprecation can form

○ BLUE NOSES, **Sex Art-3,** 2004, Video, Courtesy Galerie Volker Diehl, Berlin and Guelman Gallery, Moscow

○ BLUE NOSES, **Sex Art**, 2003, Video, The girl adopts the poses of the most popular nudes in world art on the kitchen table. Courtesy Galerie Volker Diehl, Berlin and Guelman Gallery, Moscow

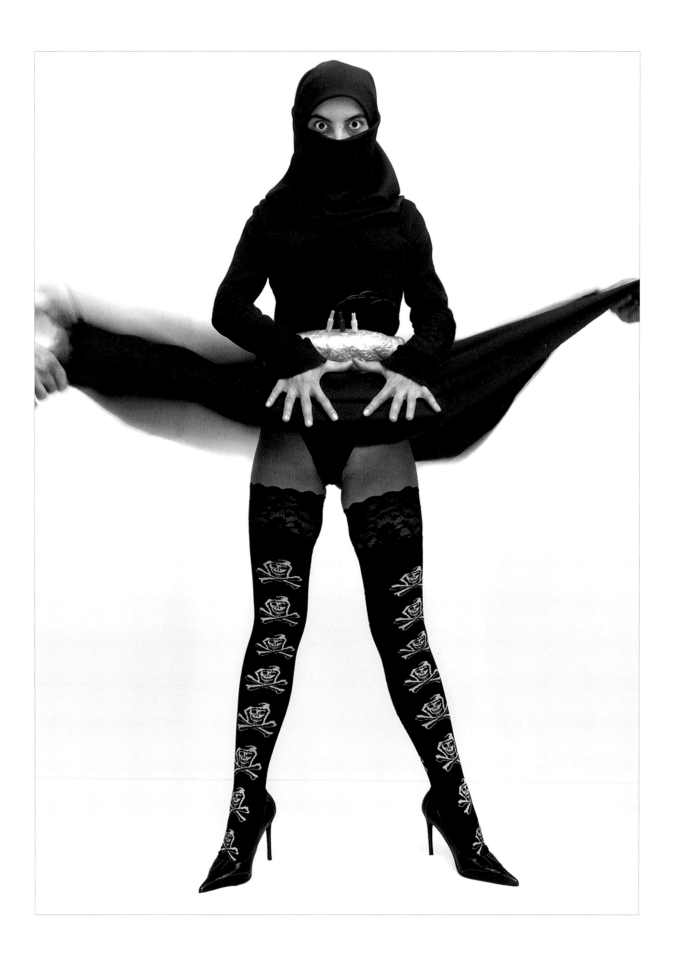

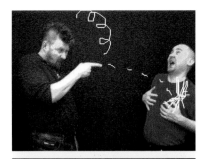

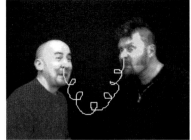

the basis of artistic practice. But then, when working as independent artists, 'imbecility' was a common strategy long before they met and formed 'Blue Noses'.[19] Shabunov, who studied at the School of Fine Art in Sverdlovsk (1980–86), soon realised that an art for the provinces had to be that of and for the 'little man'. Thus he began his 'groundwork strategy', turning commonplace objects in his own life into a museum collection and accumulating things from his own immediate environment: "My Daily Path from Home to the Bus-stop: Photos taken every 15 Steps." Mizin, meanwhile, who studied at the Institute of Architecture at Novosibirsk (1980–86), began by making implausible utopian architecture out of paper: 'Extra-Terrestrial Settlements of Mankind'. In 1990 Shaburov became a photographer, though his anarchic strand remained uppermost – he always took photographs without taking the cover off the lens. In 1993, Mizin found himself working as a painter, but found

it an emotional subsidiary to the vibrant reality of living life, the only place where he thought the artist should function. In the wake of a six-month hospitalisation, following Shaburov's excessive lifestyle and drinking bouts, he began to engage with the body. His obsession was that his penis was the most expressive of organs, leading him to photograph it in juxtaposition with a whole array of objects. He linked "the fate of the cock to the fate of the human being as such."[20]

In the mid-90s, within the context of 'Moscow actionism', Mizin also began to use his body, creating a *Self-Portrait* using his own blood, and *Shower-bath* (1995) in urine. In the wake of this, Mizin made a film in which he simulated the annihilation of all rival artists. Hence through shared contexts and approaches, by the late 1990s, Saburov and Mizin formed a natural empathy. It was manifested in *The New Holy Fools* (1999), a sixteen-photograph project where they stood in the winter streets in only their underwear. And, while 'Blue Noses' began as a group, what emerged was a like-

minded double-act using primarily video and photography. The name itself came from the video *The Blue Noses Present 14 Performances in a Bomb Shelter* (1999), which parodied many of the different video 'plots and genres' of Western-influenced, contemporary art, vis-à-vis Eastern Europe. While the location of the bomb shelter remains unspecified, they wore blue bottle caps on their noses throughout the performances. As a result, the name stuck. What they share – albeit little – with Jake and Dinos Chapman is an interest in the scatological, but without any marked sense of an intellectual or ideological purpose. Growing up in the Soviet Union, the 'Blue Noses' are extremely resistant to art that has any trace of an ideological or intellectually manipulative motivation. The freedom afforded by the late Yeltsin years at the end of the millennium, meant they could express their anarchistic tendencies, attacking and appropriating any or all forms of popular culture. Thus a no-holes-barred approach was taken towards politicians, advertising, television, popular religious icons, tokens of high culture and what they considered arbitrary forms of modern technology. They are anarchists if only to the extent that they reject overbearing authority and a fixed ordering of society, and parodists to the extent that they pursue ridicule and mockery to achieve their ends. Their references of identification are with the provincial, the so-called 'little people', and by extension with the commonplace of everyday life. That said, their art is extremely funny and deliberately charged with a sense of hit and miss. Their works are discussed in more depth in the chapter on performance and sexual and social anarchy.

Not all transgressions cause immediate shock and social opprobrium. There is the undermining of traditional conventions and institutional attitudes, as strategy which may in the long run have a more enduring effect. The Danish and Norwegian artists Michael Elmgreen and Ingar Dragset are a double act that strikes at the very heart of the institutional art world, namely the site of reception[21] – a site that they have problematised socially, culturally and sexually. They are a male partnership who met in 1995 and who, in the last decade, have continually undermined contemporary concepts of ex-hibition and presentation. In line with the shifting grounds of post-minimal presentation, they question the social meaning of space.[22] Space is not seen as a neutral idea, as the use of the white cube supposes, but sites where social meaning is made and/or control is exercised.[23] Thus the intention of their work is to make the viewer rethink the boundaries of art and its site of presentation.[24] In a work like *Cruising Pavilion/ Powerless Structures* (1998), they installed a white container with internal partitions in a public park in Aarhus. The interior walls suggested rooms, but were pierced with openings so that people could touch or have contact with each other through the openings. Since the park was a common meeting place at night for the local homosexual community, it took on

○ *ELMGREEN & DRAGSET, **Powerless Structures, Fig. 11**, 1997, Courtesy Louisiana Museum of Modern Art*

ELMGREEN & DRAGSET

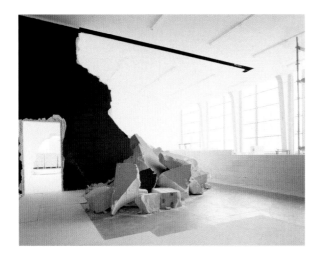

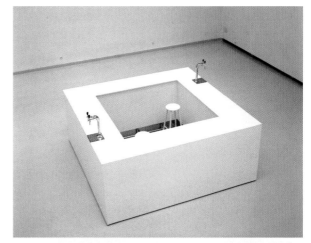

a double function. By day it served as a minimalist sculpture-cum-community shelter and, at night, functioned as a 'cottage' or 'dark room' where men met and had anonymous sex. When the artists planned to install the structure in the Witte de With in Rotterdam, in 2001, permission was refused. However, not all their projects take such a provocative line of approach. In a project called *Between Other Events* (2000), at the Galerie für Zeitgenössische Kunst in Leipzig, they used two unemployed painters to repaint continuously the empty space throughout the period of the exhibition.[25] Thus what is usually the hidden interral 'between exhibitions' became the exhibition itself. Some thirty-five coats of white paint were applied. The outcome simultaneously challenged the white cube presenting a world apart (this is in its pose of neutrality), and at the same time exposed social contents – a process that lead to the creation

of such a world.[26] As Elmgreen put it: "Throughout the last century a lot of effort was put into developing a completely neutral architectural environment for art presentation … something that is obviously not possible."[27] It highlighted the fact that the contemporary is always temporary. Yet it goes almost without saying that problematising the site of presentation (the white cube being an extension of the idea developed by Alfred Barr, at the Museum of Modern Art, New York, in the 1920s and 30s), finds it origins in Marcel Duchamp. It follows therefore that Elmgreen & Dragset question and point to the site of presentation and reception, as the place where art is sanctioned and takes on its identity as art. The monosyllabic certainty with which the white cube and exhibition space has asserted itself – it was never true of Dada and Surrealism, though perhaps true of Constructivism – in the

○ (left) ELMGREEN & DRAGSET, **Taking Place**, 2001, Courtesy of the artists

○ (right) ELMGREEN & DRAGSET, **Powerless Structures, Fig. 21 - Queer bar**, 1998, Courtesy Galerie Nicolai Wallner

○ ELMGREEN & DRAGSET, **Andrea Candela, Fig. 1**, 2006, Courtesy Galleria Massimo de Carlo

post-war period, denies the social modalities and meaning that brought it into being and continue to sustain it.

In a whole series of *Powerless Structures* in 2000/01, the artists posed questions as to what makes up the fabric of the site of presentation. A particular emphasis was placed on points of entry and exit. Doors formed a special theme as well as impossible points of entry and exit (no doubt indebted to Duchamp's *Door, 11 rue Larrey*, of 1927), in several works shown at the Nicolai Wallner Gallery in Copenhagen (2000/01). Walls and steps also played an important role, as in their sculpture for the Statens Museum, Copenhagen. A wall and door portal laid on its side as an object, and a set of three steps with a stair railing that leads nowhere representing itself as a mere entity, are but two examples. Steps, ladders, walls and doors are all part of the accoutrement of the social fabric that is the space of presentation, and hence part of its meaning. The artists drew attention to these omnipresent facts, which are always treated as if they are a hidden visible. The artists Elmgreen & Dragset have made our awareness of

them visible. Even the floor and ceiling are usually accepted as a given. It was the floor and ceiling of the white cube that was among the most significant of their earlier works. Their project for Portikus in Frankfurt in 2001, completely changed the meaning of the white cube exhibition space in a truly phenomenological sense. Inside Portikus the artists created a sweeping wave in the floor and ceiling, so that as the viewers entered the former white cube space they were visually and physically swept upwards towards the ceiling – so much so that you felt as if you could almost touch it. Conversely, the

⬤ *ELMGREEN & DRAGSET, Photo: Bruno Serralongue, bruno@brunoserralongue.com*

ceiling swept downwards, the whole sensation being like a roller-coaster ride. Hence, what was formerly a simple rectangle or cube became a surfing experience where all familiar points of reference were dissolved.

> "When Ingar and I met, I had already been part of the local art scene in Copenhagen for several years. Our first collaboration emerged from this context, but I admit that our first works together were due just as much to our being in love as wanting to say something serious using the performance medium."

The role of performance and working fabrication is a recurrent theme for this double act. Indeed, as early as 1997, in a project called *Twelve Hours of White Paint/Powerless Structures,* Elmgreen & Dragset painted a white cube over a twelve hour period using 164 litres of white paint. One is tempted to believe that many of their ideas spring from this moment. It is after all common for young artists to earn money, by being employed by gallery owners to re-paint spaces between exhibitions. The role of transformative and performance actions by the artists Elmgreen & Dragset, be it themselves, or orchestrated for others to perform, is discussed later.

MICHAEL ELMGREEN, 'Taking Place', 2001, pp. 36-37

The work of the double act Tim Noble and Sue Webster could hardly be more different. Whereas Elmgreen & Dragset are not overwhelmingly present in their works (even their performances lay no visual stress on asserting their individual or collaborative identities), the British artists Noble and Webster are omnipresent in almost everything they undertake. Their work overtly expresses their relationship and their working together as a strategic double act. That their relationship is intense is revealed by their series of erotic pencil drawings and the publication of their love-making, entitled *The Joy of Sex* (2005, p.132/133).[28] While it appropriates the famous 1972 publication of the same name, the drawings were all made from pencils found in the international hotels they have stayed in around the world.[29] Noble and Webster met in 1986 at Nottingham Trent University Art School (1986–89) and, though both Midlanders, their backgrounds could not have been more different. Tim Noble came from a family of artists; his father was a figurative sculptor and teacher at Cheltenham School of Art in Gloucestershire. Typical of the British 1970s generation, Noble's father was extremely anti-art market, and thought it a more honourable profession to be an art teacher. However, a childhood friend who lived nearby was the son of the famous 'Geometry of Fear' sculptor Lynn Chadwick.[30] In fact, the first two exhibitions Noble attended in London in his teens at the Tate Gallery were those of Francis Bacon (existential

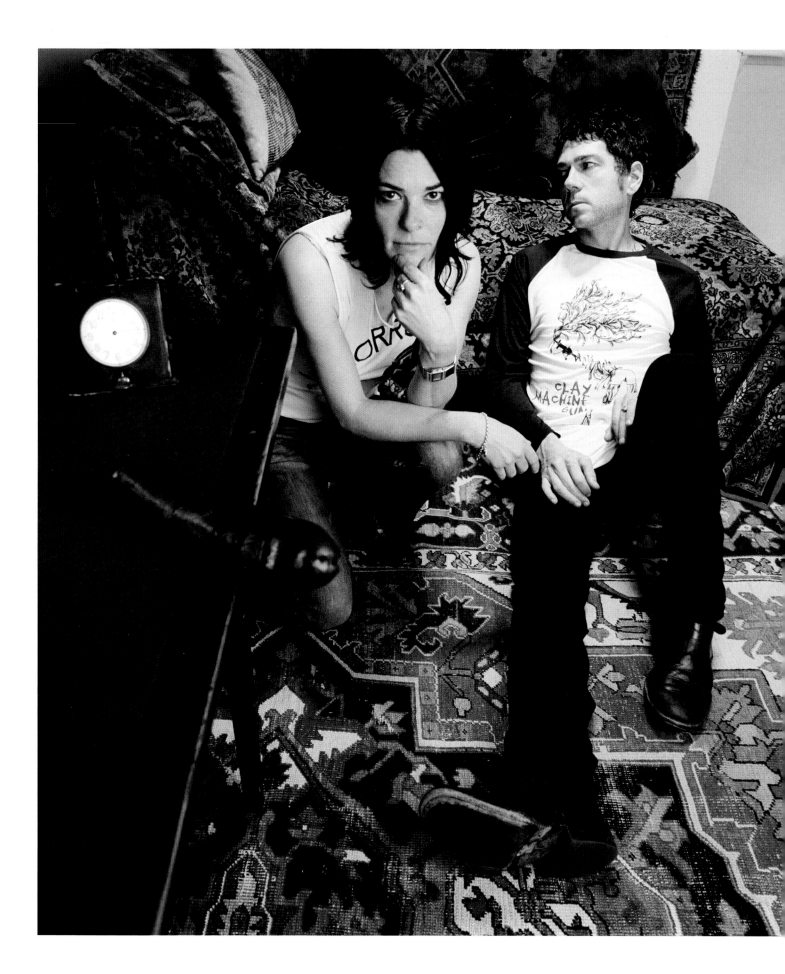

and expressive), and the Swiss artist and *bricolagiste* Jean Tinguely, who assembled found materials into Heath Robinson-like mechanical machines. Both in their different ways would seem to have been a subsequent influence on Noble. Webster comes from a thoroughly working class family with aspirations from Leicester. Her roots and her non-conformity (resulting in periods of depression in her teenage years), reminds one a little of Joe Orton, who also came from the same city. Her father was an hard-working electrician who subsequently taught her many electrical and lighting skills. Meeting in Nottingham, they did not become Noble & Webster straight away, but shared a taste in music and a fascination with junkyards and found materials. Rock music has been a vital influence on their lives. As a couple while at art school, they travelled in the summer months together to Turkey and the United States (twice). On their trips to the United States they became even more fascinated with junkyards and trash, as well as emblematic signs of the American consumer culture. After finishing art school they lived in the then bleak city of Bradford (a city with a huge Asian community), with its massive unemployment during the Thatcher decade, and found a strong sense

of identification with the disenfranchised and the underclass – a common term coined in the 1980s – including bikers and small time criminals. At this time (1990) they shared a studio at Dean Clough, near Halifax. An initial aversion to London was overcome and the two artists moved there in 1992. Tim was accepted at the Royal College of Art, while Sue was turned down. The decisive shift that took place in the British art scene in the wake of Damian Hirst and others, following the Freeze exhibition in the late 80s, was no doubt an important spur to the artists on their arrival in the capital. Webster's rejection seemed to make little difference, since Tim gave Sue his security password, and while at the Royal College they continually worked together, almost all the other artists assuming she was on the course. It is from this moment, perhaps, that we can speak of their becoming a double act. Something exemplified by Noble's student exhibition submission (though never finished on time) which was to be a capsule of both their excrement floating in a vitrine of water, and a capsule of cream floating in another, derived from a friend saying "the shit and cream always rise to the top." The vitrines were cordoned off by an electric fence. Another large metal sculpture called *HYPE!* was to accompany it, but was not finished on time. Though it

was never fully realised Webster's brilliance at drumming up publicity made them something of a minor *cause célèbre,* with all the usual press responses (the hype intended to be part of the art), there was the proverbial comment 'the shit hit the fan'. In the wake of this, their art has always been questioning and transgressive. It will not have eluded notice that Jake & Dinos Chapman also studied at the Royal College (finishing two years earlier), and Noble & Webster have always acknowledged an awareness of Gilbert & George. Indeed, they all live just a few hundred yards from one another in London's East End. As if to reinforce their sense of identification and sublimation, they

"yeah, it scares the shit out of me, what we're doing – the denial thing, it's not natural but it feels like the right thing to do. I prepared myself for the worst, in terms of people's expectations....but you know I'm not making the show to please them, the fact that we are doing the show so soon after WOW, surely people don't expect a repeat performance, surely people are a little more intelligent than that. I am terrified though."

SUE WEBSTER, *Speaking of show The New Barbarians 'Shoplifters of the World Unite', 1999. np.*

◊ *TIM NOBLE & SUE WEBSTER,* **Dirty White Trash (with Gulls)***, 1998, 6 months' worth of artists' trash, 2 taxidermy seagulls, light projector, Dimensions: variable, Courtesy of the artists*

subsequently began to use the same black hair dye (it was also part of a project in which they included themselves in a work entitled *Simply Natural* as a photomontage, taking images from a popular dye product), and stylistically they began wear the same

clothes – though as a style it remains uniquely their own. A double light work like *Puny Undernourished Kid & Girlfriend From Hell* (2004, p. 130/131)) also shares an interest in attitudes of scatology and the aesthetics of shock with their fellow East Enders.[31] In fact the drawing for the work dates from much earlier – from 1995.

Noble and Webster work across several media: sculpture, painting, video, neon lighting, sound art and installation. The years 1993–99 were a period of initially underground experimentation and the process of developing their shared persona within their works. This included projects like billboard and fly posting (1994); a Vanity Fair poster montage *London Swings* (1997); a boxing poster montage 'Webster v. Noble' called *Home Chance* (1997) and a project of handmade tattoo designs applied to fellow members of the art scene (Livestock Market, 1997); an audio bird box called *Abusive Crow* (1995); and cans of baked beans as an exhibition invitation for *British Rubbish* (1996). However, two dominant themes

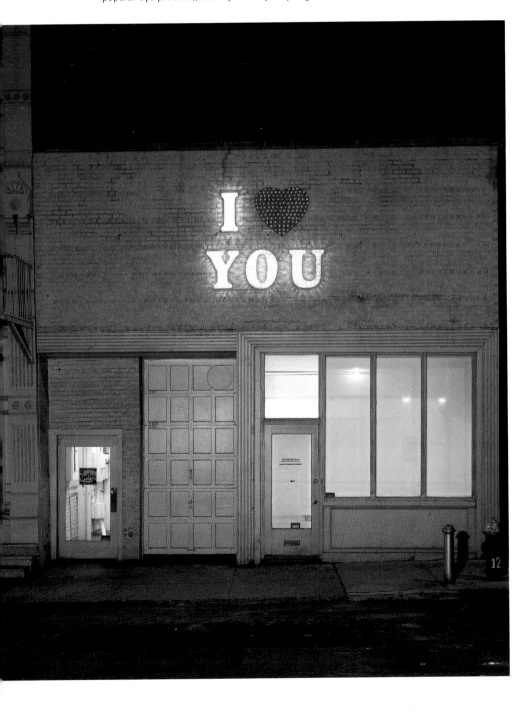

12

appeared during these years: the light works, and the rubbish or trash installations that cast silhouettes of the artists. The light work began in a seminal state with *Flash Painting* (1993), shown in a self-organised show at Atlantis in Brick Lane. Other leading artists of the new generation took part, including Chris Ofili. It was a minimal monochrome painting whose rectangle was surrounded by white golf-ball light bulbs, somewhat like those found around a mirror in a traditional actor's dressing room. The role of theatre and presentation cannot be omitted when considering any of their works. It was a sort of 'minimalism meets pop art'. From this stemmed an extraordinary series of complex flashing light installations like *Excessive Sensual Indulgence* (1996), *Toxic Schizophrenia* (1997), *Vague Us* (a pun on Madonna, perhaps) and *The Sweet Smell of Excess* (1998). Developed through complex light sequencing and 4-channel bubble and light effects, they took on what appeared to be pseudo-religious themes. *Excessive Sensual Indulgence* was, perhaps, a parody on the fountain of life, while *Toxic Schizophrenia* played with a flashing Sacred Heart of Jesus idea pieced with a dagger. It is also a self-portrait of sorts. The nature of these works simultaneously suggests emblemata, or popular consumer icons, that also seem to hark back to the effect that such logos had had on them during their earlier visits to America.[32] One is reminded of Las Vegas bridal chapels and the garish signage that often accompanies them. *The Sweet Smell of Excess*, on the other hand, is reminiscent – at least to my generation – of earlier Babycham advertising. The drink Babycham was a cheap form of sparkling wine, a beverage drunk largely by women from the working classes who could never afford champagne. It also exemplified the fast and excessive lifestyle the artists were leading at this time. It is worth remembering that Webster's father taught her much about electrical circuitry and she was no doubt comfortable with this media. Alongside these works there were also the extraordinary configured piles of rubbish (trash), sometimes including animal taxidermy, as in *Dirty White Trash (with Gulls)* (1998), and *Miss Understood & Mr Meanor* (1997). The artist's use of wordplay also draws out further analogies with Jake and Dinos Chapman. In *Dirty White Trash (with Gulls)* an accumulation of six months of the artists' trash was arranged in such a manner (including the herring gulls who are frequently found on rubbish dumps), so that when light was projected from a specific direction it shows Noble & Webster sitting back to back on the wall beyond. The work *Miss Understood & Mr Meanor,* again made up of their trash and personal materials (including sexual items), has the heads of Noble and Webster spiked on poles when projected. Heads on pikes are a common *leitmotif* of English history and, with the East End's proximity to the Tower of London, it may not be surprising. While we might be tempted to think of Arman's

○ *TIM NOBLE & SUE WEBSTER,* **I ❤ YOU***, 2000, Deitch Projects, NYC, 298 coloured UFO reflector caps, lamps and holders, foamex, aerosol paint, electronic light sequencer (12 x 3-channel spell, fill & shimmer effect), transformer, 180 x 8 x 160 cm, Courtesy of the artists*

(1928–2005) poubelles and accumulation portraits of the 1960s, the effect is more readily analogous to the Victorian light shows of shadow and silhouette projections. A paradoxical sense of cultural history (sometimes even nostalgia) is always present in their work. The feeling of paradox takes on further meaning when we consider the sculptural hairless figures (translucent resin, fibreglass) Noble & Webster called *The New Barbarians* (1997–99); a hairier version called *Masters of the Universe* appeared later in 2000.[33] Noble & Webster present themselves as some earlier form of anthropoid life. While identification with 'the barbarian' has Surrealist precedents, the devolved or mutated state of a primitive Noble & Webster adds a startling sense of human displacement of their self-identity that is quite contrary to the mannequins of the Chapmans. This work particularly poses questions of altered or sublimated identity

to which I will return later. It suggests strategies of the abject and stages of human regression.

Transgression, prohibition and taboo would seem in these instances to be extremely broad in both remit and approach. But what is intended by these artists is to confront the viewer with the banal complacency of the gallery or museum. For artists like Jake & Dinos Chapman and Tim and Sue Webster, the effect is intended to shock, though it should be mixed with a fair dose of humour and a tongue-in-cheek approach. In the case of the 'Blue Noses', the intention is to debunk the art institution, suggesting that artistic life exists elsewhere and what passes for high culture is merely for the self-indulgence and gratification of the bourgeois middle classes. Elmgreen & Dragset address the site of presentation and display head on, suggesting that it has to rethink itself as regards its cultural role and social meaning.

○ *TIM NOBLE & SUE WEBSTER, **The New Barbarians**, 1997–99, Translucent resin, fibreglass, Figures: 79 x 69 x 137 cm Infinity cove: Painted medium-ply board, Dimensions: variable, Courtesy of the artists*

○ MUNTEAN/ROSENBLUM, *To Die For*, Heike, Heinz, Antonietta, Jonas, Sebastian, Clara, Kira, Phillip, 2001, C-prints, Ed. 5, 170 x 125 cm, Courtesy Georg Kargl Fine Arts, Vienna | Maureen Paley, London | Irit Sommer, Tel Aviv | Arndt & Partner, Berlin/Zurich | Galleria Franco Noero, Torino | Team Gallery, New York

To speak of gender is not necessarily to speak of sex, any more than to speak of desire is to speak of eroticism.[1] Something more complex than mere biology is at work. Gender is about identity, as desire is about longing and yearning – and besides that far more.[2] Although gender in its common usage is applied to distinctions between the male and the female, within society it is about a social and cultural construct. The degree to which it is biologically determined generally indicates the prevailing attitudes of that society. Language has played an enormous part in determining matters along the conventional lines of biology. In many languages, gender objects and phenomena follow the traditional male/female dichotomy. Other languages place gender in a 'neutral' context. While it remains merely a linguistic convention, nonetheless language constantly reinforces physiological and biochemical analogies with gender 'connectors and fasteners'. For example the language of plugs and sockets, or male and female threads to pipes – the male pipe is for insertion and the female pipe is the receptacle. There are hundreds of other examples in all the major languages of the world. In instances where a person feels his or her gender identity as incongruent with these determining categories, he or she is forced into a state of alterity – and is called transgender or gender queer. Even with other euphemistic terms such people are removed from the mainstream of society. However, in practising a specific form of

PIERRE et GILLES

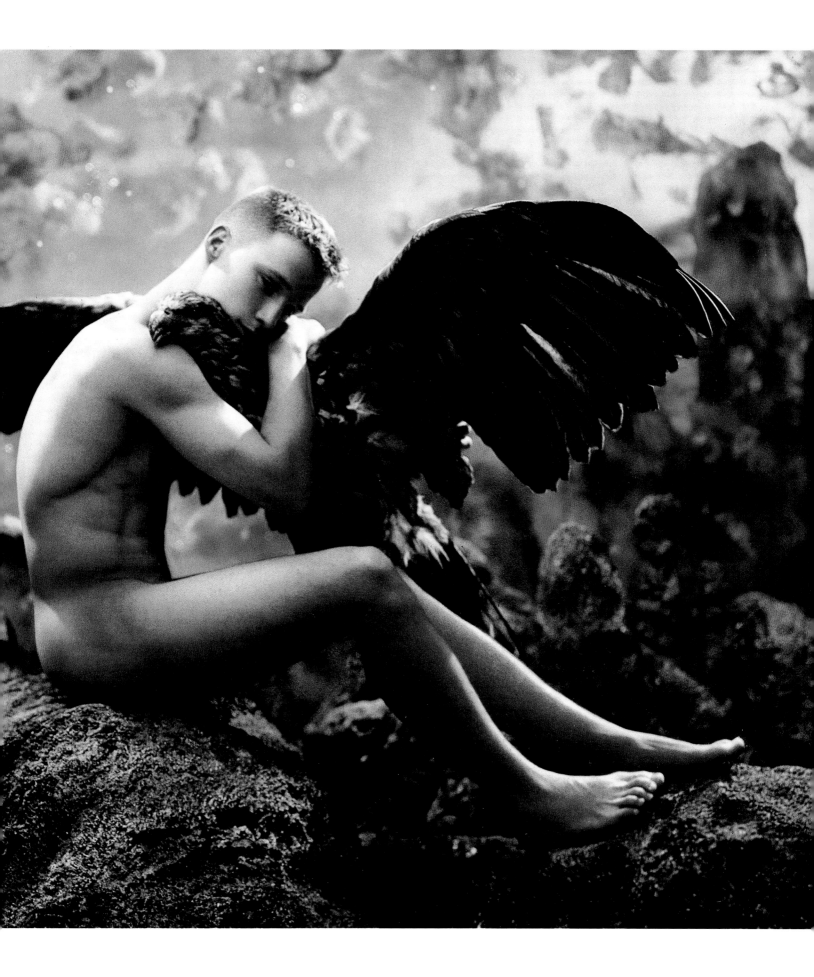

sexual act or role, the matter is not necessarily a sexual one. Sometimes – through dress or behaviour – it questions the traditional roles and stereotypes inscribed within the arbitrary use of language as a form of expression. In such contexts, transgendered social behaviour (as well as exaggerated eccentricity) tends to be sublimated and made anomalous. It can be blushingly admired or soberly punished.

The double-act artists in this chapter embrace issues of gender and desire, though not always in an immediately transgressive or sexual sense. Muntean/ Rosenblum address aspects of desire and confusion in adolescence, since one of the main characteristics of adolescent desire is "the feeling that accompanies an unsatisfied state." A sense of wanting, yearning and longing that leads to anxious and unfulfilled feelings of frustration. A certain sense of visual lassitude is brought on by this confusion. Adolescence and post-adolescence is of course a crucial time in the development of social and cultural gender identity. By contrast, the 'life's a dream' approach of Abetz/Drescher focuses on rock music heroes and the musical memorabilia of the 1960s and '70s. This is often expressed by self-portaiture and through several levels of identity association with what Abetz/Drescher consider to be a period of musical sincerity. Aspects of the fabulous and the surreal fill their paintings. Hence they deliberately pursue and

EVA & ADELE

update earlier iconography, giving to their images at times an overwhelming sense of *horror vacui*. Conversely, Eva & Adele produce painting and art works that are an extension of their life as a performance. In pursuit of what they call a constant state of 'futuring', all traces of their earlier identities have been deliberately sublimated. They are literally a trademark or brand "Eva & Adele", so much so that the space between art and life has been all but completely dissolved. Pierre et Gilles produce photographs that are best described as voyeurism on the one hand, and scopophilic kitsch on the other.[3] Though it must be said that some people today might simply call it a form of humorous 'camp' art, in other words an adopted pose or an exaggerated fashion directed towards creating an optical frisson. Pierre et Gilles play around extensively with homosexual eroticism, expressed through a veil of mythology, history, religion and sacrilege. Beneath the surface is an intentionally ambiguous theatre of desire, and a yearning to look and to violate – be it a physical desire (most often not) or merely an exaggerated extension of voyeurism.

Markus Muntean is an Austrian artist born in Graz; Adi Rosenblum an artist who is originally from Haifa, Israel. They came together and sublimated their subjective singularity into a double act in 1992. Their previous biographical existence has been all but erased from subsequent literature. The greater body of their work is painting, though they also make videos, text-based collages, photographs, installations and sculpture – the latter often forming a part of specific exhibition installations. By intention, the sculpture compliments and reinforces the experience and understanding of their two-dimensional work at exhibitions. Muntean and Rosenblum live and work together in Vienna and London. From the outset as regards their relationship and partnership – their becoming a double act – they took up a position that was both conceptual and strategic: "This twofold authorship completely suits our concept. I think it is similar to the concept of the mask. Through the mask we created the identity of the two of us and it allows us to escape the problems of my identification of my role of being a painter."[4]

Muntean/Rosenblum's compositional approach to painting is traditional, though as much derived from the collective memory of figuration in popular media (fashion magazines) as it is from the direct appropriations from Renaissance, Baroque and Neo-Classical motifs. This said, the artist's coinventional presentation of figures in the foreground space leads one to experience them like a frieze, as found in Neoclassical history painting. As a result, in the larger paintings, one tends to read the images in a lateral sense, rather than in terms of a recessive space. Presented as tableaux of adolescent life, the images are always lozenge-shaped with a surrounding border of white. In visual terms they are not without similarity

THE FEELINGS THAT HURT MOST, THE EMOTIONS THAT PAIN MOST ARE THE ONES THAT ARE ABSURD — NOSTALGIA FOR THINGS THAT NEVER WERE. DESIRE FOR WHAT MIGHT HAVE BEEN. ANGUISH FOR NOT BEING SOME ONE ELSE, DISSATISFACTION WITH THE EXISTENCE OF THE WORLD.

to an old-fashioned television set or popular comic images. A maxim, aphorism or expressive comment, written by hand, accompanies each work though it is never directly connected to a particular figure within the image. The texts are emblematic and form a deliberately ambiguous or liminal content. This is to say they form a threshold in which they are neither explicitly related to the image, nor are they, however, unrelated to the painting. Much has been said that the works are expressions of allegories. However, they are not allegorical in the classical sense of rhetoric. If they are related, it is rather in a sense

ONCE I FELT SIMPLE AND I WISHED TO BE SIMPLE. BUT THAT DIES IF YOU STRUGGLE A LOT.

of an extended metaphor into the imagined, but without any notion of the fabulous or parable or directed moral contents. The adolescent boys and girls are most often static and gripped with a sense of lassitude. They are young and invariably attractive, but any easily readable psychological content is denied the viewer. This is certainly true of a painting such as *Untitled (Once I felt simple …)* (2001), and holds true for nearly all Muntean/Rosenblum paintings. They appear bored, regardless of the fact that they possess the fresh and vibrant attractiveness of youth. The subject matter constantly slips away from the viewer and, though we recognise these young people through their trendy clothes, their trainers, and their familiar bourgeois lifestyle and material acquisitions, there is no immediate sense and/or wish for a personal identification. In work like *Untitled (The feelings that hurt most …)* (2002), although of course we might recognise the famous vertical tree almost certainly derived originally from Raphael's *Vision of a Knight* (c. 1505) – something further emphasised by breaking up Raphael's compositional pyramid – it does not reveal any narrative content as such. The central female figure makes a suggested body and eye contact with the viewer in the Renaissance convention of Leon Battista Alberti's *Della Pittura*, but it is to no emotional effect since the adolescents seem as bored and distracted with other each as they are with the world around them.[5]

THE AIR WAS TINGED WITH AN ORANGE GLOW. THERE WAS AN ETERNAL MOTIONLESSNESS ABOUT EVERYTHING THAT MADE THEM FEEL THAT YOU LIVE ALWAYS AS MUCH IN THE PAST AS IN THE PRESENT AND THE APPREHENSION OF DISTANCE EVOKED A SENSE OF LOSS IN THEM.

While my analysis might suggest a sombre or negative tone, they are extraordinary images in every other respect. Muntean/ Rosenblum show the problematic nature of figurative painting today. In what they refer to as a polyphonic structure, they create a system of precise ambiguity with each element being knowingly self-referential and simultaneously self-critical: "One of the main issues is the contemporary notion of the subject and the question of identity."[6] Hence their analysis and investigation of the use of the figurative poses and gestures in painting today is something of a modern *Iconologia*.[7]

If we consider Muntean/Rosenblum's pseudo-taxonomic photographs of adolescents (not unlike those by Thomas Ruff), with their set poses and repetitions (another important theme throughout the artists' works), we find that

LIFE IS JUST A PRISON IN WHICH WE TRY TO KEEP OURSELVES BUSY AND TO FORGET. YES, WE FORGET, WE GO ON FORGETTING, ALL THE THINGS WE WOULD PREFER TO KNOW NOTHING ABOUT, JUST TAKING REFUGE IN FORGETFULNESS AND FRIVOLITY.

LIFE IS WHATEVER WE CONCEIVE IT TO BE.

I DON'T KNOW, YES, BUT THIS IS NOT TO SAY I DON'T CARE.

IT WOULD GIVE HIM SOMETHING TO THINK ABOUT, AND I WANT TO GIVE HIM NOTHING.

their ambivalent, symbolic translations into paintings is a deliberate act of idealisation – further stressing the subject or sitter's general anonymity and lack of identity. These young, would-be sitters are thus appropriated as types, further emphasised by the T-shirts they are wearing with designs painted by the artists. There are no scars or blemishes on these beautiful young people, no fat boy or fat girl, no violence or overt truculence expressed towards each other, nothing squalid that affirms what is often the natural circumstance and visible reality of the world. The passive figures are made invariably tall, slim and elongated, indicating that the works are more about the conventions of painting than merely recognition or storytelling. The figures are not focused on descriptions so much as on their being typological entities – only their material belongings take on a sense of being an identifiable brand. Hence there is no determined line of reading to follow and,

in this sense, they depart from the conventional notion of the pattern book – they are not prescriptive. Muntean/Rosenblum's delicate graphite drawings follow exactly the same approach. They too are accompanied by aphoristic texts and statements

"This double authrorship has almost the same function as the white frame or margins, which puts the painting into brackets. These white frames or margins of course have connotations in terms of comics or TV monitors. It allows us to deal with very classical painterly issues and iconographies and deal with subjectivity, because we put it into brackets and it's the same with the authorship."

MARKUS MUNTEAN AND ADI ROSENBLUM in conversation with Cerith Wyn Evans , 'To Die For', ex. cat., Appel Foundation, Amsterdam, 2002, p. 56 (Markus Muntean is speaking)

EVERYTHING I SOUGHT IN LIFE I ABANDONED FOR THE SAKE OF THE SEARCH. OTHER PEOPLE SEEMED TO HAVE A DENSITY, A THERENESS, WHICH SHE LACKED. THEN AGAIN, NOTHING HAS REALLY BEEN SAID YET.

(often collaged with words that come from printed text sources), as is the case with their pictorial collages and inkjet prints on paper. In a paradoxical sense, however, Muntean/Rosenblum are addressing in painting the opposite of what they appear to portend (a life event), and are able in and through their chosen characters' state of general ennui to show their subjects indexical sense of loss – the adolescent search for meaning and identity. It is what Muntean has called their 'lament-like structure'. We, as the viewer, might be said to connect with this lament intuitively, while being uncertain as to why we do so. It is our vital but narrow point of access. The paintings are able to evoke the question: "Is there still a coherent structure to the self" and, if there is, how can we find it again? In this sense, the Austrian/Israeli double act are melancholy-mannerist painters, and mannerism is of course the most self-reflexive and self-knowing of all forms of painting. In mannerism the rules have been already distended,

dissected and assimilated *a priori.* Muntean/Rosenblum's paintings are also linked to death, or rather one should say to its eschatological aspects, which is another recurrent if somewhat obtuse and complex theme in their painting. The artists' use of adolescence and youth as a syntactical trope not only reveals the seemingly pessimistic reality of these young lives, but points in a wider sense to the contemporary condition of the world today, a Western world where all forms of secure identity are in a state of continual slippage, as we increasingly experience or abandon ourselves to a state of virtual existence. Muntean/Rosenblum's deliberate and self-reflexive appropriation and masking of historical references, mediated through the popular imagery of today, is discussed later in another context.

Maike Abetz and Oliver Drescher also represent a type of pictorial displacement. In their case it is aimed towards a preferred set of particular emotional associations.

○ MUNTEAN/ROSENBLUM, **Untitled**, 2003, 2001, 2001, 2003, 2001, 2001 (from left to right), all acrylic and pencil on paper, 40 x 30 cm, Courtesy Georg Kargl Fine Arts, Vienna | Maureen Paley, London | Irit Sommer, Tel Aviv | Arndt & Partner, Berlin/Zurich | Galleria Franco Noero, Torino | Team Gallery, New York

ABETZ/DRESCHER

Abetz/Drescher's work is far less conceptual or strategically placed than that of Muntean/Rosenblum – it is expressive of the world in which they live, or, alternatively, have constructed to identify with and make reference to in their paintings. Abetz was born in Düsseldorf and Drescher in Essen, Germany. Both studied painting at the Kunstakademie Düsseldorf (1991–94 and 1994–95 respectively), and studied again together at the Hochschule der Künste Berlin (1995–97). At first they became a couple before subsequently becoming a painter double act. Their work first emerged in the late '90s, Abetz/Drescher's immediate empathy being a shared interest in rock-and-roll music culture and the electric guitar. This they associated

⬥ ABETZ/DRESCHER, **The Optic Nerve**, 2000, Acrylic on canvas, 180 x 250 cm, Courtesy of the artists

⬤ ABETZ/DRESCHER, Photo © Neulicht, Markus Schneider

with the age of live rock music and direct performance in the 1960s and '70s, prior to its replacement by the video and the electrical technologies of the 1980s. Derived primarily from the popular music magazine images of the '60s and '70s, their early paintings are filled with detailed figurative representations of British and American pop groups, like the The Rolling Stones, The Who, Jimi Hendrix among others. They are an extension and echo, perhaps, of 'air guitar' and precocious childhood fantasies following the double act artists' own date of birth at the end of the 1960s.[8] In a work like *The Optic Nerve* (2000), The Rolling Stones fill the ground on the left headed by the late Brian Jones while, on the right, Pete Townsend from The Who is typically about to smash his guitar – an image almost certainly taken by the artists from a photograph of a live performance. In *The Subterraneans* (2001) Jagger strums his guitar in the foreground, while Jones adopts an on-stage pose in the mid-ground left.

What accompanies these pop-group figures in the paintings is a veritable glossary of design items that stem from the period: a picture, perhaps, of the *ad hoc* squat-turned-pop-star existence of the so-called 'Swinging Sixties' in London. Almost no one sits on a chair but is either cross-legged on the ground or atop a television or

some other consumer acquisition of the times. The artists have included electric guitars, vinyl record covers, portable televisions, typewriters, toasters, irons, turntables, shoes and boots, a 'Mod's' Vespa/Lambretta Scooter (with Drescher on board), a welter of rug and fabric designs, plus references to London's lifestyle store and fashion emporium, Biba – and much else besides. The tone of hallucinatory and strobe-like 'psychodelia' and satirical Monty Python abounds everywhere in these painted images. There are the would-be, bikini-clad James Bond-type beauties, mini-skirted girls and flair-trousered young men, who embrace and kiss as if straight from a picture story taken from the 'True Romance Magazine'. Film sources are a complement to musical references in many of the artists' paintings. The 1960s' fashionable bouffant hairstyles (à la Dusty Springfield), cosmetics, clothes, popular drinks and comestibles are also incorporated into the heady mix of their paintings. This only adds to the general sense of the colourful cacophony of contents that are the substance of their paintings in the years 2000–04. Included in several of the paintings are self-portraits of Abetz and Drescher.[9] Drescher presents himself either as a would-be Brian Jones or Roger Daltry, with whom he particularly tended to identify at that time. These deliberate acts of self-inclusion only further state and

> **"...It's a good thing that we work together because, if you work on your own, you would lose yourself in either melancholy or euphoria".**

reinforce the artists' personal identification with the myriad-period contents that are found in all their painted works.

However, as if this were not enough, local associations with Berlin are also included. In *Vom Ort der Welt* (2004), the façade of Schinkel's Altes Museum appears, vying in proximate interest with near-naked women in dominatrix bodices and/or suspender belts, and black fishnet stockings. There are countless sex shops or similar venues providing or selling such wares throughout the city of Berlin. Like a true expression of high and low, these images re-energise the old romantic cliché 'live hard, die young', with expressions of sexual energy, teenage suicides and burgeoning opium poppies. A semi-clad brunette gestures to a Beretta with silencer, giving it something like a salutary homage with a morbid rose – the phallus-like neck and head-stock of the guitar points directly to what is taking place.

Abetz/Drescher's paintings frequently subvert contemporary concerns with political correctness. While the immediate sense of their paintings is that of identification and celebration, a gradual worm of doubt enters the mind upon closer inspection. These darker aspects are suggested by elements of

momento mori, Surrealist-derived fantasies of skeletons (one, with long hair, is playing the maracas – another, a guitar) and skulls, macabre fairy tales and an array of different Symbolist sources. There is a persistent sense of time passing, with a metronome, alarm clocks and broken pocket watches (with and without hands), some of which are affixed onto the heads of male figures, both naked and clothed. Time is the harbinger that causes and grounds the meaning of affects throughout Abetz/Drescher's paintings. Everywhere there are references to the eye and the mouth. A specific male figure is repeated, a man who has an eyeball for a head, perhaps, evoking questions of the gaze and the third eye of Surrealism – Max Ernst seems a continuous influence on Abetz/Drescher.[10] Symbols of the occult and myths are included, the hand of divination, packs of tarot cards, the occult pyramid, Pan and his pipes, the Medusa-headed Gorgon and so on. The role of fairy tales and nursery rhymes, and particularly their association with psychoanalysis, is similarly provoked. In *Voices Green and Purple* (2003), for example, the central background image directly recalls a nursery rhyme: "There was an old woman who lived in a shoe ...", but becomes the domicile of dominatrix playgirls with their sado-masochistic bodices, and the shoe in which they live is now a high-heeled stiletto.[11] We find many references to phallocentric candles and candlesticks, and old-fashioned candle holders – common to illustrated fairy tales

OLIVER DRESCHER, 'Harald Fricke, Gemalte Zeitreisen (Painted Journeys through Time)', www.deutsche-bank-art.com/art/2004/4/d/1/219.php

○ ABETZ/DRESCHER, ***This is Tomorrow***, 2002, Acrylic on canvas, 250 x 200 cm, Private collection

– are placed provocatively. The paintings include not merely references specifically to the 1960s/70s musical phenomena but also the scientific and esoteric interests predominant at that time. There are references to factual science with astronauts and space travel, alongside those to science fiction. Nearly all of these motifs, usually culled from magazines, come from television programmes or films of the period – the Munsters, James Bond movies and those of Stanley Kubrick seem particularly relevant. There are cartoon figures like King Kong waving a broken toilet brush, walking cartoon-like guitars and sets of walking dividers. This continues the artists' concerns with the anthropomorphic categorisation of objects. Like giant collages of visual association, the feeling for the viewer is that of an immersion, perhaps, brought on by the 1960s/70s fascination with drugs like LSD and the altered states of conscious that invariably ensued. In formal terms this is emphasised by Abetz/Drescher's use of spatial dislocation, impossible spaces that only a state of drug-induced reverie might conjure up. Yet, perhaps more than anything else, there is a saddened sense of lost hope suggested by their paintings. A nostalgia for all the failed beliefs of a purportedly egalitarian Western generation. The artists' present the sense of an age that dreamed of an erasure of divisions between 'high and low' culture, a time of revolutionary attempts at social equity that were so vitally proclaimed and embodied in the music and

○ ABETZ/DRESCHER, *Voices Green and Purple*, 2003, Acrylic on canvas, 180 x 200 cm, Courtesy Sammlung aARTa, Mainz

visual expression of the 1960s and the early '70s. A time when the pessimistic anarchism of Punk Rock had not yet arrived.

Eva & Adele present something quite different. They are a living trademark and an ongoing event. Though it is difficult to imagine two people as an event ,"… in their case, art and life, work, public appearance and person are interwoven to such an extent that this assertion is, as regards its content, perfectly correct."[12] While Eva is Austrian and trained as a painter, Adele is German and trained as a sculptor. However, any trace of their previous existence before the 'newlyweds'' first appearance at the exhibition 'Metropolis' in the Martin Gropius Bau in Berlin, in 1991, has been judiciously expunged. Though earlier appearances together existed, it can confidently be said that the 1991 marriage at the Gropius Bau represents the moment of commitment to life and art as a double act. A daily shaving of their heads and identical make-ups (recorded by a Polaroid), and their provocative

and flamboyant transgendered dress code – they design the female outfits themselves – bear witness to an art and strategy that is aimed at a completely sublimated identity. It is studiously pursued and ruthless in its discipline. Their apartment and home life, their public performances and double act presentations, their videos, paintings and drawings, mean they are never separated from one another at any time. The prevailing and predominant colour code of pink, both in terms of home furnishings and dress, explicitly challenges all forms of gender stereotypes – regardless of whether the stereotypes are projected from a heterosexual or a homosexual standing. They see themselves through what they call 'futuring' as embodying a new type of gender reality. And it is in this respect, that they claim that wherever they are 'is museum'. The sources for their paintings, videos, watercolours and drawings are all derived from the press and magazine literature that has been generated by their performance-appearances and attendances at countless major art events. Whether it is the Biennale in Venice, the Documenta, or numerous other worldwide biennial openings (though frequently not invited), art fairs and art-related events, they have become a continuous and living presence over the last sixteen years. Indeed, it seems almost paradoxical when they do not appear. They see themselves as simultaneously a human brand, a logo and a registered trademark.[13] As a strategy it amounts to life

○ EVA & ADELE, **Mediaplastic No. 133 Cosmopolitan**, 1996-2004, Oil on canvas, 220 x170 cm, Courtesy Schultz Contemporary, Berlin

○ EVA & ADELE, **Cum**, 1997, LOCI: Paris, POSTALIS: Amsterdam, **Cum**, 1997, LOCI: Tokyo, POSTALIS: Summer Hill, Aus., **Cum**, 1997, LOCI: Paris, POSTALIS New York City, Courtesy Galerie Jérôme de Noirmont, Paris

extended into continuous performance through intervention. A central emphasis and supposition in Eva & Adele's work is that art invents life, an inversion of the general assumption that life creates art.[14] Hence their continuous travelling reveals how, with or without their pink mobile van, they are in a constant state of their pursuit of 'futuring'.

The painted art works that Eva & Adele produce are thus by extension a form of materialisation of their earlier biography. The fact that they are derived from pre-existent photographic material translated into paintings, watercolours and drawings, stands alongside their live performance interventions or

"... No, it's not really a performance. It is our life. It is our work. That is enough ..."

videos, as a record. It is part of re-appropriating their biographical past and actively projecting it into the future – a future sense that seeks to generate a new form of gender-identity that they consider is still to be made. Or, as one of their many stamping and franking logos puts it, a commitment to 'The Beginning After the End of Art'. Hence a description of their paintings as *Mediaplastik* brings together an array of concepts taken from the mass media from which they derive, plus an extended mediation in terms of the role they perform, while 'plasticity' is the remaining material

○ EVA & ADELE, *Rote Liebe*, 2005, 200 × 300 cm, oil on canvas, Courtesy Galerie Jérôme de Noirmont, Paris

EVA & ADELE, 'Thea Herold, The Call of Marco Polo, A Visit with Eva & Adele in Berlin', Berlin March 2000.

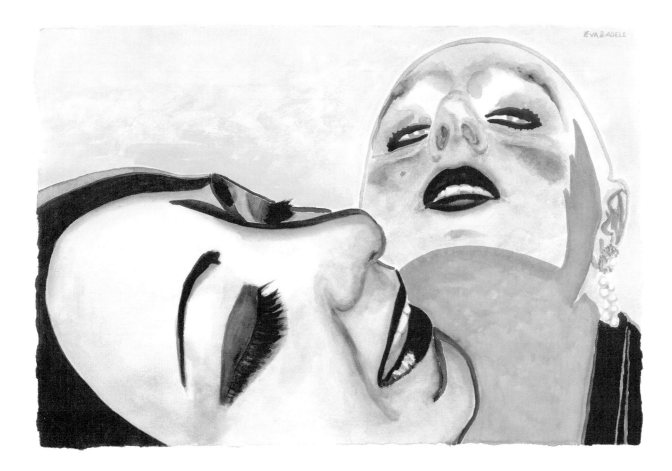

outcome of their realisation. What this amounts to for Eva & Adele is the idea that to perform is to transform. An example of such is shown in an oil on canvas painting *Mediaplastik No. 133 Cosmpolitan 1996* (1996–2004) which presents a pictorial flatness and a literal presentation of their posed image from a pre-existing photographic source. Stylistically, Eva & Adele's application of paint is either that of a flat field and/or a stippled-type of broad divisionism. The original publication's source is painted using the same typeface as the original, giving it the appearance of a painting-like simulacrum of the pre-existing

printed or stencilled transcription. However, Eva & Adele do not seek out the sense of the neutrality of the photographs that they use, as one might imagine with someone like Gerhard Richter, but rather they transpose the contents into vivid (sometimes garish) colours.[15] The approach of their a-chronological dating is also intended to elide the sense of timeline biography in favour on the continuous sense of future projection.

Eva & Adele's watercolours and drawings are developed in series. They are invariably close-up double portraits, either derived from their standard logo and trademark

*▲ EVA & ADELE, **Futuring Company**, 2000-2003, Watercolour and mixed techniques on drawing paper, 40 x 60 cm, Courtesy Galerie Patrick Ebensperger, Graz*

or from close-up double-portrait photographs where their heads are in close juxtaposition. In an early series called *Transformer-Performer* (1989–92) they are transparent out-lines of the standard trademark superimposed upon a grid-like arrangement of referential objects or abstract forms. Conversely, the double series *Orlando* (1991–93) consists of intense colour-saturated watercolours on absorbent hand-made paper. That they are both biographical and diaristic is also evident in the series of works called *Nippon Diaries I and II* (1991–93) and *New York Diary* (1991–93), but clearly also derived from the daily use of the Polaroid image recording of their identical, day-to-day, cosmetic make-up. In the more recent series *Futuring Company* (2000–03) the two systems of drawings/watercolours have been integrated and have been laid one on the another.[16]

The artists' generally monochrome line or single colour drawings were developed from photographs of them-selves at museum and gallery openings and other related art events from the early to mid 1990s. It was at the same time that they developed their series of trademark stamps which are generally franked on the images. Their presence in museums and galleries, juxtaposed with existing institutionally established art works extends the idea of where they are being a 'museum'. And, it is quite clear, particularly in the context of their transparent drawings, that Francis Picabia

(1879–1953; another famous artist-magus-showman) was a considerable influence at this time with regard to Eva & Adele's approach of creating their own living and 'futured' iconography. Nevertheless, it also has to be seen as part of their much broader gender-displacement strategy. The fact that some of their earlier self-designed outfits have wings suggests the non-gender state of the angel to which they obviously refer. Their clothes are an essay in themselves; in their high cape collars one is reminded of the chameleon and its power to change and transform. While always amiable and affable at the art events they attend, Eva & Adela have a radar-like awareness of where the photographers are located at any given moment. This too is part of their project, since the press images reproduced serve as the future source material of their art production. It provides them with the literal contents to continue 'futuring'. Thus it is the primary ingredient of their stated aim as a double act, turned as described by Eva & Adele towards their goal of creating a new form of gender-identity. As far as they are concerned, gender is generated through culture and biological determinism has been set aside.

The photographic works of the French, double-act artists Pierre et Gilles, though not unrelated to Eva & Adele's concerns with gender, are of a different order. They draw upon our collective memory and the past, and translate them into images of 'high camp' or exaggerated forms of kitsch.[17] Their main

PIERRE et GILLES

sources are the iconographic sentiments that lie hidden behind, but are evoked by the known status of pre-existing iconic images. In this respect, they have to rely upon a sense of recognition and a set of pre-given associations and dispositions in the viewer who is experiencing them. This is hardly surprising since sentimentalism depends upon repetition – the circularity of familiar repetitions that make up the day-to-day conventions of the world. Heavily 'photo-shopped', the photographs of Pierre et Gilles are always either ex-aggeratedly homo-erotic or implausibly beautiful; they are images of desire taken to excess. What is important, it seems, is that Pierre et Gilles appeal to aspects of our human nature that we are all prone to deny. They celebrate the gaze and typify human aspects of exaggerated voyeurism. Their subjects are unblemished objects to be looked at and draw heavily on stereotypes. Pierre et Gilles deliberately reveal nothing about the subject or their sitters and models as people (save that they are young and beautiful). They are dream-like fantasies that are not in any sense psychological but simply associative. The feigned script or reference as such exists in the mind of

the viewer to the extent that they are familiar with the subject matter. At the same time the viewer is most often confused into not knowing whether he/she is merely acting as a passive respondent or a visual predator. As a result we are frequently cast into a confused state of self-reflexive comparison and denial. It is not surprising, therefore, that so many of Pierre et Gilles' visual ideas have been used to promote the desire-based and libidinal economy of fashion, lifestyle and advertising. Indeed, it was at the opening of a Kenzo boutique in Paris in 1976 that the two gay men first met. They became a couple and lived together. The period from 1976–81 was one where they frequently photographed celebrities such as Salvador Dalí, Yves Saint-Laurent, Mick Jagger, Iggy Pop and Andy Warhol. Gilles had worked earlier as a photographer with magazines like 'Dépêche Mode', 'Interview' and 'Rock & Roll'. This continued when they came together as a double act working on the publication 'Façade'. It was in this milieu of photography, film posters, fashion and lifestyle that their art work first emerged. Indeed, early readings of their work suffered when compared to this overt lifestyle or populist association. Unfortunately it has led at times to their art works being seen in relation to their celebrity value rather than on their merits. This has, perhaps, been furthered emphasised by the pop videos and films that they made, particularly in the wake of their meeting and friendship with the pop star Marc Almond after 1989.

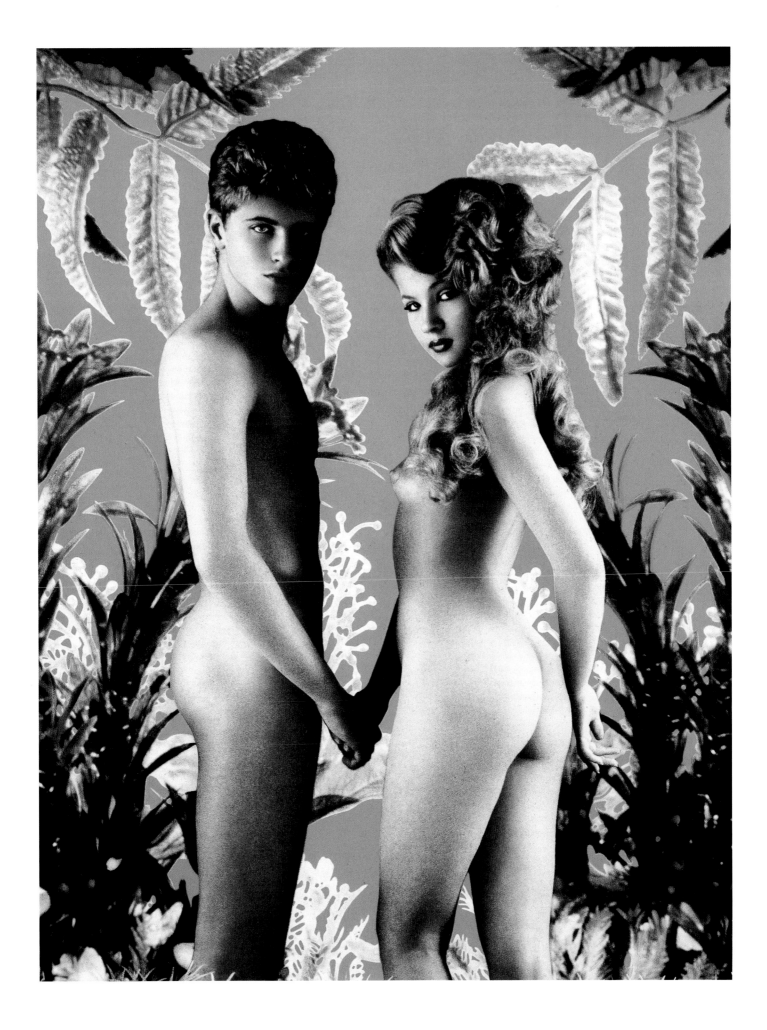

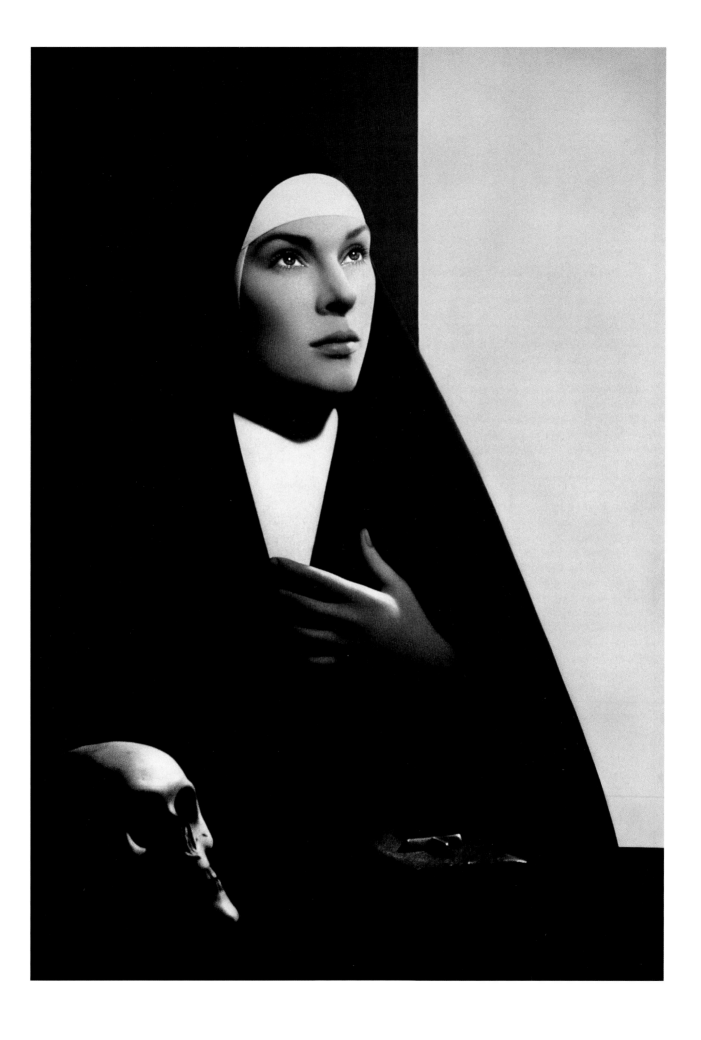

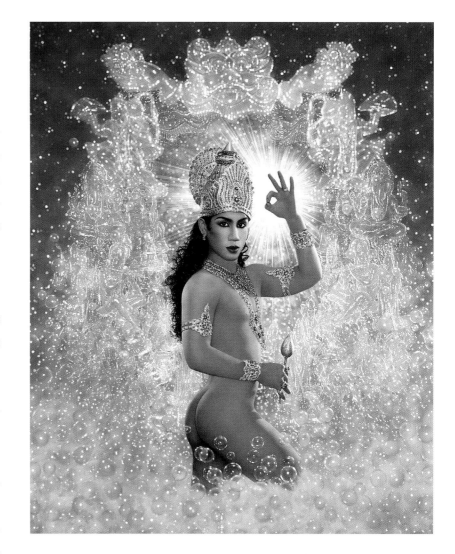

Gilles Blanchard was born in Le Havre in 1953 and studied painting at the local École des Beaux-Arts. Pierre Commoy was born in 1949 in La Roche sur Yonne and, after studying photography in Geneva, began work as a photographer working for fashion-lifestyle journals and magazines. Blanchard initially pursued an individual career as a painter and collagist, a background that was to be of vital importance to the subsequent emergence of Pierre et Gilles's working practice with images. In fact the art of Pierre et Gilles forms an interface between photography and painting, with the photograph, the painted elements and their subsequent fusion being incorporated in the re-photographing and presentation process. The artists deal with quite circumscribed themes such as religion, mythology, metamorphosis and sacrilege, often presented in highly elaborate or stylised and 'camp' frames. Pierre et Gilles are essentially Baroque and Roman Catholic in their avowed taste, illustrated, perhaps, by the images of themselves as altar boys. They often develop works as a small group to a specific theme and have frequently travelled to map out the parameters of a given theme or subject matter. Their adolescent *Adam and Eve* (Kevin Luzac and Eva Ionesco, 1981), for example, was developed in the Maldives and Sri Lanka – not doubt the tropical islands standing in for the Garden of Eden. However, far from innocent, the supposed progenitors of the human race suggest a pert and knowing self-presentation, as with the boy's neat hair trim and Eve's elaborate bouffant. They appear as if the have just emerged from an early '80s hair stylist's salon. In short, they represent the type of image you might expect to find at that time on a New Romance vinyl record cover – not surprisingly,

bearing in mind that Pierre et Gilles had worked for Thierry Mugler in 1979 and produced album covers. The theme of Adam has returned persistently throughout their work, appearing at intervals as in *The Temptation of Adam* (Johan, 1996), or *Adam Discovers that he is Naked* (Julian, 2006). From this 1980s experience they developed their *Paradise* series and their *Boys of Paris*. These formed the basis of their first art exhibition that took place at the Texbraun Gallery in Paris in 1983. Frequent references to the Bible have served as a basis for continued extensions into using figures from other religious literature as well. One example is the work *Krishna* (Tao, 2000) in which Jesus appears alongside Buddha.

The early '80s was an intense period of working with musicians and singers and the interface masked the boundary between what was art and what was commercial production. By the mid-'80s Pierre et Gilles began to develop a continuous series of Christian saints, like *Saint Gertrude the Great* (Edwige, 1990) and, inevitably, their well-known *Saint Jeanne d'Arc* (Catherine Jourdan, 1998, and Ophélie Winter, 1997). Numerous others have been added, including the saints

Vincent de Paul and John the Baptist, along with intercessional entities such as the Sacred Heart of Jesus, Our Lady of Fatima, the Archangel Michael and Old Testament kings and prophets such as David. All are young, beautiful and unblemished, homaging as much a Cecil B. DeMille Hollywood movie as having anything to do with fact or legend related to their subject matter. But the fact that it appears is the very point of their artistic endeavour; rather than evoke any true sense of devotion, they reveal the rancid conditions of human sentiments to the extent that not even the pious extremes of a Murillo painting could expose.[18]

In the last twenty years Pierre et Gilles have just as systematically rifled the world of ancient mythologies, Greek, Egyptian, Hindu and Buddhist. A work like the triptych of a naked *Ganymede* (Frédéric Lenfant, 2001), apart from its homoerotic content of the boy cup-bearer whom Zeus ravished in the form of an eagle, says nothing beyond the sensual immediacy of observing the handsome blond-haired acolyte. The stuffed bird looks as much like a vulture-predator; the young man eagerly enamoured of the moment of his deflowering. The theatre of innocence that, on the surface, Pierre et Gilles seem to propose

tentatively, is quickly dissipated by the beautiful bodies of the young men who could just as easily pass for pornstars. The fact is that the artists choose to exemplify these roles; besides the beautiful (mostly) male and female models, they are frequently substituted by fashion models and musical celebrities: Naomi Campell as the Greek Goddess *Diana* (1997), Marilyn Manson and Dita von Teese as *The Great Love* (2004) or Kylie Minogue

as the Australian *Saint Mary MacKillop* (1995) riding a carousel horse in black stockings and a suspender belt. Though some might read the images as sacrilegious, they are more often entertaining in their extreme campness. The appeal of Pierre et Gilles' images is most often their sense of professional accomplishment rather than bringing any feeling or insight to their subject matter. The bodies are extreme in their almost air-brushed perfection and are feted by their accompanying settings among flowers (usually roses) and baubles. Tinselled and bedecked while surrounded by kitsch simulacra, they take on a dream-like presence – even if it is one generated by the constant cosmetic application of Rimmel or Max Factor. Dressing up, be they as Spanish matadors, Egyptian pharoahs, Hindu deities, French matelots or Communist soldiers, the male models are never equipped to perform the roles they purport to portray.[19] They are dysfunctional entities of male beauty, quite literally becoming objects transposed into a fantasy world. They are as synthetic as the glittering and iridescent objects that often surround them in the images. And, like the gaudy and excessive picture frames that encase them, they emerge as imagined shrines of sentiment. We should not be surprised by this, perhaps, since places of pilgrimage and cultic venues have always had a strong profit motive. It is clearly the same ambiguous status of this commodity of cults

that brings fashion, cosmetics and mass consumption into an intimate and closely entwined relationship in today's world.[20] In that sense, at least, the images reveal a truth. However, unlike Andy Warhol's 'dumb images' of commodity, the images of Pierre et Gilles are not diagnostic of our age, being a dream-like attempt to escape from it. The fact that they utilise the kitsch extremes of sentimentality, derived and adopted from what formerly might have been considered images of high culture and/ or social value, only confounds the paradox that is at the centre of all their work. Pierre et Gilles have no strong sense of stylistic evolution. As their work has changed over the last twenty-five years (in its eclectic and post-modern fashion), the themes have merely become extended and further elaborated.[21] From this point of view future generations will discern shifts in their work, less through specific content (though they have tended to become more explicit), than through dress, costume and make-up. They mirror many of the visual vanities of the time in which they were produced. Similarly, gradual alterations can also be discerned in the developmental sense of photographic technology. Issues of gender in this context have to be understood as being less to do with that determined by any link to biology, but more to do with the pursuit of consumer culture that promotes an escapist libidinal economy of desire.

IV-WARIII
CRIME
POWER AND
SOCIAL
SCULPTURE

○ *JANE AND LOUISE WILSON, **Stasi City
(Operating Room)**, 1997, C-type print on
aluminium, 180 × 180 cm, Courtesy of the
artists and Lisson Gallery, London*

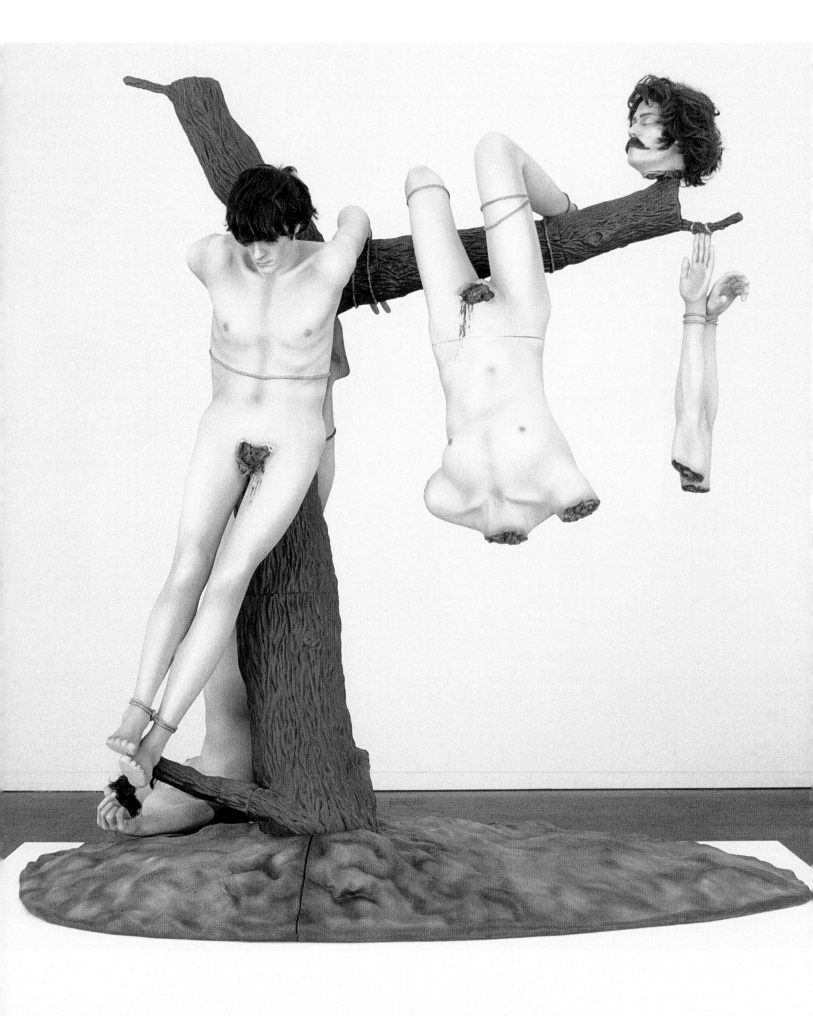

War is a form of wanton, legislative violence that is, for the most part, only loosely configured, and at other times barely controlled. The so-called 'Laws of War' apart, artists have always been interested in recording or criticising the lunacy of humans undertaking the mass killing of each other. There is a strange paradox in what is on one day criminal murder, and on the next something that is judicially licensed and promulgated. Crime is an act committed or omitted in violation of a law forbidding or commanding it and in which the punishment is imposed upon conviction. In short an unlawful activity. The relationship between war, crime and atrocity is, therefore, fraught with conditions of related but unresolved ambiguity. In a world of social sanction and denial, what is criminal at one moment can just as readily be legitimate the next – its determinism being shaped by whoever has been given or has taken power over our lives at the time. If history is anything to go by, it is seemingly a human trait to desire to have power over others and to manipulate them – and it usually dresses itself in the language we call politics. In other words an intentional rhetoric of persuasion and coercion, something that can be overtly political or simply psychological and/or applied relationally to those around us. To stand outside this

reality one would have to withdraw from it and abandon the world. Hence this chapter has a loosely framed theme that touches upon war and society, those counteractive forces that both build and destroy the social order.

In the case of Jake and Dinos Chapman it is a fascination with the subject of war and atrocity, inspired by Goya's famous etchings entitled *The Disasters of War* – that the Spanish master worked on during the second decade of the nineteenth century – and with the National Socialists' period of power in Germany (1933–45). The art of Jane and Louise Wilson ('The Wilson Sisters') comprises large, multiscreen video installations and photo-pieces, frequently about sites of institutional power (sometimes commercial) and their subsequent abandonment. Their work often reflects the ebb and flow of powerful political or economic forces at work in the world. In the case of Teresa Hubbard and Alexander Birchler it might be said that their film and video work deals with issues of individuals and small groups and/or social formations – that is to say how the individual self interacts with the social collective and vice versa. In the widest sense, their work touches upon the anxieties of individual and collective socialisation while, conversely, that of Clegg & Guttmann deals with issues of a social aspect – here generically called social

○ JAKE & DINOS CHAPMAN, *Great Deeds Against the Dead*, 1994, Mixed media, 277 x 244 x 152.5 cm, © the artist, Courtesy Jay Jopling/White Cube, London

○ JAKE & DINOS CHAPMAN, *Disasters of War #11*, 1999, Etching with watercolour, Paper size: 24.5 x 34.5 cm, Photo: Stephen White, © the artist, Courtesy Jay Jopling/White Cube, London

JAKE & DINOS CHAPMAN

sculpture. It is, however, not so much social sculpture in the Beuysian sense, but rather how – through interventions into sites, both institutional or otherwise – the forces that forge the conditions of the social can be analysed and questioned. Nevertheless, this chapter is broad and generic, and the subject matter often spills out of its predefined frame.

Jake and Dinos Chapman have always had a virtual obsession with Francisco de Goya (1746–1828) and spe-cifically with the series of etchings he produced against the background of the Napoleonic conflict of the Peninsular War in Spain 1808–14. As Jake has claimed, the brothers even considered changing their surname to Goya.[1] The Chapmans first treated the subject of *The Disasters of War* in 1993 as a form of miniature tableaux, in which they systematically mutilated a series of toy soldiers, twisting their limbs, or renting their bodies, and painting them so as to reconstruct the scenes depicted in the Goya prints.[2] The following year the Chapmans extracted print number thirty nine from the series, entitled *Great Deeds Against the Dead* (1994), and created a mannequin depiction of the three brutally mutilated figures from the etching which have been castrated and decapitated and their limbs amputated. The head of one of the figures is spiked on the branch of a tree.

The idea of creating a miniature tableau serving as the basis for elements that will be subsequently enlarged into an autonomous sculpture is common to their practice. It can be seen again in the tableau *The Rape of Creativity* (1999), in which the central caravan element served as the basis for their installation of the same name at the Museum of Modern

"Goya's *Great Deeds Against the Dead* represent, as we see it, a humanist crucifixion- "Humanist" because the body is elaborated as flesh, as matter. No longer the religious body, no longer redeemed by God. Goya introduces finality – the absolute terror of material termination".

Art in Oxford in 2003. What is more important, however, is that their engagement with Goya's subject matter opened up a major thematic element in their work that not only touched upon sexuality and violence (common to the mannequins of the 1990s), but was wider and extended their concerns to include the scopophilic aspects of abjection, atrocity and disgust.

If Georges Bataille has always been an influ-ence, so too are the sources and ideas of Julia Kristeva on abjection,[3] and Gilles Deleuze and the rhizome metaphor.[4] Jake and Dinos Chapman created a miniature tableau called *Rhizome* (2000), dealing as it does with the ubiquity of McDonald's. A later miniature work further elaborated the idea and was called *Arbeit McFries* (2001). More recently, Nietzsche, in the *Twilight of the Idols* (2003), a series of hand coloured etchings, has again been evoked by the artists, although the reference first appeared in what some thought was a savage parody when the paraplegic physicist Stephen Hawking in his wheelchair was included in a work called *Übermensch* (1995, p. 191).[5] Elevated on a fake rock outcrop the sculpture not only parodied the German Romantic landscape

◑ JAKE & DINOS CHAPMAN, **Sex I**, 2003, Painted bronze, 246 x 244 x 125 cm, Photo: Stephen White, © the artist, Courtesy Jay Jopling/White Cube, London

JAKE & DINOS CHAPMAN, 'Holy Libel', p. 150,

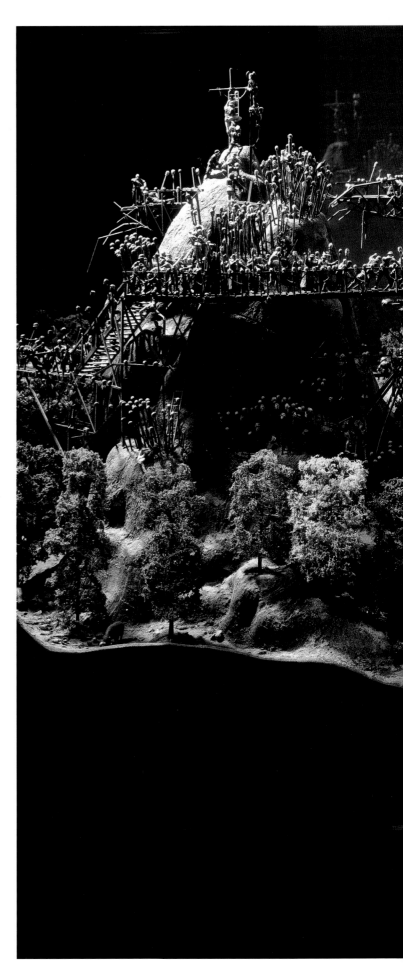

painter Caspar David Friedrich, but also the English painter Edwin Landseer's nineteenth-century painting of a great stag called *The Monarch of the Glen* (1851).[6] The interconnection of these intellectual sources is hardly surprising since the writers mentioned above all demonstrate an intimate knowledge of the great German philosopher and of aspects such as the 'death of God' and 'eternal return'.[7] The artists' intentional use of miniature tableaux also deliberately gives the viewer an aerial or god-like viewpoint and, as a consequence, implies an indirect culpability. In short we are made to feel complicit in some way in the events that are taking place as we are looking at them.

Jake and Dinos Chapman's fascination with Goya, however, has less to do with art history and more to do with the convulsive sense of catharsis and shock that such images generate. After all, there is not much visual space between Goya's *Disasters* and those conveyed by the atrocities of the recent past such as in Rwanda or Iraq. This is not to suggest that the artists' work is intended in any way to be moralistic, far

*JAKE & DINOS CHAPMAN, **Hell**, 1999-2000, Glass-fibre, plastic and mixed media (Nine parts), Dimensions variable, Photos: Stephen White, © the artist, Courtesy Jay Jopling/White Cube, London*

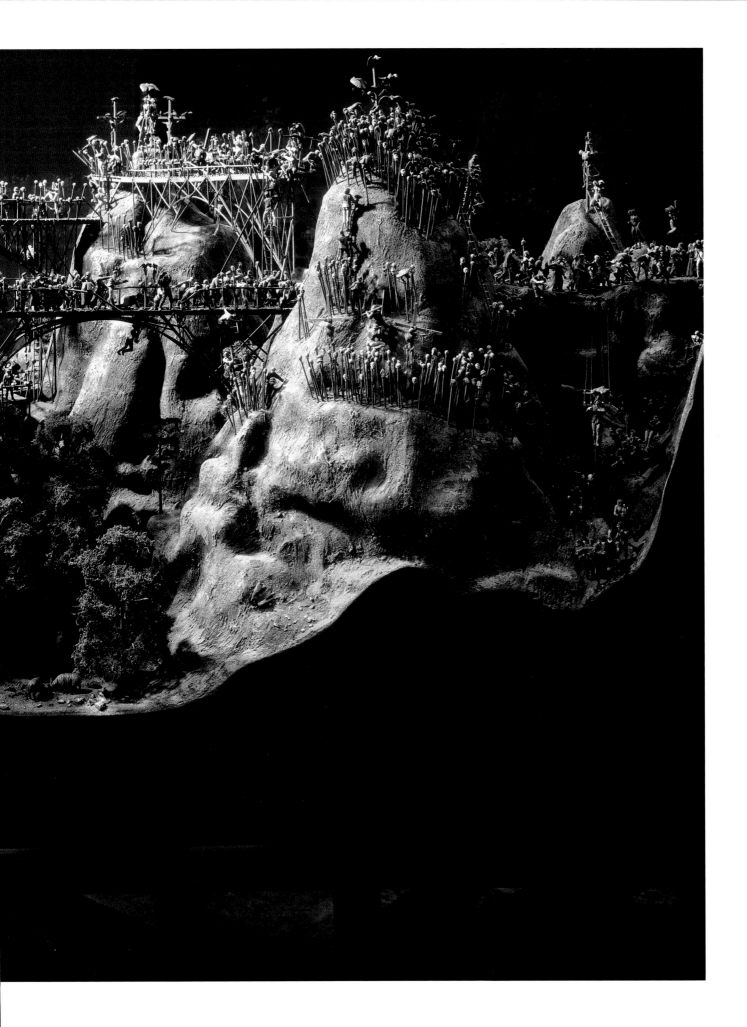

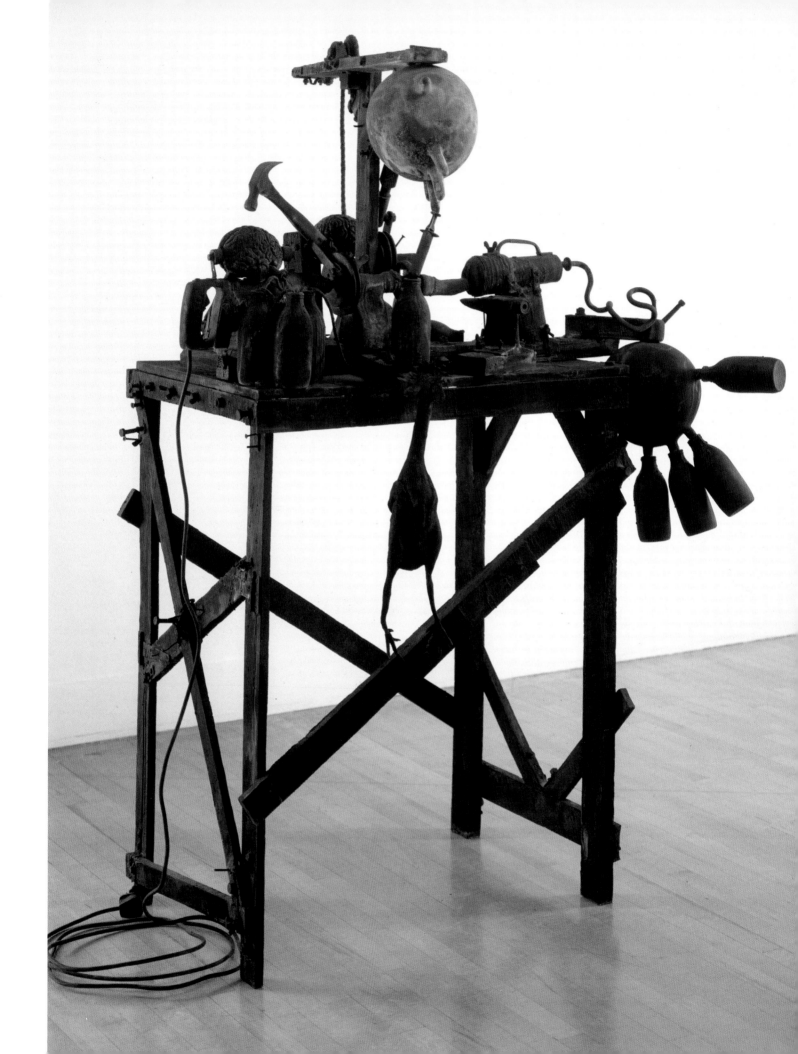

from it, but rather it is about the strategy of convulsion itself.[8] And, of course, theories of convulsive beauty derive from the tradition of Surrealism with its Freudian, automatist and unconscious discourses.[9] That it is a strategy is made clear by Jake and Dinos, indicated by their well-known drawing *All of Our Ideas for the Next Twenty Five Years* (1997) and works such as *The Return of the Repressed* (1997).[10] References to Surrealism are also apparent, not only through Bataille, but in their *Exquisite Corpse (Rotring Club)* series of twenty etchings (2000–01), *cadavre exquis* being one of the French Surrealists' favourite parlour games.

In true Nietzschean mode Goya makes his eternal return, notably in *Disasters of War* (1999–2001), an extraordinary series of eighty-three hand-coloured etchings in which Jake and Dinos Chapman dealt directly with the print medium and developed their own interpretation, making references to the Nazi emblem of the swastika, concentration camps and the Holocaust. At the same time, in another series called *Gigantic Fun* (2000), they superimposed details of the *Disasters* in the reverse on large children's drawings, juxtaposing the horrors of war with the fantasies of childhood. The theme of children and childhood remains a constant reference in their works, as in *Etchasketchathon* (2005), a series of children's images of horrific content that also recall elements from Goya. The title is a probably a parody of children's television and adult-directed socialisation in the form of charitable fundraising – an 'etch-a-sketch-a-thon'. [11]

In a series called *Insult to Injury* (2004), the artists actually acquired a series of the eighty Goya *Disasters* prints at £25,000 (printed from the original plates in 1937), and materially intervened, turning the heads of the human figures into literal but somewhat laughable monsters.[12] The provocation and defence was that Jake and Dinos' prints sold individually for a sum considerably in excess of the amount they had originally paid.[13] In 2005 a series called *Like a Dog Returns to its Vomit* (the quoted title is biblical – Proverbs 26: 11), they again returned to Goya, in this case the Spanish artist's series of etchings entitled *Los Caprichos* (1799). The Chapmans produced yet another monstrous mutation and disembowelled presentation.

Like their earlier use of the title of a work *The Return of the Repressed*, derived from Freud, the sculpture *Great Deeds Against the Dead* was to return again in *Sex (I, II, III)* (2003). Ten years later the figures are in a state of fetid decay, being consumed by worms, maggots and an array of animal species that erase all traces of an identifiable material existence. A warped human parody of disgust, the decapitated head now has devil's horns, a single eyeball looks out towards the viewer, the skull of the tree-bound skeleton revealing a savage laceration that was the probable cause of death in the

*◯ JAKE & DINOS CHAPMAN, **I am the turd that is ready and the world is the wide open anus machine**, 2007, Bronze, 180 x 141 x 88 cm, Photo: Stephen White, © the artist, Courtesy Jay Jopling/White Cube, London*

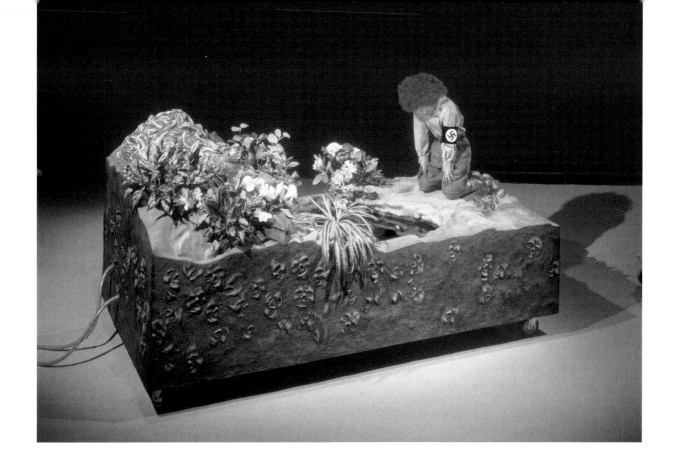

first instance. It is a deliberate pantomime or circus of horrors, witnessed by the fact that a red nose has been placed on the skull,[14] no doubt a reference to 'Red-Nose Day', a national day of charitable funding-raising in Britain – the artists frequently being critical of the commercialisation of purported acts of charity. The skull is a *leitmotif* that appears frequently in their work, as in the giant version of skulls for their installation *Eine Barocke Party* (2001), at the Kunsthalle in Vienna.

If Goya pervades almost all of Jake and Dinos' art works, either directly or indirectly, their more recent fascination with the Nazis and National Socialism merely **extends the theme into another theatre of historical horror.** The artists had shown an interest in the subject in their work *Black Nazissus* (1997), where in deliberate perversity a black child mannequin with an Afro hairstyle stares at himself in a pool wearing a Brown-Shirt outfit with a swastika armband. What looks back is an emergent head with its penis-nose and open sphincter from a blood-coloured pool.. The pool is surrounded by artificial flowers and a pile of human intestines. The visual elements shock, while the second feeling is that of laughter in the word-play of the title 'NAZI-SS-US', standing in for the mythological character that Freud used to develop his gender-

◯ *JAKE & DINOS CHAPMAN, **Black Nazissus**, 1997, Fibreglass, mixed media, resin and artificial blood, 137 x 125 x 260 cm, © the artist, Courtesy Jay Jopling/White Cube, London*

based Narcissus complex. The subject is one with another pictorial Surrealist pedigree, namely *The Metamorphosis of Narcissus* (1937) by Salvador Dalí.

The large vitrine project *Hell* (1999–2000) is a tableau of giant proportions in terms of contents over scale. It comprises nine glass cases arranged for installation in the form of a swastika – a part of Jake and Dinos Chapman's vast project *The Shape of Things to Come* (1999–2004). The use of toy soldiers – the playthings of childhood – to create miniature worlds of atrocity is an extended metaphor throughout their work. The extraordinary sense of minutiae has the intended effect of overwhelming the viewer. A current revival and interest in the Baroque and macabre theories of evil is something that has become an increasingly common theme in contemporary art.[15] The nine glass vitrines and their tableaux are more a cipher than a deliberate attempt to describe historical events. Nor is it specifically anti-German as some have supposed or imagined. What is presented in the series is simply a systematic slaughterhouse of annihilation, a farmyard of atrocities made into a seeming commonplace of utility and blind obedience. The railway siding, the death strip and gas chambers are juxtaposed with a church and a hospital, while a nearby volcano gorges forth SS soldiers and a 'welcome' sign 'Kunst Macht Frei' ('art liberates', based on 'Arbeit macht frei' – 'work liberates' or 'work brings freedom' – over the gates to concentration camps) beckons you in. Perhaps this work, more than any other by Jake and Dinos Chapman, expresses their complete disbelief in the powers of reason and, with it, the end and dismemberment of the so-called Enlightenment project.

That childhood portends this outcome is represented by a recent return to the subject of hell in *Hell Sixty Five Million Years BC* (2004–05) a massive installation of child-like dinosaurs, part of an exhibition for the Kunsthaus Bregenz called 'Explaining Christians to the Dinosaurs'. Since the nine-vitrine project was destroyed in a fire at a collector's warehouse, the artists are remaking *The Shape of Things to Come* on a larger scale (though not for the same collector) beginning with *Gott im Himmel! Ze Viscous Circle!* (2006). The title is surely intended to echo Nietzsche's eternal return and the concept of the 'circle' the fact that the artists reject outright historical theories of originality. The pun is on the word 'viscous' (instead of vicious), perhaps, a bad joke on the sticky area they have entered.

Jane and Louise Wilson are a double act both in the actual and literal sense of the word, since they are identical twins. Though they did not initially train together – Jane studied at Duncan of Jordonstone Art College and Louise at Newcastle Polytechnic – but came together as an artistic double act on the master's programme at Goldsmiths College in London in 1990–92, soon after the Freeze generation which

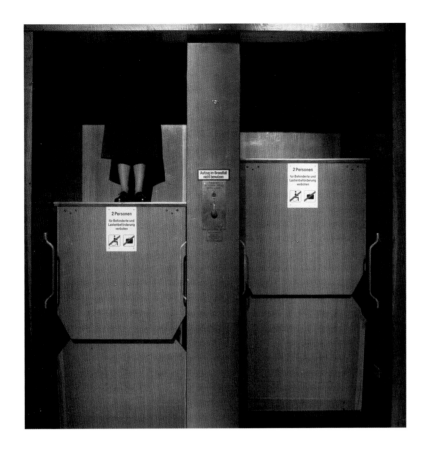

This was followed by another claustrophobic work, *Crawl Space* (1994), which deals with issues around the oppressive conditions of secret spaces.

The question of the psychological fears and phobias of architectural spaces and their symbolisation is both a crucial and continuous theme in their work. In *Crawl Space*, the Wilsons investigated the spaces under the floorboards of the home, the camera both dramatising and bringing together the secret points of hidden access. These earlier works were largely (though not always) films and photographs of experimental performances extended into installations. Nonetheless, it was these works that first brought them to a wider international attention.[16] With their double-screen work entitled *Normapaths* (1995), they firmly established themselves among the major film and video makers of their generation. The film was shown at Chisenhale Gallery in London in a cabin-like structure in the centre of the gallery, and also in the United States. The 1990s saw a huge revival of film and video that had largely been moribund as a medium since the 1970s[16] – with the exception of artists like Bruce Nauman and Vito Acconci, who were profoundly

left the college in 1989. The years 1993–95, immediately after leaving college, were characterised by a rapid development and formation and included their early claustrophobic and existential works such as *Garage* (1989–93), where a black-and-white photographic installation shows Jane with a noose around her neck, pouring water into an aquarium where her sister seems to be drowning. In the work *Hypnotic Suggestion* of 1993, the sisters videotaped themselves while under a state of hypnosis, while further emotional and psychological experimentations were explored in works such as their film *LSD*.

○ *JANE AND LOUISE WILSON,* **Stasi City (Paternoster)**, *1997, C-type print on aluminium, 180 x 180 cm, Courtesy of the artists and Lisson Gallery, London*

influential at Goldsmiths and on the so- called YBA (Young British Artists) generation. The film *Normapaths* again echoes claustrophobia: filmed in an empty factory space, the two sisters, wearing black catsuits, jump up and down on a trampoline (though it is not in view). The film is a sort of strategically funny parody: "The costumed performers plainly relished acting savage, grim and decadent. One of them bursts through a wallboard partition, super-hero fashion. Another (or the same?) follows. Having nothing left to burst, she briskly punches a dangling wall board fragment."[18] With a mixture of fake affection and aggression the work parodied such television shows as *The Avengers*; the leading female character Cathy Gale and later Emma Peel (the former played by Honor Blackman, the latter by Diana Rigg) was always known for wearing similar catsuit outfits. In short it was also a send-up of MTV mentalities and rock videos, and of the fake narcissism and illusion-based presentations that had so obsessed the 1980s. From 1997, their work shifted distinctly in a political direction, while still retaining

an emphasis on the secret power generated by the architecture of institutional spaces.

In considering now the years 97–99, three outstanding works need to be addressed, namely *Stasi City* (1997), a work inspired by their DAAD one-year scholarship in Berlin and Hanover in 1996, followed by *Gamma* and *Parliament* (1999). These works also further emphasised the role of introducing added or related sculptural elements of association into the films and photographic installations – an intervention that further

○ *JANE AND LOUISE WILSON, **Stasi City (Reconstruction of Doors, Erich Mielke's Office)**, 1997, mixed media, variable, Courtesy of the artists and Lisson Gallery, London*

○ *JANE AND LOUISE WILSON Photo: © Shannon Oksanen*

elaborated upon the subject matter. The sculptural often took the form of restitutions or reconstructions on site and, though they had also existed in earlier works, the issue was never specifically brought into the foreground.

The film *Stasi City* was based on Hohenschönhausen Prison and Interrogation Centre in East Berlin and the title derived from a term used by a West German reporter who had visited the centre in 1989. This work represents all the standard charac-

○ JANE AND LOUISE WILSON, **Gamma (Mirrored Figure Command Centre)**, 1999, C-type print mounted on aluminium, 122 × 122 cm, Courtesy of the artists and Lisson Gallery, London

JANE AND LOUISE WILSON in a dialogue with Lisa Corrin, Jane & Louise Wilson, Serpentine Gallery, London, 1999, p.14

teristics that make up the film and video work of the Wilson sisters. The first is that of a multi-channel screen video installation, in which the spaces are investigated and, given the positioning of the viewer, they feel strangely incorporated within the nexus of the moving projections, so as to become almost part of the film. This at times creates a sense of disorientation and anxiety for the viewer by having to confront the position in which they have been placed. The austere images of *Stasi City*, as one curator observed, emit a "leanness that has become a signature style" of composition for the artists.[19]

"In the early works, we weren't consciously presenting ourselves as twins, but it became interesting to explore this as a formal device such as doubling or mirroring of images, or when we played with the xynchronising of visuals and sound. But is has never been the *raison d'être* of the work.".

The second aspect of the Wilsons' works concerns the still shots on site, though not necessarily always part of or taken from the film itself. The third regards the sculptural, almost like stage-set restitutions, as props or objects simultaneously incorporated into their work. In *Stasi City* the film gradually reveals the corridors of hidden coercive power, a building that was in a suburban street and which many of the local residents were not even aware of as regards its status as a prison or secret police telephone-tapping centre. The viewer moves through interconnecting rooms, interview cells, peripheral spaces, and doors concealed in cupboards. There are hints of coercive interrogation: two feet appear at the top of a photographic frame hinting that the figure is hanging from the ceiling; another still shows the half-figure of someone standing on top of what seems to be a filing cabinet. Yet the film's persuasive power is deeply linked to the commonplace, the ordinariness of such places where aspects of hidden state power are secretly exercised. Thus the issue of a hidden psychological surveillance permeates the sense and tone of the film, notwithstanding the building's abandoned status at the time the Wilson's filmed there. The viewer is made uncomfortable on the basis of their own projection as much as what is actually shown.

Jane and Louise Wilson have always been interested in theories of psychological power like the Panopticon, a subject very much to the fore in the wake of Foucault's analysis, and a near-standard text of reference in the British art schools of the 1980s.[20] As the sisters put it: "What is interesting about Jeremy Bentham's Panopticon is the centrality of the

observation tower and how the cells radiate from its focus. The point of view of every cell is linked to the central 'eye' – like the relentless eye of the camera as an all-seeing eye connected to a little series of interlocking boxes."[21] If *Stasi City* represented the former Soviet power through its East German surrogate, after their return to Britain, they sought to find an analogous British location that was a surrogate of the United States.

The film *Gamma* was something of a parallel facility of secret power that had closed in 1992 at the end of the Cold War, but was known still as RAF Greenham Common. It was where the Americans held and stored nuclear weapons in a military facility given over to them by the British government. The location was famous in the 1980s, when the Nuclear Disarmament Movement, especially the 'Greenham Common Woman's Peace Camp' picketed it throughout much of the decade. It had been the site of much media coverage, noted for its protesters and civil disobedience, after Mrs Thatcher gave the Americans permission to base BGM-109G Gryphon cruise missiles there in the 1980s. Strangely, from the outside, it appeared just as inconspicuous as Hohenschönhausen. A similar filming approach was adopted and progressively the viewer discovers the now empty nuclear silos, the control centre, the operations room, control panels, and decontamination and ventilation units. What makes both *Stasi City* and *Gamma* so eerie and chilling is the artists' decision to add uniformed figures (stage soldiers and police) which gave the feeling less of an abandoned site and more of merely a mothballed facility – a facility that could be made operative again at any moment.

While it can be said the following film the Wilson sisters made called *Parliament* is not that of a mothballed location, certainly many cynical members of the British public think its secret and arcane ways exist in a world set apart from the people it pertains to govern. Given access to the Houses of Parliament (the Lords and Commons), the Wilson film reveals its many corridors, side rooms, press gallery, peers' private telephone room and all the hierarchical paraphernalia of the parliamentarians closeted existence. It is a place of underground tunnels, heating and pipe units and secret meeting rooms. They discovered strange pieces of equipment, a periscope in the engineer's room – a legacy of another age –once used to gauge and assess the temperature in the House of Commons above. The countless archaic traditions are gradually but systematically exposed: which carpet you are allowed to stand on and which not, where you can sit and where you cannot, where you can stand and where you have to keep moving, and so on. They were particularly interested in the ornate architectural structure and how the two chambers force the parties to confront each other like adversaries in an arena – a theatre of adversaries but reminiscent of a private

members' club. Through the process of watching the film the viewer increasingly becomes aware of a strange impenetrability represented by the day-to-day administration of power, although it is a venue every Britain knows from television. "These insti-

tutions are made that much more impenetrable because nobody is going to come forward and tell you what they mean. We are left to speculate."[22] Parliament does not emerge in a particularly favourable or transparent light, the viewer being left with the feeling of claustrophobic spaces, secret deals and compromises in small hidden rooms. A hint, perhaps, of what Shakespeare described as 'backstairs work' when speaking of politics. The Wilsons' film, however, reveals again how architectural spaces (and crucially how the optical viewpoint they adopt when filming is used to suggest hidden narratives) both govern and shape the behaviour and events that take place in them. When we return to Jane and Louise Wilson later on, it will be less related to a grounded space, but more to space travel and their film *Star City*, made at the Cosmonaut Space Centre near Moscow.

In terms of contents the work of Hubbard/Birchler could hardly be any more different from Jane and Louise Wilson, even though they use the same media. Hubbard/Birchler are predominantly film and photographic artists, the photographic work often deriving from stills from their film projects. It is an extensive and complex body of work that is best served by looking at some specific key examples. It is far less easy to see it systematically unfold in a diachronic way, but better to read it through a series of ongoing thematic concerns of fragmentary (or non-linear) narration. Allied to this, there is

often a palpable sculptural and architectural sense of space – domestic or otherwise – as a form of human containment or focus, be it emotional or physical. Their filmed video loops are mediated by a powerful and continual awareness of cinematic procedures and techniques and what they often bring to it is a personal – and sometimes disturbing – intuitive sense of the *unheimlich*, or uncanny.

Teresa Hubbard is Irish and Alexander Birchler Swiss. They both studied together on the master's programme at Nova Scotia College of Art and Design in 1990–92 and now live and work together in Austin, Texas. Their initial works were based on a trinity of relations between sculptural casts, installations and photography. *Noah's Ark: Unpacking, Lunchbreak, Working* (1992) is a photographic moment depicting them in stages of labour and rest while purportedly working on a large pictorial tableau. The notion of tableaux-diorama was also the basis of their double vitrine installation *On Loan from the Museum in US* (1993), in which two mannequins (male and female) are seemingly being consumed by forest flora and fauna in a display case. In works like *First and Last* (1993) and *Shortcut* (1994) there is a strange ambivalence that suggests that Hubbard/Birchler are not yet fully resolved as to the boundaries between the different media they using, an ambivalence that is better resolved with their photographic series called *Falling Down* (1996). In this intriguing series of photographs, half a

○ *TERESA HUBBARD/ALEXANDER BIRCHLER,* **House with Pool***, 2004, High Definition Video with Sound, 20 min 39 sec, loop, Projection 16:9 NTSC 2 Ch Stereo, Installation dimensions variable, Courtesy the artists and Galerie Barbara Thumm, Berlin*

TERESA HUBBARD/
ALEXANDER BIRCHLER

person or a figure's midriff can be seen in the act dropping things – no facial image ever being shown to evince emotion. The viewer is party to a partial or potential narrative that we have to make up for ourselves. The same procedure is followed in their series called *Holes* (1997), where sections of sitters are photographed through random apertures or asymmetric openings like ladders, or from under the sink. And, again there is a similar approach in a series of photographs called *Stripping* (1998). A discernable strategy of fragmentary story-telling by allusion emerges from these works, or, better still, optical referents of evocation as to a possible narration that can be read into the images. This becomes increasingly important as an aspect of their video-loop film productions, where there is no immediate indication defining action, time and place. Quite literally nothing is given.

Thus Hubbard/Birchler deconstruct, question and expose how we set about telling a story today. But more than that they question the actual syntax and grammar of filmmaking – a language they see that operates unto itself or for itself. In this

publication, three of their video loops have been taken as examples of works which seem adequately to reflect their approach and procedure.[23] They began to work specifically with film and actors in 1998. However, from the sculptural and photographic legacy of Hubbard/Birchler there are strong grounds for establishing that those aspects also feed into their own special 'grammar of cinema' – a grammar they have adopted and radicalised for themselves in their personal approach to filmmaking. That is to say while the production procedure is not fundamentally different from traditional cinema, the outcome radically differentiates itself from what might be considered standard filmmaking and story-telling. The fact that the films operate on a continuous video-loop means there is no certain sense of a beginning, middle or end. The effect is not unlike an endless Mobius strip[24] or band, where one is left to suppose the point where the narrative might begin. The artists set a possible beginning, and reason generally dictates that the visual events should be read or determined in a certain way. But it is not always the beginning that one might choose as a personal reading of the images that are taking place in the film. Hence Hubbard/Birchler videos always take on an aspect of syntactical ambiguity, and that of an undefined interstitial reality. They exist as multiple film narratives, at least potentially, operating in a creative space of never fully resolved optical slippage as to their reading. This

is what they intend to be understood when they state that their works are non-linear narratives.

The works chosen are *Detached Building* (2001), *Eight* (2001) and *House with Pool* (2004). The video loop *Detached Building* is an example of their use of the split narrative, the events being seemingly connected and disconnected at the same time. A group of musician is in the middle of a rehearsal or a private 'jam' session is in an old, corrugated metal shed. The camera gradually reveals the space and its contents starting at hip height – musical instruments such as drums and guitars as well as old sofas, etc. In an Antonioni-like manner the camera passes in a continuous shot to outside, where a single woman stands waiting but then later raises a stone to throw at an abandoned house. Since the camera movement is seamless and uncut, we are left to ponder how the two events are related. The fact that the camera uses a continuous dolly take seems natural, but would in fact be impossible without a stage set. The use of the sound of the guitar, a dog barking, crickets chirping and the smashing of the window heighten and exaggerate the continuity.

If ***Detached Building* at least suggests something a narrative, the film *Eight* seems to have no end or beginning.** We are shown what purports to be an eight-year-old child's birthday party that has been spoilt by a rain storm. The tables and remnants of what must have been a disaster for the eight-year-old are presented (though no parents or other party guests are included), as if the images are a series of still lifes: the half-eaten food, the cups, the candles, etc. The child enters, cuts herself a piece of cake, and then goes back into

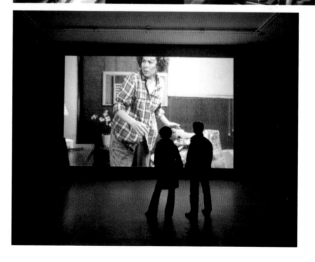

○ *TERESA HUBBARD/ALEXANDER BIRCHLER, **Single Wide**, 2002, High definition video with sound, 6 min 10 sec, loop, Projection 16:9 PAL 2 Ch Stereo, Installation dimensions variable*

○ *TERESA HUBBARD/ALEXANDER BIRCHLER, **Single Wide**, Installation shot, Courtesy the artists and Galerie Barbara Thumm, Berlin*

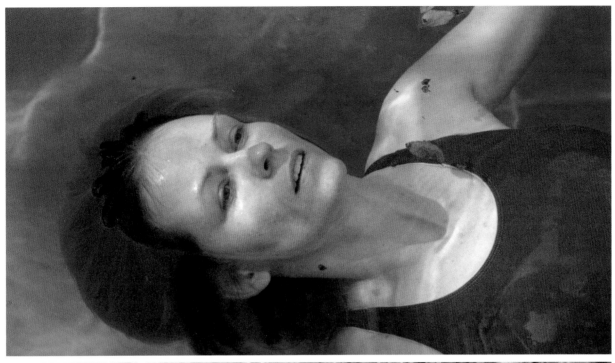

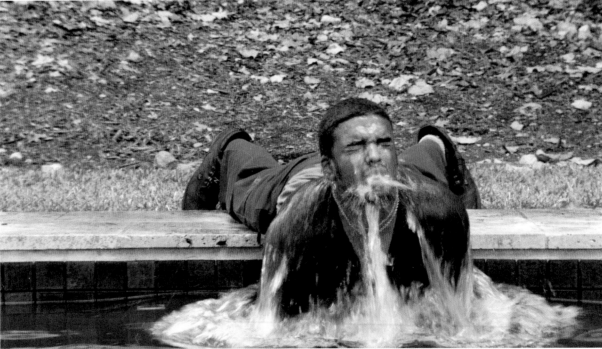

the house. Outside and inside are again continuously linked without a cut and the viewer is then made party to the different rooms of the house. Close-ups of the solitary child and objects of sentimental association are all sequentially discovered and something that pertains to be the child's personal and imaginary world is presented. Like *Detached Building*, the video *Eight* is able to give a complete sense of continuity (or even reality), though we know technically that it must have been realised with sets and complex scripting to achieve the effect. Again it is an example of how video and film deliver an apparent reality that transcends what is actually practical and achievable. It is the grammar of film that purports reality and yet is able to displace our immediate sense of the displacement while it is taking place.

A more recent film like *House with Pool* develops the complex use of film language to an even greater degree. In this instance there are three human character elements, a mature woman, a young girl who is probably the daughter, judging by her gestures and appearance, and a gardener/pool-cleaner. The latter is seemingly the person who is the witness to the events (or, non-events) since nothing strikingly untoward takes place. The upper-middle-class house in this case is not a stage set, but a place where Hubbard/Birchler spent one summer and where the permission of the owners was granted for them to use it. The film is an interaction of

different mental worlds: the woman swims in the pool, plays the piano, drinks a scotch, changes from day to evening wear, and we discover the intimacies of the house. The possible daughter falls asleep on a recliner late one evening, a hind enters the scene from the nearby woods and pauses close to the young woman. Later the hind is found dead by the gardener in the pool, apparently after falling in and drowning. What is presented by the film is a small but peculiarly redolent world. In the distance the sound of a party can be heard, dogs bark far away and there are intermittent sounds of raccoons in the ventilation shaft. It is a strangely eerie film of sound and sight, yet it is simultaneously poignant. There is no dialogue but a densely scripted setting, the house and location offering the core meaning to the piece.[25] An intense poetry where matters of absence are made palpably present.

In the case of Clegg & Guttmann, who have been a double act for over a quarter of a century, socially-related concepts have been taken in a completely different direction. Both born in 1957, Michael Clegg and Martin Guttmann first met and began working together in 1980. They are primarily socially-committed conceptual artists who live and work in New York and Vienna. In the 1980s they became known as a result of their photographic group and landscape portraiture. However, their concept of portraiture had little to do with individual sitters and more with corporate or social groups of power, as in their

○ *TERESA HUBBARD/ALEXANDER BIRCHLER, **House with Pool**, 2004, High definition video with sound, 20 min 39 sec, loop, Projection 16:9 NTSC 2 Ch Stereo, Installation dimensions variable, Courtesy the artists and Galerie Barbara Thumm, Berlin*

CLEGG & GUTTMANN

first two-person show *Group Portraits of Executives*, held at the Annina Nosei Gallery in New York in 1981, and *Allegories of the Stock Exchange* (1983). Seen from today's standpoint, their works are reminiscent of the arbitrageur age and the decadence associated with the executive excesses of the '80s, and with the 'me, me, me' of conspicuous consumption. One might readily think of the world of Oliver Stone's film 'Wall Street' (1987) and the character Gordon Gecko. Clegg &

Guttman's acute observation and internal critique of this world established their international reputation.

A decisive change took place in 1990. Following a request and commission from the City of Hamburg, they moved in the direction of social sculpture. Their concept of social sculpture is complex: while it often has elements of sculpture and installation, it is equally concerned with defining and constructing audiences. In this sense their work posits social

○ *CLEGG & GUTTMANN,* **The Open Public Library***, Hamburg, 1993, Courtesy the Artists*

○ *CLEGG & GUTTMANN,* **Prototype Open Public Library***, New Jersey, 1989, Courtesy the Artists*

○ CLEGG & GUTTMANN, **"Falsa Prospettiva"**, Installation view Lia Rumma Gallery, Milan, 2001, Courtesy Lia Rumma Gallery, Milan

theory and research. It challenges and re-develops ideas around what constitutes public art and public participation. It advocates art works that are socially embedded and participatory. This often has the effect of de-contextualising the objects and materials that they use – removing them from

> "... Art should be in unexpectad places, this is really an important point, this is the basic tradition of the avantgarde it has a surrealistic aspect, but on the other hand, it's about institutional critique".

museums and institutional spaces and translating them into outside public spaces. Audiences are forced to rethink their own assumptions about the objects and sites in which they might normally be experienced and institute a new sense of community portraiture. This also frequently involves the audience in a form of participatory self-organisation.
The Hamburg project in 1993 was called *The Open Public*

Library **and furthered an idea used at the Kunsteverein in Graz, Austria, in 1991, in a slightly different form.** It was constituted by using power boxes of the City of Hamburg's Electricity Board, and filling them with books. The public were invited to read, take away books or add to the collection: "You can take a limited number of books for a limited time. Contributions of books welcome." This had the effect of deregulating public library practices of accountability and fines for theft or damage – library books after all are normally paid for by the local taxpayer. Similarly, it undermined the categorising ideas of a library's structure, since their was no cataloguing or ordering of the library. The only indication that it was an art project were references and the telephone numbers of the Kunstverein and the Cultural Administration of the City. The project was seen as a utopian attempt to undermine bureaucracy and arbitrary regulation. It was also deeply embedded in method-based notions of particularity and site specificity. However, the project was linked to the Kunstverein show 'Backstage,' where large scale photographs of the three library sites were displayed.

The use and development of unique sitespecific libraries has been the dominant, continuous theme in Clegg & Guttman's work since that time, the core concept of which was articulated in the ongoing project *The Open Public Library in Graz* (1990–2005).[26] These projects have taken on many forms; some have been realised while others

remained simply as proposals, some have permanent fixtures while others developed as temporary installations. The chosen media has also varied from photographic documentations to sculptural or installation-based objects. The focus is sometimes on books and at other times on music – Clegg & Guttmann having a passionate interest in music. The music libraries have included the temporary public project *The Open Music Library, Firminy* (1993), the *Open Music Library, Johannesburg*, a proposal for a temporary public project (1994) and a design for a temporary public project *The Open Music Library Proposal, Black Forest* (1995). Each library has assumed the specificities of the place it is conceived for, as in *Train Library* – their proposal for a project on the German railway network (1993), *Open Public Library, Mainz* – a semi-permanent public project (1994) in the city of Gutenberg,

or *The Open Public Library, Copenhagen*, a proposal from 1996 for the city of Hans Christian Andersen. In *The Seven Bridges of Königsberg* (*Open Public Library*), Duisburg, 1999, the library was located in Kant Park and shares the structural configuration of the seven bridges of Kant's home city. Library projects and proposals have also focussed on specific contents, as in *The Political Physiognomical Library – Metropolis* (an exhibition at the Martin Gropius Bau in Berlin in 1991) or *The Children's Archive*, O.K. Linz (1998). *Breaking Down the Boundaries Between Art and Life* at the New School for Social Research, New York (1995), involved the direct physical intervention to an existing library while *Die Open Public Library Graz – Recontextualised* at the Galerie Landesmuseum in Graz and The Royal College London (1993) further elaborated upon existing projects. More recent

○ *(left)* CLEGG & GUTTMANN, **The Seven Bridges of Königs-berg (Open Public Library)**, Duisburg, re-contextualized - A Social Sculpture, 1999/2005, 229 x 486 x 267 cm, wood cabinet, 5 framed photographs/drawings (100 x 120 cm each), Courtesy Georg Kargl Fine Arts, Vienna

○ *(right)* CLEGG & GUTTMANN, **Sha'At'Nez or "the Displacement Annex"**, re-contextualized - A Social Sculpture, 2004/2005, 270 x 180 x 125 cm, 3 wood book cases, 1 metal book case, metal ladder, metal circle, xeroxed book copies and book dummies, 9 photographs (inkjet prints mounted behind plexiglass), card index box, Courtesy Georg Kargl Fine Arts, Vienna

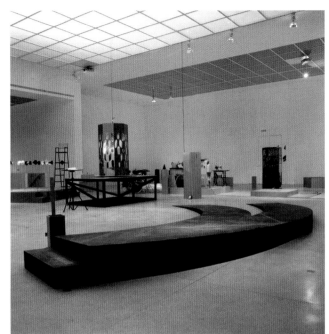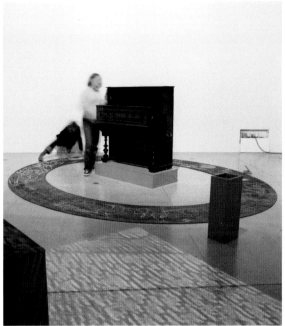

projects have tended to be library-related sculptural objects, as in the *Moebius Library*, Stift Melk (2005). The library bookshelves are in the form of a Mobius strip[26], and the shelves contain the papers and books of the academics attending the conference for which the work was commissioned and conceived. Historical conferences are sometimes reconstructed as in *1897 – the first Zionist Congress in Basel* at the Kunsthalle Basel (1997). The project was linked to the *Zionism as Separatism* event at Basel University Library held at the same time. The role of social education is central to Clegg & Guttmann's work, as reflected in a more recent project, *The Public Library at the Education Alliance Building*, at the Educational Alliance in New York (2005).

In addition, there are the artists' project installations related to social research and experimentation, such as ***The Sick Soul I, Morbid Fascination*** and ***Behavioural Research in Micro Sociology, Reality TV and Avant Garde Art* (1996).** This was the final part of a series of sociological investigations dealing with morbid entertainments – *The Sick Soul II*, in New York (1996), *The Sick Soul III*, Cologne (1996), and finally *The Sick Soul VI – An Auditorium for Film, A Runway for Fashion, A Stage for Music Performance* (1997). Added to these are Clegg & Guttmann's projects for public sculpture, which almost always include references to language and the book, as in *The New Tower of Babel* proposal for a public project in Riem Munich (2000), the *Holocaust-Mahnmal und Gedenkstätte für Jüdische Opfer (Proposal for Judenplatz, Vienna)* (1996), and again, more recently, the *Monument for Historical Change* Linienstrasse, Weydingerstrase, Rosa-Luxemburg-Platz, Berlin

○ *CLEGG & GUTTMANN, **Mach vs. Boltzmann**, Secession Wien, 2006. Photos: Hannes Böck, Courtesy Georg Kargl Fine Arts, Vienna*

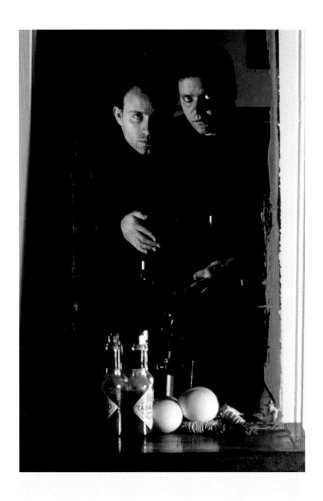

(2004) – the latter being a large and complex project bringing together historical objects, texts and site specificities.

Aspects of interaction with the workplace and work facilities are also important to Clegg & Guttmann, as shown in *A Museum for the Workplace*, The DG Bank in Frankfurt (1994) or,

much earlier, making work tools available in the public space as in *Model for an Open Tool Shelter, Toronto, The Power Plant, Toronto* (1991). Dialectical relations with the installation itself are always questioned in work such as *Falsa Prospettiva – A Knowledge of Sculpture*, Milan and the Valencia Biennial (2001/02), and *Negations of Strict Order: Anarchism, Cubism and Syncopated Music*, New York (2002). There are acts of international transposition as in an Innsbruck project *Bibliopolis, Innsbruck*, when the streets of the city were re-named and re-mapped using the Library of Congress Classification System, or investigations into re-building the psycho-graphical history of Berlin, from its post-First World War revolutionary period of 1918/1919 in a project entitled *Decomposition <=> Reconstitution Berlin – 1918* (2003).

The ideas of Clegg & Guttmann are copious and coherent and they present an active sense at all times of engaging with the social dynamics of public space. To Clegg & Guttmann public art and social sculpture are one and the same: not merely an object to be looked at, but a pool of ideas generated from experience that provide a direct access to social engagement.

○ BLUE NOSES, *The Hot Heads*, 2004,
C-print, 75 × 100 cm, Ed. 10. Courtesy
Galerie Volker Diehl, Berlin and Guelman
Gallery, Moscow

If this chapter characterizes anything, it characterizes strategies of what must be called the performative aspects of life. However, it is in no way performance in a traditional sense of describing role play as you might find it in an entertainment such as in theatre or film.[1] Nor, for that matter, is it strictly speaking part of performance art as we usually know it, for all its long and complex history.[2] Performance as used here refers to an utterance and performs an act creating a state of affairs, illustrated by the fact that it is being made under appropriate or conventional circumstances. Hence the artists discussed below lead an artistic life that follows a certain resolved course. There is no clear boundary between what they do and how they live. This is not a self-delusional state, as if the truth were an alternative reality, but rather a strategy of double-act presentation. In the case of Eva & Adele, they are simply Eva & Adele (copyright) and their life – how they live, the clothes they wear and the décor of their apartment in Berlin – are not a separate world but also integral to their concept of 'Futuring'. In the case of Blue Noses, their position as social anarchists is not simply adopted, but a lived attitude and shared point of view. While Elmgreen & Dragset use performance either as

a matter of personal participation, or for ideas they conceive and set up for the purposes of orchestrating situations that others are to perform, Noble and Webster position themselves as sexual and social provocateurs.

With (Tim) Noble and (Sue) Webster the years since 2000 have been ones of elaboration and refinement. Given their early success they have been able to develop their ideas in terms of fulfilling ambitions that would not have been materially possible earlier. The titles which have always had a sense of sexual wordplay, reflect contents that have become ever more explicitly sexual. If their early works made material references to abjection, Noble and Webster's recent use of it has become more subtly applied. A reflector-cap light piece like *Golden Showers* (2000), while it is closely reminiscent of their work *Excessive Sensual Indulgence* (1996), extends the wordplay of deviant sexual behaviour where people delight in urinating on each other.[3]

That sexual anarchy was much in their minds at that time is found in another work called *fuckingbeautiful* (snow white version, 2000), a blue neon piece shaped in the form of a heart. There is also a red version of the same title in hot pink. And, by extending the provocation they produced a large, two-metre-high work called *The Original Sinners* (2000) made of replica fruit, bark, moss and cooking oil, which brought together their ideas of the fountain and their light projections as a couple.

○ ○ *TIM NOBLE & SUE WEBSTER, **Instant Gratification**, 2001, US 1$ bills, bulldog clips, MDF, formica, perspex, 3 electric fans, slot machine mechanism, plastic tokens, light projector, 76.3 x 76.3 x 222.5 cm, Courtesy of the artists*

Indeed, the year 2000 was a particularly close and fertile year for the couple as a double act. The issue of creating what have been called anti-monuments was evident in *The Undesirables* (2000), shown in the millennial exhibition 'Apocalypse – Beauty and Horror in Contemporary Art', held in

> **"people think we are brother and sister, which is happening more often now, and it's funny because when we met each other we were complete opposites, I had bleached hair and Tim had a huge Michael Jackson style hair do, because his hair grows outwards instead of down....and he was absolutely black because he'd just been to Greece or something....."**

SUE WEBSTER, from 'The New Barbarians', 1997, p. 23

the Royal Academy in London that year, alongside other artists of the YBA generation. The use of taxidermy was also extended and became increasingly sophisticated, as in the stuffed animal and silhouette profile called *British Wildlife* (2000) – a pun no doubt on their being British and leading a 'wild life' – while, at the same time it was also a fusion of British taxidermy-based natural fauna (foxes, badgers, game birds and the like). In this latter sense it was an ambiguous tribute to the long history of their depiction in the 'hunting, fishing and shooting' traditions of British art.[4] Although the work was refused entry into the United States, its quite extraordinary mastery of materials and many sculptural qualities pointed to the later accomplishment of the artists' welded works. That *British Wildlife* was ambiguous is not to be doubted. Other works of that year included *A Couple of Dirty Fucking Rats* (2000), another silhouette projection of rubbish and two

○ *TIM NOBLE & SUE WEBSTER,* **Puny Undernourished Kid & Girlfriend From Hell**, *(Diptych) 2004, 82 multicoloured neon sections, transformers. Puny Undernourished Kid: 180 x 4 x 284 cm, Girlfriend From Hell: 210 x 4 x 280 cm (Puny Undernourished Kid 42 neon sections; Girlfriend From Hell 40 neon sections), Courtesy of the artists*

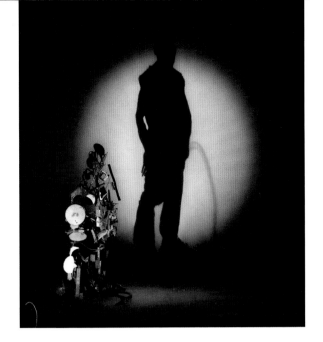

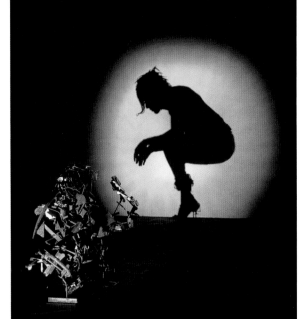

copulating rats – a theme that was further extended in their self-projections of personal domestic detritus called *Wasted Youth* and *Cheap'n Nasty* (2000).[5]

The sensation that many of these works provoked led to an increasing number of commissions. The role of money and commercial success was to become a theme or subject matter in its own right. *A Pair of Dollars* (2001) shows two large, illuminated dollar signs propped up against the walls in a gallery space. They are made of the white reflector lights not dissimilar in reference, perhaps, to their early work *Flash Painting* (1993). Another light work at the same time entitled *Yes* (2001) seems to affirm their assertive sense of and fascination with banknotes.

The works *Instant Gratification* (2001) and *Made of Money* (2002) are quite literally made of just that. The first comprises 10,000 one-dollar bills, presented in free-standing case. It is a projected double self-portrait made almost entirely out of cash. This work brought them into conflict with the US currency authorities, who claimed it was illegal to withdraw money from circulation. The work was thus carefully constructed without glue or adhesive so that at some later date (if necessary) the dollar bills could be retrieved undamaged. A year later *Made of Money*, an English version, was made out of 5, 10 and 50 pound notes, the stipulations of the British monetary authorities being seemingly less intractable.

○ *TIM NOBLE & SUE WEBSTER, **HE/SHE**, (Diptych) 2004, Welded metal, 2 light projectors, HE: 96 x 148 x 185 cm, SHE: 100 x 186 x 144 cm, Courtesy of the artists*

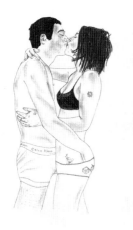

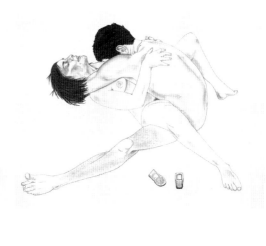

While, at one level, one immediately thinks of Warhol as an antecedent, on another level, concerns about money also tapped directly into their private lives. The years 2001–02, were difficult for the couple. They had acquired a property in Chance Street in the East End of London and financial pressures were also beginning to take a toll on the double-act relationship. Since Noble and Webster's art and life are synonymous, this also became the subject of another double portrait called *Falling Apart* (2001), in which their silhouetted projection is in a gradual state of fragmentation. A sense of separation and personal stress is also reflected in *Real Life is Rubbish* (2002), yet another wordplay, where the mixed-media projection work shows them sitting apart with their backs to each other. They have seemingly withdrawn into their own individual worlds. A mawkish condition also shapes the work *Kiss of Death* (2003) in which their heads are shown on pikes as in their earlier work *Miss Understood and Mr Meanor* (1997). Made of thirty-four stuffed animals, including six rats, a mink, eight carrion crows, eight rooks, eleven jackdaws and an assortment of bones, the creatures included all pick over the carcasses of the dead. A single carrion crow perches and pecks an eye out of Noble's head. A sense of depression seems to descend on the artists, not least, perhaps, with the relative failure of their *Black Magic* (2002) series of paintings at this time. However, in sculptural terms, rapid advances were also being made.

We are familiar enough with their use of the ready-made and their by now increasing use of kinetic elements.[6] In 2004, again appearing somewhat apart, they produced the welded metal/light projections, entitled *HE* (2004) and *SHE* (2004), as if recalling their early interest in Tinguely and metal-based *bricolage*.[7] Abjection again appears, since the projection shows Noble and Webster urinating, but executed in a manner that is extraordinarily delicate in its material achievement. The more obtuse back-to-back work

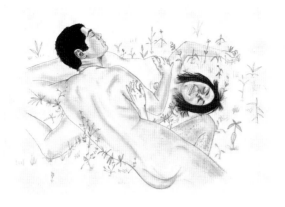

called *The Crack*, not surprisingly also appears at this time, the title also having the same wordplay aspects with which we have now become so familiar. The word 'crack' can have either a sexual connotation, or is the common Irish usage for a good conversation or joke. Jokes, bad taste and the role of *agents provocateurs* may also have informed their assemblage made of cigarette packets, tin cans (shot at with air gun pellets) and a wooden bench, called *Sunset Over Manhattan* (2003). When projected, the work reveals a Manhattan skyline with the twin towers. Whether this is an ironic take on 9/11 is hard to say. What it does reveal, however, is a layering of references that link back to neo-Dada and Nouveau Réalisme, Niki de Saint Phalle's 'shot' works, and (less directly) to works by Daniel Spoerri and Robert Filliou. Since 2005, the artists' work has been increasingly directed towards welded sculpture, as in more recent works like *The Spikey Things* (2005) and *Twin Suicide* (2005). Thus Noble and Webster, as the primary

subject matter of the their artistic practice, can be said to form art works that are interwoven and integrated completely with their personal lives.

In the work of (Michael) Elmgreen and (Ingar) Dragset, the use of performance tends to be impersonal – it does not replace the object as is more commonly the case with performance art.[8] Indeed, often the objects themselves are a material performance in a metaphoric sense, as in *Elevated Gallery/Powerless Structures* (2001, p. 4-5), where a white cube space, presented as an object in its own right, was lifted off the ground by two black vinyl balloons. It therefore became a gallery object within another gallery space and showed the false determinism that suggests an exhibition space could ever be neutral. The same principle also applies to *Descending Gallery/Powerless Structures*, produced at much the same time, and where a white cube was inserted into the floor of another existing gallery space.

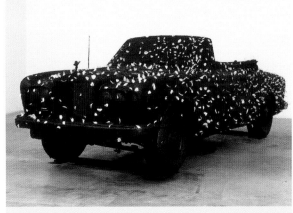

The years 2000/01 were particularly rich in ideas for Elmgreen & Dragset in their quest for creating transformations to the white cube or what they would define as its displacement and de-neutralisation. Similarly, the contemporary art white cube was taken outside in *Traces of a Never Ending History/Powerless Structures*, upended at an angle and set in the ground. The work is loosely reminiscent of Martin Kippenberger's famous subway station.[9] The latter had earlier precedents in Elmgreen & Dragset's *Dug Down Gallery/Powerless Structures* of 1998, where it was simply inserted in the ground in a project for the i8 Gallery in Reykjavik, Iceland. The general effect was of a small gallery at you feet seen from above with the ceiling removed (at night the interior was illuminated).

An even more austere example expressed by its literalism was the presentation of the old Klosterfelde Gallery in Linienstrasse, Berlin (it now serves as a project space for the new gallery). Elmgreen & Dragset transposed its exact dimensions in replica as an object to the new much larger gallery space in Zimmerstrasse. It was similarly presented

○ ELMGREEN & DRAGSET, *Short Cut*, 2003, Courtesy Galleria Massimo de Carlo

○ ELMGREEN & DRAGSET, *Disgrace*, 2006, Courtesy Galerie Emmanuel Perrotin

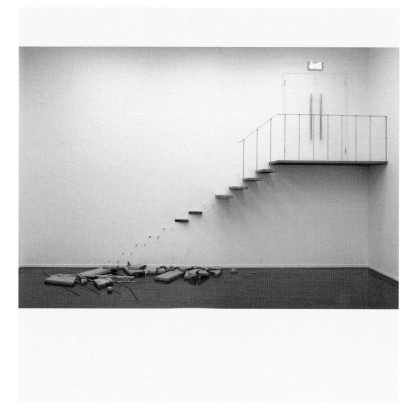

empty, standing in for itself as an object of a former space as an object, and called simply *Linienstrasse 160* (2000/01). If the question of transformation was uppermost (things that reveal themselves as themselves), as distinct from *a priori* suppositions imposed on objects and spaces, re-exposing the given has also always been of vital interest to Elmgreen & Dragset. In this manner they are able to introduce a new sense of mental space (to reconfigure the mental horizon and comprehension of the thing seen) that continually undercuts the formerly given pre-suppositions of a physical space and function.

The continual use of white and of minimalist tropes serves less to celebrate its formal clarity and more to undermine and illustrate what it invariably tries to exclude, namely social aspects. The artists' project for Manifesta 3 in 2000 was to create a white cube as a potential commercial

gallery, with staff and all the accoutrements of running a gallery business, but placing it within the confines of a major international exhibition. In other words, they were to reveal the socially operative contents and fabrication, and the fact that utility is always linked to everyday social needs and practices. Hence the commercialisation of the white cube has become another major theme that runs through Elmgreen & Dragset's work. In their Zurich Kunsthalle project *Taking Place* of 2001, they created an exhibition while the Kunsthalle was in an actual state of dismantlement and complete refurbishment. In the process they exposed the inside and outside, giving access to areas of the Kunsthalle normally hidden from view, or requiring private access. The desolation of what was literally the white cube in a state of ruin and transformation was documented, incorporated and exposed in such a manner as to reveal the hidden state of artificiality that lies at the heart of a presentation of the contemporary arts. As the curator puts it: "A theatre of the authentic expanded before the viewers' eyes, exposing both the perceptions and experiences of everyday life to critical questioning and perhaps triggering a process of reorganisation of symbolic forms within the context of later use."[10]

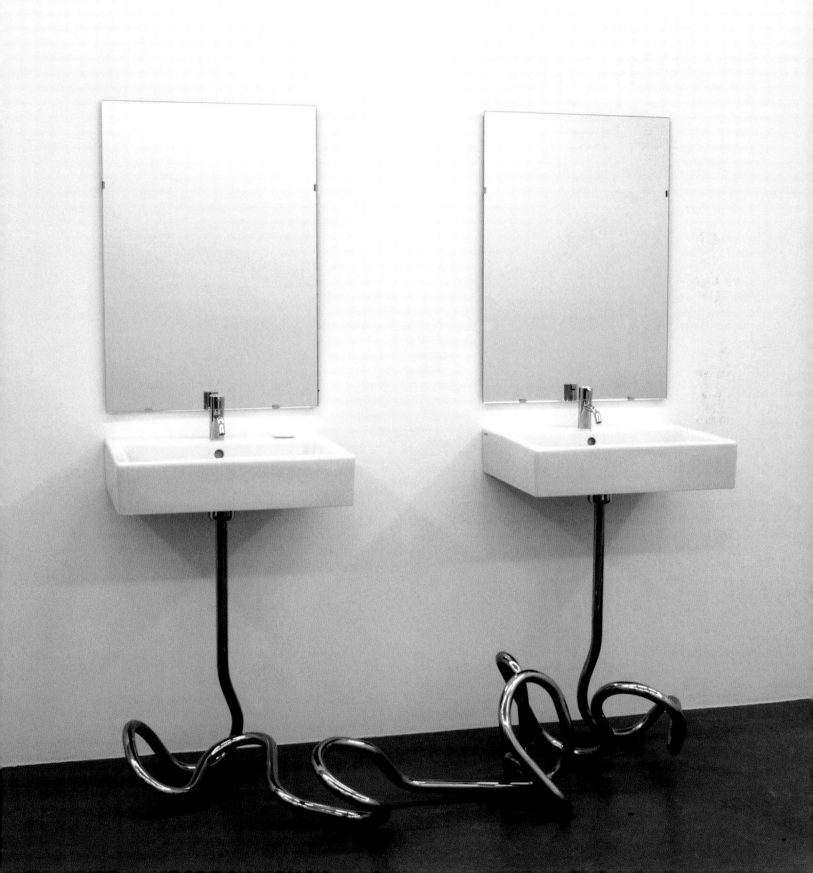

ELMGREEN & DRAGSET

As regards what might be called Elmgreen & Dragset's physical painting performances, which they call their live installations, they freely admit that the parts they play could just as easily be substituted by others. As Elmgreen stated: "I admit that our first works together were due just as much to our being in love as our wanting to say something serious using the performance medium."[11] Thus the performances are closely related to their personal relationship and, when speaking of

performance and a gay sexual identity, "… we did indeed intend to redefine gay sensibility, especially at the beginning of our collaboration." Among their earliest works is *Untitled* (1995), a performance given in Oslo which served to illustrate where the two artists first began. Dragset studied theatre and was working with a small struggling theatre group at the time they both met. Dragset's interest in what he calls 'Living Theatre', particularly Allan Kaprow and Carolee Schneemann, is a telling background

○ *ELMGREEN & DRAGSET, **Drama Queens**, 2007, Barbara Hepworth 'Elegy III', Sol Lewitt 'For Cubes', Hans Arp 'Cloud Shepherd', Jeff Koons 'Rabbit', Giacometti 'Walking Man', Ulrich Rückriem 'Untitled', Andy Warhol 'Brillo Box'. Seven sculptures from the 20th century meet on stage and talk about life. Dimensions: seven life-size sculptures. Made for Skulpture Projekte Münster 2007, was shown four times on the 16th and 17th of June 2007 in Städtische Bühnen Münster. Photo: Elmar Vestner, Courtesy of the Artists*

in this respect.[12] As Dragset puts it: "In some performances we've been more interested in spatial issues than in performative issues ... In the same way our installations often suggest a potential activity that could take place in them."[13] One example is their 1998 *Powerless Structure* performance in Oslo in which, in a Dan Graham-like glass rectangle, they systematically applied paint and then just as systematically washed it down and removed it. It was thus an action of endless circularity with only the smeared glass an each occasion registering residual traces.

In their most recent work called *Drama Queens* (2007) for the current Münster Sculpture Project, they have brought back their early interests in theatre and performance. It is a play without actors, during which seven famous sculptures will be presented for thirty minutes to an audience in an 'aesthetic egos and sensibilities on stage' type of event. In a scripted play of sorts, Tim Etchells, the artistic theatre director of the Sheffield-based group Forced Entertainment, orchestrates issues of the static object and performance being brought together. The sculptures include – among other diverse sculptural forms – a Barbara Hepworth-like work (nature and elegy), a Jeff Koons (kitsch and pop) and a large Ulrich Ruckriem (nature and monument). As they are presented to each other a sort of histrionic conflict between the different sensibilities is brought to bear. Hence the classic gay attribute of 'drama queens' becomes both a fittingly witty and at the same time a telling title for the work, while simultaneously satirising the notion of singular aesthetic subjectivities.

The sexualisation of the white cube and the commercialisation of the same are also closely linked. Not surprisingly, perhaps, since both operate in the sphere of the libidinal economies of desire and/or consumption. A work like Elmgreen & Dragset's *Queer Bar/Powerless Structures* (1998) is a white cube sculpture with bars stools, only the bar dispensing taps have been inverted and installed facing outwards. Clearly, the pun is on the notion of 'inversion' – a term often used as a pseudo-medical or psychological definition for homosexuality. But is also noticeable in this, as in so many of Elmgreen & Dragset's works, that there is an immaculate, an almost tender approach towards acknowledgement and denial in their use of minimalist space and objects. In the work *Powerless Structure* for the Louisiana Museum, Humblebaek, in 1997, they took one

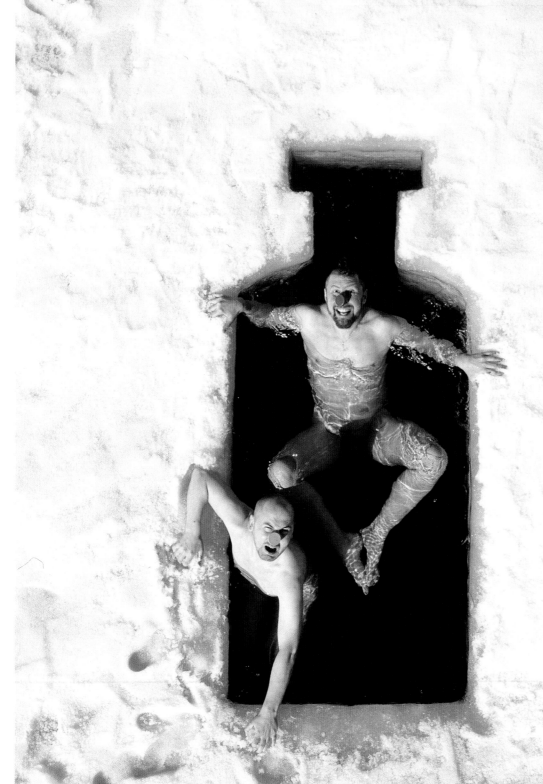

ABSOLUT BLUE NOSES

of the gallery spaces and added a diving board. The board, passing through the window, invited viewers to metaphorically dive into the cold Baltic Sea immediately beyond the window.

Perhaps the most telling link between the commercialisation of the white cube and desire was the artists' project *Prada Marfa* (2005, p. 174-175).[14] The work was foreshadowed in some respects by *Opening Soon/Powerless Structures* (2001), when their gallery in New York, Tanya Bonakdar, presented a work in which her space feigned to be opening soon as an outlet for Prada. The world of fashion and luxuries of desire are of course closely linked to sexuality (as is so often in the world of art). In *Prada Marfa* Elmgreen & Dragset built a Prada store outlet in the middle of the Texas desert. In was not un-coincidental that it was close (in relative Texas distances) to the late Donald Judd's Chinati Foundation at Marfa. In a form of homage and critique – Judd's use of the formal minimalist language on the one hand and his lack of immediate social contents on the other – the work was an adobe structure in the local vernacular. It was then screened in white and presented all the Prada conventions of blinds and signage. Ironically or coincidentally, it was close to the (g)host town Valentine, the name of which exaggerated the artists' play on sexual and social desire. Inside the permanently closed installation, a range of fashion shoes and handbags – the latest at that time

– could be seen. Alone and isolated, thirty miles or so from anywhere significant, with only the passing truck or car on the adjoining highway, it symbolically critiqued the urban addiction to consumption and the commercial appropriation of the white cube art space. At the same time, however, it parodied the tradition of Land Art, with its notions of intervention and the creation of man-made natural monuments, works that had been exemplified earlier in the '60s and '70s by Robert Smithson's *Spiral Jetty* (1973), James Turrell's *Roden Crater* (1978–present) not so far away, and Michael Heiser's *Double Negative* (1971).[15] Land Art invariably valorized solitude and denied the social, the works of Land artists generally being intended to be experienced in terms of reflective isolation. Hence the functionless structure *Prada Marfa* was an act of complete displacement in a double sense. Not only are there no potential customers, but it is never open (a time switch illuminates it at night), and the ironic distance between the world of Stetson and cowboy boots (a gay fantasy) gives the work a desultory sense of humour. Like the faded fashions of yesteryear the work is gradually being consumed by the environment that surrounds it.

The repeated doubling in Elmgreen & Dragset's work, not only in terms of their status as a double act, is constantly reinforced by their use of formal tropes and

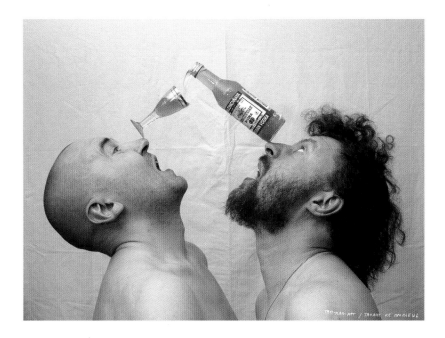

BLUE NOSES

social contents. Visually formal and phenomenological in their use of Edmund Husserl's idealistic 'bracketing', or Maurice Merleau-Ponty's dualistic *epoché*, it calls forth a visual sense of introspection.[16] While, at the same time, their works evoke and expose the hidden social meaning behind what is being looked at, it flows outwards in an extended self-questioning as to what is being experienced.

The art works produced by the Siberian duo Vyacheslav Mizin and Alexander Shaburov – the Blue Noses – are commercially successful forms of social anarchism. If that sounds somewhat contradictory, it merely illustrates the contemporary art world's ability to assimilate and consume all forms of social critique within the market place. While there is a large body of work for both artists individually prior to the formation of the Blue Noses, it has not been included in this context.[17]

The artists are so spontaneous and prolific that it is necessary to break down their work into specific themes, all of which operate either through video, photographs, and/or video or photographic installations. In many instances they derive from records of performances. The use of anarchic parody adopting cut-out paper masks emerged with *The Mask Show* (2000). Bush, Putin and Bin Laden are shown lounging like 'reclining nudes' on a couch in their underpants. Acts of pseudo-buggery are taking place, the masks are interchanged, as Bush and Putin support Bin Laden on a pair of crutches. Other comic characters appear in *Contemporary Siberian Artists* (2000) and figures like George Soros (the benefactor to Eastern Europe), where they are presented higgledy-piggledy, as if taken from a child's game or from children's television. There is a series of ever more chaotic mask ex-changes

○ BLUE NOSES, **TALENT CANNOT BE BOOZED AWAY**, From the series 'Hit-Or-Miss-Art', 2004, Photograph, Courtesy Galerie Volker Diehl, Berlin and Guelman Gallery, Moscow

○ BLUE NOSES, **SEX SUPREMATISM**, 2004, The Russian avant-garde became a stylish brand and in mass consciousness neighbours talk about sex and slimming, Photo comics, 5 photos, Courtesy Galerie Volker Diehl, Berlin and Guelman Gallery, Moscow

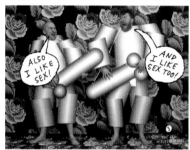

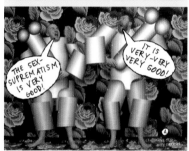

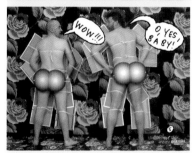

running through the series of eight photographs.[18] Who has exchanged with whom can only be ascertained by keeping track of the different underpants. The idea of masks or papier-mâché heads has been used several times since by the artists. A work like *Kids From Our Block* (2004) is a series of four photographs of locals boys dancing around while wearing paper face masks of Putin. The same idea has also been made to reflect the news and politics of the day, as in *The Oligarch Boris Berezovsky Masked as President Putin at a Press Conference* (2003), or as anti-globalist papier-mâché heads of the leaders of the G8 countries (2005). Just as readily, it is used to criticise American war propaganda, as in *Fall of Washington* (2004). The satirization of history and how politicians appropriate famous figures of the past to themselves, can

be seen in *The Candle of our Life* (2004), in which a figure with a paper cut-out mask of the great poet Alexander Pushkin uses a throwaway cigarette lighter to ignite a candle held by Shaburov with a mask of Christ the Saviour. President Putin warms his hand (in a Christ-like gesture of peace) on the flame of the candle held by the Saviour next to him. The work is itself a parody of a parody, namely Kukrynsky's famous caricature called *The Heroic Trinity* of 1974 that was, in turn, derived from Andrej Rubljoff's *Trinity* (1425–27) in the Tretyakov Gallery. Here it is used to satirise advertising and the clichés of political self-promotion by association.

The Blue Noses' attacks on art and art history have been just as apparent in recent years, though this can often appear mixed in with other themes, as in the *Art Sex* (2003) series. In these works, male to female sodomy is simulated while wearing cut-out paper masks taken from Picasso's Cubist

Primitive period, or as a parody of famous painting traditions, as in their photograph series *New Barbizon Painters or Out of Town Excursions* (2001), in which the figures are buried up to their necks in sand by a lake, with only their heads visible. The Blue Noses are not averse to the immediate stealing of other contemporary artists' ideas: they appropriated *Kissing Policemen* (2004) from the British art anarchist Banksy's *Kissing Coppers* (2003). Whereas Banksy's version was as a stencilled street art image next to a lamppost, the Blue Noses' photographic work places the 'snogging' policemen in snow-bedecked silver birch forest in mid-winter.

The recent marketing of heritage and avant-garde Russian history has been a repeated theme of attack in works by the Blue Noses. In *Sex Suprematism* (2004), in what they call their photo comics, famous works like Malevich's

Futurist Strongman (1908) with its abstract 'tubism' has been made into a satire by the two artists wearing simulated stainless steal outfits whilst holding up their massive erections. The scene, as with many other works, is against a background of popular floral fabrics. The same anarchic approach has been taken in *Kitchen Suprematism* (2005–06), where Malevich's abstract intellectual paintings have been simulated or re-conceived using cheese, sausages and salami.[19] Food and its often integral relation to sex and consumption is a constantly repeated theme in the Blue Noses' anarchist projects. The same approach was taken in what they jokingly call 'dinner plate Suprematism' – during the revolutionary period of the 1920s, the artists turned their endeavours to making industrial designs and utilitarian objects, ideologically placing themselves at the service of the then recently forged Russian Revolution. Nothing

Разве только кофе, а Winston? Разве у меня нет вкуса?

АЛЬФА·БАНК ПРЕДСТАВЛЯЕТ 20, 21, 22, 23 ОКТЯБРЯ

ЗАКАЗ Б В КОРОЛ АНЦА
933- 2 Подробная инфор концертах на сайт
WWW.A BANK.RU

Разве я не попаду на вечеринку? Разве я похож на неудачника?

is safe from being satirized by the Blue Noses – and there are few areas of Russian culture that they will not transgress.[20]

At the same the artists attack advertising in a series of poster works, beginning with *The Lower Depths (The Fear of Being Thrown on the Scrap Heap)* in 2001. There are photographic street interventions and adaptations dealing with sex and fashion, such as *Requisite for Revolutions* – a series of four light boxes (2002), or a visual critique of a local Russian Winston advertising campaign, *Do I Look like a Loser?*

(2001). It should be remembered that the 'New Russia' and youth culture are deeply embedded in public relations, advertising, and new media. Further examples include *Consumers of the Future* (2003) and the series *Resistance Wholesale and Retail* (2006). The artists' send-up of an advertising campaign for vodka was a series called *Absolut Blue Noses* (2003), for which they received sponsorship – leading art world sponsors often being open to a critical approach. In addition, there are countless videos and photographs made *ad hoc*, either related

EVA & ADELE

to a specific site or on the move on trips to install exhibitions. Nothing seems to escape their view that cannot be parodied, be it *Sex Art*, *Airport Art* (2003) or war and terrorism as in *Chechen Marilyn* (2005, p. 46) – indeed, there is a whole plethora of works relating to these themes. However, there is at times also a redeeming sense of self-parody, as in the series of videos called *Two Against the Russian Mafia* (2002/03) which includes episodes with titles like 'Attack of the Clones', 'The Mummy's Back', 'Show Girls' and 'Exquisite Corpses',[21] – although this might also be seen as a send-up in different ways of the obsessions of Russian television and the general

complacency that set in during the Yeltsin years with regard to organised crime.

The cardboard box video presentations called *Little People* (2004/05), when opened up, reveal video screens at the bottom. Unusually, these seem to show some measure of personal affection, frequently illustrating violent parodies and frustrated sex. Perhaps this is how their favoured 'little people' – as the artists call them – experience their day-to-day lives. The Blue Noses' work and performances – the videos frequently being a record of performances – are made in terms of the immediate assimilation of what they experience at a

○ EVA & ADELE, Hotel Drei Könige, EVA (left) & ADELE (right), 1995, each 80 x 120 cm, Ed. 5, 2001, Courtesy Galerie Jérôme de Noirmont, Paris

particular time. Whether it is sex, advertising, politics, film or any and every form of so-called 'high-cultural' endeavour, it must be parodied. While, at the same time, the Blue Noses are pocketing their rewards and taking them to the bank, this may be their most supremely anarchic action – the true delight and consequence of their art-making. It provides the means to live well while simultaneously biting the hand that feeds them.

When speaking of performance in relation to Eva & Adele one needs to be circumspect, since their life is their performance and it is a performance that requires rigid discipline. In one sense they are the most conventional of married couples, yet in another sense they are the least conventional one can imagine.[22]

From the moment they get up in the morning and shave their heads, apply their identical make-up in their own separate cosmetic rooms (perhaps the only moment of actual separation), and record it on Polaroid, they are quite literally never apart in the rest of their daily life. Their health and their daily regimen is a scripted routine. What they wear for the day is decided upon from their enormous wardrobe of clothes which they specifically design to be identical in their different sizes. The environment of their two-storey apartment is similarly scripted and repeats the central décor decisions that conform to every aspect of their lives together. What they eat and what they drink is done and generally decided in unison. While they travel extensively to perform at art openings and art events, every aspect must be planned and scripted. This is the same whether they travel in their pink camper van or fly to their destination. The extraordinary paradox this creates is that when you meet them and talk to them, they are extremely friendly and seemingly completely relaxed in their new and resolved personae. This is so, even though they have sublimated all but a few of the residual traces of their former lives.

Eva & Adele's art – as discussed earlier – and their daily work in the studio on the lower floor of their apartment, becomes but an extension of their 'Futuring' lives as a performance and a work of art. The fact that it is the locus of re-inscription of past biographical performances and events means that their visual realisations remain constantly on the point of projection. One might think that such a life is all but self-consuming, that a double act becomes a 'single act' by another name.

VI – HISTORY III MEMORY AND NOSTALGIA

In an obvious sense and at a certain level, all painting, filmmaking, sculpture and installations call upon history. **No medium of artistic expression exists in a void; there is none that does not have a material or technological history attached to it. The question is, however, whether a given artistic practice merely recapitulates or extends the discursive historical contents of the sources to which it makes reference.** In the case of the double act Muntean/Rosenblum, they at times deliberately re-articulate the gestures and physical iconography of history painting, renewing them within a contemporary idiom of expression. That the gestures and physical expressions themselves are visually well known, is linked not only to their historical origins, but at the same time to the fact that they are in a constant state of repetition and mediation within modern culture. They appear again and again through sources such as popular advertising and magazines. History is thus ineluctably linked to our memory, and this is so whether it is executed in a conscious or unconscious manner. The boundary between historical determinism and innovation remains opaque, and can only be argued for within the context of its contemporary use and interpretation. Nostalgia is quite literally a bittersweet longing for things, persons, and situations of the past. Often seen in a negative light, as a form of sentimentalism, this frequently denies a fundamental reality that much of human life is embedded in ideas of longing and recall. Without memories we would live in a state of amnesia. However, a false nostalgia, the desire to rebuild the past in the present constitutes a non-creative strain of the sentimental. As Søren Kierkegaard, pointed out long ago, repetition has a dialectical relationship with the past that is brought into the present, "Repetition and recollection are the same movement, only in opposite directions; for what is recollected has been, is repeated backwards, whereas repetition in the true sense is recollected forwards."[1] The use of repetition thus converts and projects, while simple recollection can stultify the mind. Repetition is the past renewed rather than merely re-enacted. The artists in this chapter deal with the past in decisive but quite different ways. A double act like Stepanek & Maslin revivifies landscapes and skyviews from unique viewpoints, and with an intense colour saturation and presence. By contrast, the Starn Brothers might be said to engage with natural history, what in Germany was once called *Naturgeschichte,* and which they develop in relation to scientific human thought and material expression. Jane and Louise Wilson frequently investigate the spatial dreams and aspirations of technological recent history, while Abetz/Drescher evoke an ironic sense of a macabre contemporary nudist pastoral, a mixture of *Déjeuner sur l'herbe* fused with the surreal.

In more recent years Muntean/Rosenblum have either focused in part and whole upon the conventions of

history painting.[2] In a literal sense a painting like *Untitled (The day doesn't promise…)* (2003), refers also to Manet's *Déjeuner sur l'herbe* (1863), with the nude no longer the female but the male. The Manet work is a classic icon of painting history, and its symbolic reference is that it marks a decisive movement from earlier history painting to that of modern life.[3] In their video-film *Disco* (2005), large parts of Géricault's famous iconic history painting *The Raft of the Medusa* (1819) are quite literally re-enacted. It is based on the shipwreck of the frigate Medusa in 1816, where the 150 survivors clung to a life

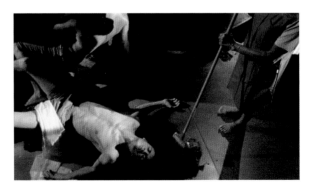

raft, but were reduced to animalistic cannibalism in order to survive.[4] The fact that these beautiful young 'white' people (the foremost figure in the Géricault painting is black) are all the same age (a singular exception being the older Heraclitus figure, loosely referencing sources like Rodin's *Thinker* and Raphael's *School of Athens*), suggests less that it is about the travails of a shipwreck, than the cannibalism of painting and image-making itself. An aspect further emphasised by the

*◐ ◑ MUNTEAN/ROSENBLUM, **Disco**, 2005, HDTV, 5 min 5 sec, looped, 16:9, Ed. 7, Courtesy Georg Kargl Fine Arts, Vienna*

IT WAS AS THOUGH WE HAD CROSSED SOME INNER THRESHOLD, AND ALL AT ONCE THE WORLD BECAME DIFFERENT, A PLACE OF UNIMAGINABLE SIMPLICITY.
A MOMENT MORE AND EVERYTHING WILL HAVE LOST ITS MEANING.

event taking place on the stage steps of a dance club, with a silver glitter ball, and suggesting that the young men, having taken off their T-Shirts, are in the post-event of a dance or rave. Portrayed is the shipwreck of a night of excess, with a concomitant hope and longing for an event that has meaning. We are all familiar with the 'down' effects (the young, perhaps more so) that follow upon an escapist night of excess. As with all their paintings, specificity has turned into the non-specific, for though it makes a reference to a historic source the outcome is completely displaced. In the years since 2005, and the move from acrylic to oil on canvas, the use of gesture and pose in Muntean/Rosenblum's paintings has become ever more compositionally exaggerated and referential. While they are darker in tone (suggesting a gravitation from Mannerism to the Baroque, allied to the new use of oil), older prophetic but usually passively posed male and female characters have been increasingly included. It should be said, however, that they are more like figures than characters since they do not create or intend precise or defined characterisations. The active poses are invariably (though not always) taken by the younger figures. A contemporary Raphaelesque Madonna and child appears in rocky landscape called *Untitled (The sky was pale…)* (2006), or an ecstatic bearded older man with arms raised in an urban industrial setting as in *Untitled (There are days when everything…)* (2006). In both cases they follow the

Renaissance convention of the upturned head and skyward gaze of a feigned reverie.

However, it is not of immediate importance that we recognise these obvious historical sources; they are, after all, part of the collective unconscious of images the we derive from art history. So I return again to question what Muntean/Rosenblum are able to bring to an analytical understanding of that which constitutes contemporary figurative painting today. In a whole series of recent paintings like *Untitled (It was as though…)*, *Untitled (The landscape looked both…)*, (2006), and *Untitled (Memories are a great trap…)*, (2007), there is a decisive shift in formal terms. Rather than their earlier frieze-like presentation there is greater compositional gesture and posed complexity, allied to the use of *repoussoir* in a painting like *Untitled (The landscape looked both…)*. The figures block and shape the recessive depth, creating a parallax effect of the poles on the left with the rail track and figures on the right. The gestures and poses of the left figures also recall something of the earlier Géricault subject, while on the right they are reminiscent of a Donatello relief, where, perhaps, the iconography of forward stretched arms finds its ultimate origins. The blond-haired youth lies supine and foreshortened on the railway lines foreground, unharmed and apparently (as yet) inviolate. No train is in view that might run across these desolate urban rail lines, and the subject

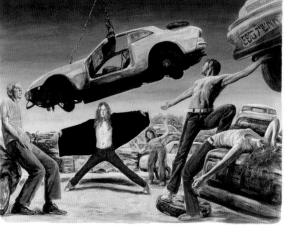

matter is quite deliberately hysterical. The posed figures are thus representative of a desolation in themselves. It is a fragmented narrative painting about the non-making of a determinate narrative. The composed figures are concerned with their own condition of being just figures, and as usual the accompanying text or aphorism gives no illumination or structured access to what is actually taking place. Throughout all the painted works of Muntean/Rosenblum, the hermeneutics of painting are always questioned and challenged. How can this image be interpreted? What do they mean? What is being said? The same effects are evident in a landscape setting such as *Untitled (It was as though...)*, where we feel we are looking at a compositional stage set – a Baroque or operatic theatre performance conveyed through the visual relocation into contemporary dress. It is a theatre of compositional interrelations, the foreshortened youth with his arms outstretched forming an arc of inclusion with the cowboy-

like figure holding a rifle and seated centre left. The yellow blanket with its V-inverted drapery folds, almost identical with those invented in fourteenth- and fifteenth-century Florentine painting. Paradoxically, perhaps, among the most striking achievements of Muntean/Rosenblum is their ability to have fundamentally digested and elided former distinctions between abstraction and figuration. If modernism set the two positions apart, indeed, created an arbitrary dichotomy between abstraction and figuration, transposing Muntean/Rosenblum's figurative compositions into abstract block relations can be achieved instantaneously in the mind of the viewer. This is particularly true of a painting like *Untitled (Memories are a great trap...)*, where the suspended car shell is formally echoed in the figure's open black jacket and scissored legs. Muntean/Rosenblum paintings seem to suggest they are less about subject matter than about the matter of painting suborned by a subject that merely reinforces their reality as paintings. The

artists seem to be saying that contemporary figure painting (as painting) has become something of an echo, a shifting ground that is never certain and/or perpetually indeterminate. Hence the works of Muntean/Rosenblum are not literal paintings of contemporary life in the modernist sense of the tradition instituted by Édouard Manet, and they do not attempt to transcend history painting so much as expose to view its fragile (sometimes facile) and eternally repeatable vocabulary. If they are laments, as has already been stated, they are the lamentations of human emptiness, the isolated mantra of an eternal return or incessant repetition. In short, they are the most common commodity of our everyday lives, but particularly so among a youth culture with promised expectations which are easily suffused into an ennui of lassitude and disappointment.

The artists Alice Stepanek and Steven Maslin also deal with many of the traditional conventions of painting, though in their case it is determined by another genre. They paint largely landscapes and what they have called skyviews, often bringing together the contrary visual aspects of stasis and speed. There is never a human presence. In other words, the present the mutable and immutable contents of the world, an appearance of change in juxtaposition with an unchanging circularity of seasonal regularity. Their approach is a form of heightened realism fused with pictorial artifice. They met in a London pub in Charing Cross Road, twenty-five years ago, whilst they were both studying at St Martin's School of Art, where they both trained as painters.[5] Alice Stepanek is German and born in Berlin, and Steven Maslin is English from London. After their studies they settled in West Berlin, and later in the 1980s, moved to Cologne. After some years living as a couple double act, they have now continued a professional partnership, in which they work together on their paintings. The paintings since the mid-90s, have concentrated on issues of perception related to landscapes while sometimes alluding to speed and motion. Their works are a sort of compendium of natural landscapes that are at times presented as if seen from a point of speed, while at the same time possessing elements of the static within the same painting. Their work in the 90s, having been described as a "way of looking, a mixture of fragmented and compressed perception, becomes a gaze caught in a permanent process of passage."[6] More recently the use of the static image has become directly expressed as a heightened perceptual experience, and in this respect (though different from Muntean/Rosenblum in every other) they also question the limits of landscape genre in contemporary painting. The greater distinction between the German/English and Austrian/Israeli double acts is a concern with phenomenological or perceptual affects, rather than conceptually hermeneutic figurative effects enacted by painting today. In a painting like *Untitled 23* (1996), the format

presents the optical contradistinctions. The foreground space shows a large bush stretched across the centre field, as if one were passing at speed in a car or train. By contrast in the mid-ground left and rear ground they show a static content with meticulous intensity. This bifurcation, or doubled sense of perception, was particularly typical of their work in the 1990s, through to the millennium. Stepanek & Maslin's interest at the time was forest and woodland night scenes. A strong emphasis on seasonal changes was also considered at that time, with works dealing with forests or general snow scenes, and occasional townscape horizons as seen from a viewpoint set in nature. Investigating every avenue of landscape, there has always been in Stepanek & Maslin's paintings a sense of a dialectical relationship between macrocosm and microcosm, of panorama contrasted to much smaller detailed motifs. They have a complex sense of part and whole, a fragment (a part-whole) presented as an autonomy, or a generic view presented as a universal landscape metaphor. The landscapes themselves are not identifiable as such, nor are they intended to be. In fact one might argue that they are far removed from 'nature

red in tooth and claw', often suggesting parkland settings or landscapes groomed, harvested and/or maintained by human intervention. This has led one writer to speak of them in terms of the technological sublime, as "three of the paradigmatic conditions of modern perception: the speed factor, the view from outside, and artificial lighting."[7] And, though it is a cliché that should not be overstated, they further develop and extend the great tradition of German/English landscape painting.

Stepanek & Maslin's more recent paintings have shown a marked shift towards the aerial/sidereal and macrocosmic viewpoints, alongside their primary terrestrial interests. In the years 2000-04, though not without precedent in their earlier works, they developed a series of skyviews.[8] These were viewpoints constructed if one were lying supine looking up towards the sky and clouds, often through severely foreshortened trees (sometimes distorted) or natural flora. This of course has a strong Romantic set of precedents in the 'cloudscapes' or studies by John Constable (1776-1837).[9] However, the artificiality of the viewpoint shows it is not an attempt to depict the real, but to heighten it and to extract an

○ ALICE STEPANEK & STEVEN MASLIN, **Untitled 17-06**, 2006, oil paint on linen, 130 x 90 cm, Courtesy of the artists

○ ALICE STEPANEK & STEVEN MASLIN, **Untitled 23**, 1996, oil on canvas, 80 x 280 cm, Courtesy of the artists

ALICE STEPANEK
& STEVEN MASLIN

abstract perspective-perception from the world. At times these skyviews are almost dizzying and vortex-like, creating an optical suction effect as if you are being drawn upwards.[10] This is particularly evident in works like *Untitled 26* and *Untitled 28* (2004). Within this series, and its further development, we also find singular motifs, a leaf or a butterfly, ears of wheat or barley, flowers or the tendrils of convolvulus, set against the vivid colour of the sky and clouds, either with or without aircraft vapour trails. An extraordinary example is *Untitled 17* (2006), a landscape/skyview seen across the horizontal bough of a silver beech, with leaf tendrils crossed and descending from above. The cross form appears several times in their recent works, suggesting at times something like a pseudo-religious view of nature. What we find in all these Stepanek & Maslin works is a synchronicity of what were formerly separate landscape sub-genres. The pastoral, the picturesque and the sublime have been fused together in simultaneity to form a new language of contemporary landscape expression. Hence they are as much landscapes of the mind, an imagined reality, as they are depictions of the natural world. In returning to terra firma in the works of 2006 include open woodlands where the trees appear as heightened colouristic transverse columnar structures, as in *Untitled 2* and *Untitled 18* (2006). The artists also have an acute sense of the use of

surface formats, at times using circular or oculus supports that stress the telescopic nature of their skyviews.[11] At others times they use the square. The vertical format has been used for their recent works where crossing motifs appear, and long horizontal surfaces are frequently used for their panoramic views or to suggest the transent passage of the motif. In this sense they are definitively optical painters, paying less attention to what might be considered the conceptual history of the painted image, in favour of a visual and perceptual sense of the ocular. Traditional in their use of oil on linen, Stepanek & Maslin's sense of colour is at times deliberately abstracted. That is to say, the colours are not so much an exact replication of a colour seen, as an exaggerated intensification of visual experience. Hence we are left in no doubt that we are looking at a painting, rather than a transposed photographic representation of the natural world.

With the brothers Doug and Mike Starn, their attitude towards nature has been distinct from the beginning since it stems from a conceptual and investigative scientific approach, rather than a purely perception driven view of nature.[12] However, they share with Stepanek & Maslin a strong feeling for the phenomenological and sensory contents of

nature. In the artists' predominantly conceptual photography and video works, they bring together natural science and natural philosophy, often influenced by Eastern thought and ideas. Like the sisters Jane & Louise Wilson, the brothers Doug & Mike Starn are identical twins, born in 1961 in New Jersey. They studied together at the School of the Museum of Fine Arts, Boston, and graduated in 1985. They became internationally known following their showing at the Whitney Biennial in 1987, and after their two-man show at Leo Castelli's Gallery in 1988. However, in the years 1987-93, they were acclaimed in America by a whole series of public museum exhibitions which travelled the country.[13] Their photographic images deals with the ephemeral, frangible, and the entropic contents of the material world, in which they draw frequent natural and philosophical analogies between material objects and human mortality. The Starn Brothers' approach is to investigate thoroughly a subject, develop a concept, and see it through as a completed project. On occasion the projects sometimes take several years and have stages of continued development. I intend to speak only of their works since 2000, as they embody and encompass many of their earlier ideas and seem particularly prescient in the context of current issues of global warming and the health and well-being of the planet. Doug and Mike Starn have an ongoing interest in darkness and light (central to photography) with its accomplishments

◐ DOUG & MIKE STARN, *Structure of Thought 15*, 2001-2007, MIS and Lysonic inkjet prints on Thai mulberry, gampi and tissue papers with wax, encaustic and varnish, 152 × 183 cm, © 2007 Doug and Mike Starn/Artists Rights Society (ARS), New York

DOUG & MIKE STARN

like photosynthesis, and the power it possesses to transform material life has always been important in their work. At the same time the question of natural structures, those similes between human biology, botanical, and biochemical formations, places their work in the context of a continuous interconnectivity. Indeed, in many respects their art works can be seen as operating at the interface of art and science. To Doug and Mike Starn, human thought is inseparable from these analogous structures and natural similes. After all, they might argue, among other things, the human body is a walking, talking, and thinking biochemistry set. But it does not exempt life from a spiritual dynamic at the same time. The exhibition-installations they create are often like science-art gallery stage sets, bringing together in a mental-emotional sense the complex aspects of nature and its wondrous interconnectivities.

The series called *Attracted to Light* (interrelated 1996-2004), deals with moths (Lepidoptera) and their sometimes suicidal fascination with light.[14] The work takes several forms including small scale silver prints on hand-coated Thai mulberry paper, that can then be placed in lepidopteral-like boxes and presented on low

tables. However, while at one level it mimics earlier historical conventions of scientific taxonomy, at another it places the viewer in the aerial viewpoint as one must imagine the moths themselves possessed in their headlong flight towards the light. The delicate silver print technique that they have further developed also bears comparison, not only to the nineteenth-century origins of the silver print, but also to the visible silvery and dusty-luminescent qualities seen on the wings of the moths themselves.[15] The same subject also appears in a large-format (10' x 10', or 10' x 30') series of coloured laminated Lambda digital c-prints (2000-04).[16] The question of light and its absorption was part of the Starns' intensive ongoing investigations of 2000-2002, and appeared again in a further developed but related way in the exhibition called *The Gravity of Light*

(2004).[18] This drew an analogy with the most fundamental of natural light sources, namely the sun. A ten-thousand-square-feet exhibition space was lit by a single brilliant arc lamp which mimicked the sun, but was based on the Humphrey Davy (1778-1829) arc lamp discovery and the invention of electric 'artificial light' (electrolysis), in 1804. Hence the spaces were flooded with ambient light, in which was displayed a large transparent video projection on a glass screen showing that light was not only capable of luminescence but of generating darkness (the implied light/dark that formed the gravity of the title). Similarly, in this near-industrial cathedral of light works from *Attracted to Light,* from the series *Black Pulse* (2000-2007), and

the *Structure of Thought* (2001-2004) and *Ganjin* series (2005) were also exhibited. The main aspects of *Structure of Thought* had appeared in the 'Behind the Eye' exhibition (2004) and again in *Absorption + Transmission* (2005).[19] These exhibitions were the culmination of a long process of investigating trees, photosynthesis and their light absorption. The material use of transparency and layering has been a consistent practice of Doug & Mike Starn from their earliest of works. As has the sense of giving their works a feeling for a fustian/coarse pre-aging quality that suggests the entropic and ephemeral. Indeed, their designed artist's books and catalogues often materialise in adapted form as the actual contents of their exhibitions. An

○ DOUG & MIKE STARN, **Black Pulse 13** (Lambda), 2000-2006, Lambda digital C-Print, 104 x 231 cm, © 2007 Doug and Mike Starn/Artists Rights Society (ARS), New York

The Journals of Doug and Mike Starn
Quoted in 'Behind The Eye : Doug and Mike Starn', Neuberger
Museum of Art (March 7 – August 8), 2004

extension of the same principle of interconnectivity, to which I earlier alluded. In the large multi-sized series *Structure of Thought* there is not only the linking of photographic prints to the translation of light-and photosynthesis promulgated as a specific idea, but also trees themselves are to be understood as the product of light. They are in a constant state of reaching towards the light – seen to be material entities that are light-driven. The complex architectural structure of trees has also served as direct similes, and has been related to modern technologies like MRI, and the new brain scanning and imaging techniques. It is an idea given even greater stress in the series they call *Black Pulse,* a series of computer-generated leaf images, with their complex veins reflecting in microcosm the tree whence they derive. These are often presented by being pinned to the walls and configured in grids. The use of the grid and superimposition of images is part of the Starns' idea of interconnection. A grid is an interconnecting aspect, and also in this instance analogous to the internal structures of computer chips and internal circuitry, whence the images are derived. It also suggests a taxonomy of likeness, while simultaneously stressing the difference that is expressed by each leaf. It is not unrelated to the typological approach used by Bernd and Hilla Becker. To the Starns the idea of light is inexorably connected to darkness or blackness; leaves and trees themselves carbonise in due course. Over millions of years of geological transformation they become pure carbon as coal. As the Starns put it, "Black is literally the absorption of all visible light. The black of written information, the

"Light is power, knowledge, it is what we want, it is what we need, it is satisfaction, fulfilment, truth and purity. It is history, the future, and spirituality. Light is what we fear and hate. Light is what controls every decision and action we take. Light is thought. Light has gravity. Light is what attracts us. Light implies – necessitates darkness, the shadows created by anything physical".

black ink of the pages of books through thousands of years of transcribed thought and creation."[20] The artists' interest in continuous technical experimentation, and the revival of older photographic techniques, are brought together in their four-colour carbon prints of Buddhist sculpture such as *Ganjin* (a nineteenth-century technique in origin). The visual presentation always suggests dissolution and a pre-aged image or sense of oxidisation. They are also arranged as a grid presentation and are made up of hundreds of distinct but

different photographic contact prints, sometimes achieving a huge scale – as in the 'Gravity of Light' installation, 2004 – of some 22' x 22'. It thus becomes difficult to comprehend fully many of the works of Doug and Mike Starn without actually being physically in a position to experience them. And this is equally true of their various video works which both layer and interfold all their connecting ideas, in a unpredictable form of time-based looped sequencing. Their most recent investigation has been into the hexagonal structures of snowflakes in a series of works called *alleverythingthatisyou* (2007).[21] These large colour photographs question the ephemeral and transformative nature of natural phenomena, since the snow crystals are seemingly melting as they are being photographed. Doug & Mike Starn are currently completing a public commission and project for the New York Metropolitan Transport Authority at the South Ferry Terminal, to be completed in 2008. However, the questions they raise in their work are of pressing concern, questions that are immediately relatable

to many of the environmental issues of the present day.

Jane and Louise Wilson's concerns are more to do with techno-logical history, and in a certain sense the failed attempts of monument as memory. In the two works I wish to consider, *Star City* (2000), and *Free and Anonymous Monument* (2003), the artists continue their quest into space, architecture, and technology, while again revealing how the unfamiliar can become familiar and intimate, and vice-versa. The *Star City* project is based on two locations which they visited in 1999, a cosmonaut training centre near Moscow, and the Cosmodrome at Baikonur, Kazakhstan – home of the original Soviet Space Programme.[22] Like the video installation *Parliament* that preceded it, *Star City* systematically reveals the two sites' hidden narratives. In what is a four-channel video installation with sound, we journey through the locker rooms of the cosmonauts, which seem as strangely familiar as those you might find at a football stadium. Altough the general assumption of space flight is of complex technology, and of a life we can hardly imagine, the photographs of video images give a strange sense of familiarity and human identity. Cosmonaut training suits lie casually stretched out on a shelf, or posed in their storage bays like awkward automatons. There are control

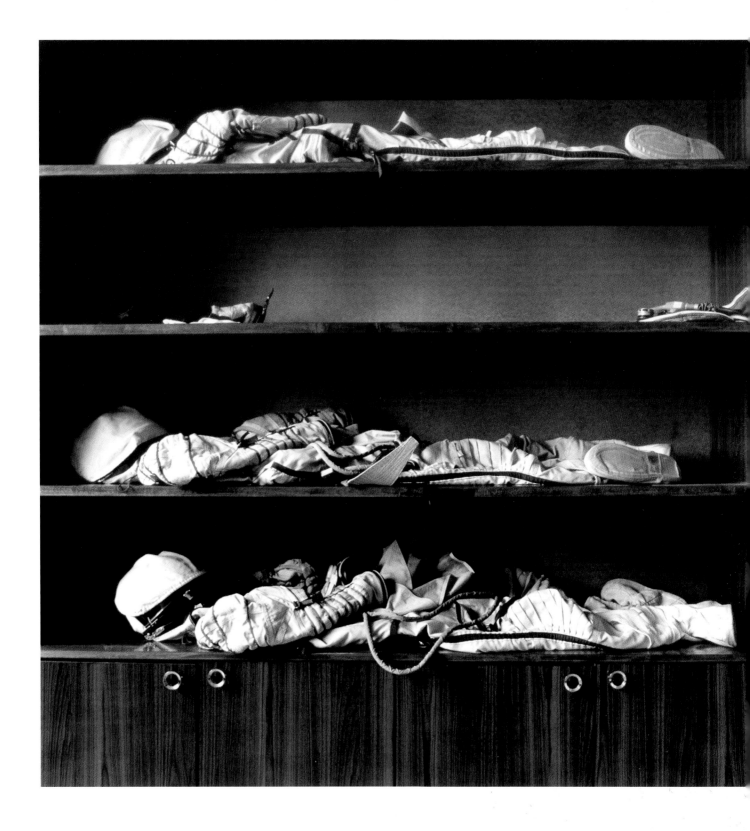

JANE AND LOUISE WILSON

rooms, weightless chambers, experimentation units, one with an optical kinetic drum, and something called a Rising I.S.S., Hydrolaboratorium, an underwater chamber for testing the different extremes of weightlessness. *Star City* served as the

"The play of children acts like a suggestion to the viewer. The scene shifts simultaneously on each screening during all the footage of A Free and Anonymous Monument except for that of the children playing. This sequence cuts randomly in order to break up the rhythm, as well as situating the Pavilion each time".

basis for more extended works related to the run-down and abandoned space programme, such a *Proto Unity, Energy, Blizzard,* (2000) again a four-channel video that dealt with the underground corridors, launch pad, and the transportation of the missile rocket units. *Dream Time* (2001), by contast, dealt with the rockets, press conference room, cloakrooms and pre-launch site of what became abandoned as 'the failure of the last utopia of modernity'.[23] The tone throughout the video and photographic series is of melancholy and nostalgia, ambitious hopes and lost dreams. However, as *Gamma* counterpoints

Stasi City, the photographic series of works *Safe Light* points to the sterilised and post-modern world of nano/bio-technology. For if the laws of physics underpinned the space programme, what has replaced it is the cold detachment of information technology, where direct human involvement is increasingly irrelevant. Indeed, humans rarely appear in the Wilson Sisters' recent works. Photographed at the Atmel microchip plant, the light-controlled environments, division and partitions, metaphorically repeat the microchip structure they research and produce. The bifocal viewpoint also reminds us not only of the sisters' own doubling of nature, but the increasing way powers outside of ourselves organise our lives. The supposed independence of looking and enquiry is increasingly undermined by anonymous social mediators.[24]

The enormous thirteen-screen installation called *A Free and Anonymous Monument* (2003) was, perhaps, the most complex of the sisters' investigations into the archae-ology of modern space up to that time. Commissioned as a project by the Film and Video Umbrella, with the Baltic Centre for Contemporary Art, the work deals with issues of decay and regeneration in Newcastle-on-Tyne and its environs, where the sisters come from.[25] At the centre of the project was Victor Pasmore's concrete Apollo Pavilion, designed for Peterlee New Town in 1958; its current degenerate state serves as little more than a youth hangout or children's playground. Victor Pasmore

(1908-1998) was a famous British artist, teacher and abstract modernist, who became an urban designer and general manager of the Peterlee Development Corporation.[26] What characterises the pavilion is the thoroughgoing commitment to a Le Corbusier-like modernism (a form of architecture for a long period much unloved by the British people), with its sense of utopianism. This modernism was the language frequently used for urban planning in the 1950s and 60s. To many people today the pavilion seems merely part of the lost utopia that formerly beguiled modernism. Its public platform or bridge viewpoint structure was an attempt by Pasmore at creating a visual synthesis of the different art forms, linking the new urban architecture with the garden setting in which it currently sits. The architectural set-up of Jane and Louise Wilson's 700-square-metre installation, shows the pavilion as an abandoned modern space, presenting its characteristics at different height levels, angle relations, and screen-size configurations. What appears is a cinematic kaleidoscope that not only relates to the Pasmore Pavilion, but to other forms of modern urban archaeology made part of the film. Cast alongside are references to older urban spaces and the regenerated industrial spaces of the new clean technologies.[27] The Atmel computer-chip factory (already mentioned) is among them. Newcastle-on-Tyne and the industrial cities that surround it were once great coal and shipbuilding cities. The Wilsons thus include references to contemporary oil-rig construction, not only to relate again the area to the sea, but also to evoke the sense of the North Sea's oil industry that has also played its part indirectly in the urban and social regeneration. The whole area was once home to heavy industry which contributed to the Industrial Revolution and created the base of production capitalism. Its decimation in the late 1970s, and the Thatcher decade of the 1980s, which generated mass unemployment in the Northeast, has now been replaced by new technologies and service industries, in fact the very services industries that the BALTIC Centre of Contemporary Art can be said to emblematise. Institutions of cultural intervention were frequently integrated into the regeneration strategies of post-industrial cities of the North of England througout the 1980s and 1990s. That this is a modern archaeological assessment (showing a continuing interest in the ascent and decline of sites of power), is made clear by the presence of isolated psychology of the modern spaces they film. In these spaces we rarely find the immediate presence of human life. In that sense they offer a feeling of lost memories and nostalgic ruin, a denial of the forever homogenous industrial culture that has passed away.

With Abetz/Drescher, the works have become ever more deliberately appropriative of historical sources and motifs. Thus in a painting like *Yes* (2005), we find the world of the 1960s juxtaposed with Renaissance sources like Piero

© *ABETZ/DRESCHER, **How to Start Your Own Country**, 2006, Acrylic on canvas, 230 × 180 cm, Courtesy Goff+Rosenthal*

di Cosimo's (c. 1462-1521) *A Mythological Subject* (also called *The Death of Procris*). One might think, perhaps, that the aim was to create a jarring effect with a foreground hamburger and smashed guitar, together with a mid-ground satyr reflecting on an allegory of love. The central female figure listening to her walkman is no doubt hearing a love song, a popular equivalent of the sentimental allegory. The fusing of classical myths with recent contemporary popular culture, and the synchronicity in which we experience such images in an age of mass reproduction, also draw heavily upon the role of memory and nostalgia. It presupposes that both sources are co-equivalent and merely relative to each other. However, the compositional structure of *Yes*, presents avenues that lead in two different directions: on the right to the façade of the Altes Museum, and on the left to seemingly personal sensual desires. The metaphors of death and human destruction, spiked skulls, a woman embracing a skeleton, the machine gun, are either placed on the right or point in that direction. This seems to suggest that history is a desolate place of entrapment – emphasised by the bedraggled web in the rear ground. History has become a tawdry place of self-deception. There are the familiar references to Art Nouveau, Symbolism and Surrealism. Magritte's foot-shoe form 'Le Modèle Rouge' (1937) has been replaced by a female high-heeled variation in the immediate foreground. The males in the painting are satyrs or the figure Pan, half-man and half-beast. The image of Pete Townsend remains, but is now reduced to smashing his guitar as depicted on a bongo drum. But like all the earlier paintings, the main concerns are derived from the culture of popular music, and the image fundamentally amounts to a surreal/psychedelic dream that takes place in the head of the short haired Jane Birkin-like listener.

If the work *Yes* represents a continuation of the works that date from 2000-04, its picnic or pastoral contents reflect a change that took place after it was completed. Many of their earlier works were in suggested domestic settings. In works like *Brave New World* (2007), the paintings have taken on a lighter sense of the pastoral.[28] There are still the appropriate references, to William Blake's *Newton*, to Van Gogh's crows (doubling, perhaps, for Hitchcock's *The Birds*), further references to the Narcissus myth, to Adam and Eve, a Medieval-Renaissance walled city in the rear ground, and the now obligatory cheeseburger, Heinz Tomato Ketchup bottle and crushed Coke can in the foreground. However, this half-naked Miranda is more knowing than the innocent of Prospero's magic island. The typewriter, temporality, time passing, are again represented as in the earlier works by candles. The same contents fill *How to Start Your Own Country* (2006), though we might imagine that the central half-clad male in his leopard-skin trousers represents Oliver Drescher himself.

A minimal-pop installation of front-loading washing machines appears in the rear ground right, not unlike earlier accumulations presented by the artist Thomas Rentmeister. However, money (dollars) has crept in and been placed on a guitar, in the foreground left hinting, perhaps, at the corrupt state of what were the former icons of rock music. In both these paintings the eyes of the main figures are closed, suggesting they have withdrawn into their own world. But the most common integration of this current series of paintings is the repetition of birds, black birds like carrion crows. In a paper work *Untitled* (2007) a crow-headed guitarist in a

1960s suit plays his guitar. This figure is derived in part from the same figure that appears repeatedly in a Max Ernst collage book called *Une Semaine de Bonté* (A Week of Goodness, 1934). For Ernst, birds and shoes were a near obsessive subject in his Paris period of the 1920s and 30s. He not only proves a historical source of interest to Abetz /Drescher, but is, perhaps, the most significant artist who links so much of their content to the history of Surrealism. To Abetz/Drescher, history sources are not about the hermeneutics of painting, as might be the case with Muntean/Rosenblum, but an endless source of visual materials (half-remembered, nostalgic or otherwise) that they feel free to rummage through at will.

VII - CONCLUSION: THE END OF SINCERITY

The term 'the end of sincerity' is intended to provoke. It does not suggest that artists today are less sincere, but rather that a singular vision or subjectivity is no longer the only valid criteria of artistic production. In fact it probably never was (at least not in the last forty years or so), since contemporary art today operates in a far more complex space between text and inter-textual discursiveness.

I hope that the series of questions in the opening chapter have, in some measure, been answered by the fourteen double acts analysed and illustrated. A double-act practice requires a strong sense of mutuality, regardless of the precise nature of the relationships from which it is formed – kinship, lovers or couples, and/or firmly founded intellectual and empathic friendships. A collaborative pragmatism is a prerequisite and this in turn influences each and every stage of an art work as it develops. The boundaries between 'who did what' and how it is defined as a result have largely dissolved. The mutuality of intention leads to an art work that is explicitly 'mutual' and becomes just as recognisable as the outcome of a double act as it might be from an individual artist. The sublimation of singular intentions, far from creating boundaries of participation, has the inverse effect. The immediate biographical specificities are displaced, often having a beneficial outcome in that the works retain a stronger sense of autonomy. Hence a double-act strategy removes the immediacy of the desire to create a bio-psychological determinism of what is produced. As regards who is included and excluded in this book, it is quite clear that I could write another volume with a completely different set of double acts. But this only goes to prove the fact that what lies behind this publication is a phenomenon that is growing apace every year, and what started as the exception has now become a flood of post-millennium, double-act art practitioners. I conclude, therefore, with a double act that has the immediacy of the moment and, I consider, reflects current trends and the itinerant nature of contemporary art production in today's global world.[1]

The work of Allora & Calzadilla represents the quiet aesthetics and politics of persistence, an approach that illustrates and reinforces many of the nomadic strategies of the moment. Jennifer Allora is from Philadelphia, in the United States, and Guillermo Calzadilla is from Havana, in Cuba. They met on an art study programme in Florence and have been together since 1995. They live and work together in San Juan, Puerto Rico, and travel extensively. They first came to international prominence in 2003.[2] Regardless of any other works that Allora & Calzadilla have undertaken, their artistic lives have been shaped in the last seven years by the Land Mark project on the island of Vieques, off mainland Puerto Rico – an island appropriated by the United States military as a bomb and missile range in the 1940s. Through a series of videos, sculptures, photo-

ALLORA & CALZADILLA

graphs and sound performances, the artists have engaged and recorded the history of the island; the expropriation of the land (purportedly rented); its subsequent abuse as a firing range (23,000 bombs and missiles alone in 1998); the islanders' resistance; their success in getting the bombing stopped in 2003; their assertion of representation and the ongoing discussions and conflict with the US government. As Allora & Calzadilla put it: "Our investigation into land marking has taken the form of a body of work that concentrates on a kind of case study ..."[3]

Their studies have also marked the scope of the American Atlantic Fleet naval firing ranges and their proximity to Puerto Rico. In the work called *Land Mark* (*Foot Prints*) (2001/02) apart from its pun and indexical status as footprints in the sand, the artists connected themselves to the protest movement by making a series of soles that could be attached to the protesters' shoes or trainers.[4] Some took the form of texts expressing direct objections to what was taking place, while others were imaginary projections and ideas as to the

○ ALLORA & CALZADILLA, *Returning a Sound*, 2004, DVD, 5 min 42 sec, Courtesy of the artists and Lisson Gallery, London

future use of the island. Leaving traces in the sand created a form of social obstruction, since firing could not go ahead if there were any civilians in the area. The positions of the footprints in the sand are also to be seen as mirroring on-going ideological positions, as one print superimposes itself and obliterates another. In the video *Returning the Sound* (2004), another form of aural social protest followed, when a local Vieques islander removed the silencer of his motorcycle and replaced it with a trumpet. As he rode his motorcycle island-wide, the trumpet magnified the sound – a powerful form of non-violent protest. In *Under Discussion* (2005), an islander used an upturned table and attached an outboard engine to it and negotiated it on a sort of ecological sea journey around the restricted parts of the island. The work not only pointed back to the earlier conflict between the island's fishermen and the United States Navy in the 1970s but, at the same time, emphasised the table as a familiar locus of discussion and

negotiation, albeit one that the non-negotiating stance of the US military had turned upside down. The Vieques islanders had resisted the US military's early attempt to have the island completely depopulated and were even eventually successful in getting the bombing stopped. The United States Ministry of the Interior has since turned the area into a 'wildlife reserve', although this is no more than a cover-up for the sixty years of missile decontamination; to date, little has been done concerning land restitution.

 The theme of bunkers and military also served the same purpose in Allora & Calzadilla's recent work *Clamor* (2006) – a large sculpture and sound performance piece, shown in Miami, London and Zurich.[5] As cursory as my evaluation must be, it is worth stressing that some form of social intervention and communal adaptation are always present in their work. Whether it is roasting a pig, with a spit attached to the rear axle of a car, as in *Sweat Glands, Sweat Lands*

(2006), their work always offers an alternative position and narratives that are distinct from our current addictions to the determinism of globalisation. They similarly parody the fake liberal attitudes and tolerance that authorities claim to have for art. In their intervention in 2002 on Lima's Plaza de Armas – the administrative centre of Peru's capital – the artists set up twenty huge, chalk cylinders. While initially passable as proto-minimalist objects, one had been drawn along the ground to leave a long chalk line. Within an hour the chalk cylinders had been broken up and used to leave messages on the ground, love notes, names, patterns, etc. Public employees on strike turned up and, shortly afterwards, the square became a giant chalk board of public grievances and ideas. It was just a short time before the riot police dispersed the crowd and the municipal cleaners were summoned. So much for public space and public expression, one might think. Yet where are the boundaries between art and life, between art and social manifestation? It is certainly true of Allora & Calzadilla that they move close to the 'end-of-art' debate, but the aesthetical/ethical boundary has always been opaque in terms of the practice of socially-committed art. The question remains: what does their work actually portend? Why does it feel so 'of the moment'? Surely it is the fact that their double-act collaborative approach mirrors the social realities with which they are involved.

Two people working together is, after all, a natural social phenomenon. It displaces – or at least mitigates – the sovereignty of the singular self, leaving one open to interact and achieve shared results. It also, of course, requires a sense of shared responsibility for what is produced. Allora & Calzadilla have frequently involved themselves and identified with the social attitudes and injustices that they expose in their art work. Their status as a couple thus extends from a double act to an increased sense of a commitment and doubled-action.[6]

○ (left, detail right) ALLORA & CALZADILLA, **Clamor**, 2006, The Moore Space, Installation view, Mixed media installation, Dimensions variable, Photo: Dawn Blackman, Courtesy of the artists and Lisson Gallery, London

○ ALLORA & CALZADILLA, *Land Mark (Foot Prints)*,
2001-2002, Series of 24 colour photographs, 50 x 60 cm,
Courtesy of the artist and Lisson Gallery, London

ABETZ/DRESCHER

(Live and work in Berlin)

Maike Abetz: Born 1970, Düsseldorf. 1991-94, Kunstakademie Düsseldorf, Professor Alphonse Hüppi. 1995-97, Hochschule der Künste, Berlin, Professor Katharina Sieverding

Oliver Drescher: Born 1969, Essen. 1990-92, Assistant Stage Director, Theater an der Ruhr, Mühlheim. 1990-94. Kunstakademie Düsseldorf, Professor Alfonso Hüppi. 1995-97, Hochschule der Künste, Berlin, Professor Katharina Sieverding

TWO-PERSON EXHIBITIONS: 2007, Goff + Rosenthal, Berlin; 2006, FRED, London; 2005, Goff+ Rosenthal, New York; 2004, *Paint it Black*, Galerie Volker Diehl, Berlin; 2000, *Electric Ladyland*, Ars Futura, Zurich; 1999, *Statements*, Art Basel, *BOING BUM TSCHAK*, Marc Fox, Los Angeles; 1997-98 *UP AGAINST IT*, Contemporary Fine Art, Berlin; 1997, *Fanzine*, Pavillon der Volksbühne, 'Jugend Musik Festspiele, Berlin.

ALLORA & CALZADILLA

(Live and work in San Juan, Puerto Rico)

Jennifer Allora: Born, Philadelphia, 1974. 2001-03 Massachusetts Institute of Technology (MS), Cambridge, MA. 1998-1999 Whitney Independent Study Program, New York. 1996 University of Richmond (BA), Richmond, VA.

Calzadilla Guillermo: Born 1971, Havana, Cuba. 1999-2001 Bard College (MFA). 1998 Skowhegan School of Painting and Sculpture. 1996 Escuela de Artes Plásticas (BFA), San Juan, PR

Awards & Grants: 2006 Nam June Paik Award Finalist, Hugo Boss Prize Finalist. 2004 Gwangju Biennial Prize. 2003 Penny McCall Foundation Grant. 2002 Joan Mitchell Foundation Grant. 2000-2001 Cintas Fellowship.

TWO-PERSON EXHIBITIONS (selected): 2007 *Allora & Calzadilla*, Center for Contemporary Art, Kitakyushu, *Allora & Calzadilla*, Whitechapel Gallery, London, *Allora & Calzadilla - Wake Up*, Renaissance Society, Chicago, *Allora & Calzadilla*, Serpentine Gallery, London, *Allora & Calzadilla*, Kunsthalle Zurich, Zurich, *Allora & Calzadilla*, San Francisco Arts Institute, San Francisco, *Allora & Calzadilla*, Lisson Gallery, London; 2006, *Clamor*, The Moore Space, Miami, *Concentrations 50: Allora & Calzadilla*, Dallas Museum of Art, Dallas, *Combine Platter*, Screening event, LA MOCA, Los Angeles, *Land Mark*, Palais de Tokyo, Paris, *(En)Tropics*, Galerie Chantal Crousel, Paris, *Allora & Calzadilla*, S.M.A.K. Stedelijk Museum voor Actuele Kunst, Ghent, *Sweat Lands*, Galerie Chantal Crousel, *Combine Platter*, Screening event, LA MOCA, (June 24, 2006); 2005, *Download*, Art Positions:, ArtBasel Miami Beach; 2004, *Unstable Atmospheres*. Lisson Gallery, London, *Ciclonismo*. Galerie Chantal Crousel, Paris, *Chalk*. 7ᵗʰ Annual ICA/Vita Brevis Project, Institute of Contemporary Art (ICA), Boston, *Radio Revolt: One Person, One Watt*. Artist in Residence Project, Walker Art Center, Minneapolis; 2003 *Land Mark*. Escuela de Artes Plásticas, San Juan, PR, *Puerto Rican Light*. Americas Society, New York; 2002, *Allora & Calzadilla*. Institute of Visual Arts (INOVA) at the University of Wisconsin, Milwaukee; 2001, *Allora & Calzadilla*. Museo de Arte de Puerto Rico, Santurce, PR; 2000, *Other Worlds*. Project Rooms, ARCO, Madrid; 1997, *Charcoal Dance Floor*. Luigi Marrozzini Gallery, San Juan, PR

BLUE NOSES

(Live and work in Moscow, Novisbirsk, and Ekaterinburg)

Viacheslav Mizin: Born Novosibirsk, 1962. 1980-86 Institute of Architecture, Novosbirsk.

Alexander Shabunov: Born in Sverdlovsk (now Ekaterinburg), 1965. 1980-86, School of Fine Arts Sverdlovsk.

Awards and Prizes: 2006, 1ˢᵗ NCCA Innovation Prize 'Visual Art', and Soratnik Award. 1998 (Alexander Shabunov) Soros Foundation Grant (for denture treatment as artistic action).

TWO-PERSON EXHIBITIONS (selected): 2006, *Blue Noses*, State Tretyakov Gallery/Marat Guelman, Moscow, *Kitchen Suprematism*, 6ᵗʰ Moscow Photo Biennial, House of Journalists, Moscow, *Casual Concurrences*, M.Guelman Gallery, Moscow, *Blue Noses*, Kunstverein Rosenheim, Munich, *Blue Noses*, Galeria Brito Cimino, Sao Paulo; 2005, *Blue Noses*, Ethan Cohen Fine Art, New York, *Blue Noses*, Galerie Volker Diehl, Berlin, *Blue Noses*, KnallGalerieWien, Vienna, *Blue Noses*, Galerie IN SITU, Paris, *Blue Noses*, B & D Studio Contemporanea, Milan, *The Vogue of Labor*, M. Guelman Gallery, Moscow, *Blue Noses*, Kunsthallen Brandts, Klaedefabrik, Odense; 2004, *Hit-or-Miss Art (How to Build Up Works of Art Just in the Kitchen)*, M. Guelman Gallery, Moscow, *The Blue Noses*, The Display Gallery, Prague; 2003, *Do I Look Like a Loser?*, State Tretyakov Gallery, Moscow, *Two Against the Russian Mafia*, M. Guelman Gallery, Moscow and Kiev, and State Russian Museum, St Petersburg, *From Siberia With Love*, Arsenal, Nizhnyi Novgorod, *Absolut Blue Noses*, Zoological Museum, Moscow; 2002, *Two Against the Russian Mafia*, Kirov Museum, St Petersburg, *The Contemporary Siber Artists*, M. Guelman Gallery, Moscow; 2001, *Out-of-Town Excursions-2*, L-Gallery, Moscow; 1999, *The New Holy Fools, or the Pathology of Performance*, Zverev Center of Contemporary Art, Moscow.

JAKE & DINOS CHAPMAN

(Live and work in London)

Dinos Chapman: Born London, 1962. 1981, Ravensbourne College of Art. 1988-90, Royal College of Art London.

Jake Chapman: Born, Cheltenham, 1966. 1985-88, North London Polytechnic. 1988-90, Royal College of Art.

Award and Prizes: 2003, Nominated for the Turner Prize, London

TWO-PERSON EXHIBITIONS (selected): 2007, *Two-Legs Bad, Four-Legs Good*, Paradise Row, London, *When Humans Walked the Earth*, Tate Britain, London; 2006/2007, *Jake & Dinos Chapman: Bad Art for Bad People*, Tate Liverpool, Liverpool; 2005, *Like a dog returns to its vomit*, White Cube, London; 2004, *The New Improved Andrex Works*, 20.21 Galerie Edition Kunsthandel, Essen, *Insult to Injury*, Kunstsammlungen der VesteCoburg, *The Marriage of Reason and Squalor*, CAC Málage; Dunkers Kulturhaus, Helsingborg; 2003, *Jake & Dinos Chapman*, The Saatchi Gallery, London, *The Rape of Creativity*, Museum of Modern Art, Oxford; 2002, *Works From the Chapman Family Collection*, White Cube, London, *Jake & Dinos: Enjoy More*, Groningen Museum, Groningan, and Museum Kunst Palast, Düsseldorf, *Jackie & Denise Chapwoman*, Modern Art, London; 2000, *Jake & Dinos: GCSE Art Exam*, Ginza Art Space, Tokyo, *Jake & Dinos Chapman*, Kunst-Werke, Berlin; 1999, *Jake & Dinos Chapman*, Fig. 1, London, *Disasters of War*, White Cube, London, *Jake & Dinos Chapman*, Gió Marconi, Milan; 1998, *Jake & Dinos Chapman*, Galerie Daniel Templon, Paris; 1997, *Six Feet Under*, (Holy Libel) Gagosian Gallery, New York; 1996, *Beyond Nirvana – Too Much is Never Enough*, P-House, Tokyo, *Zero Principle*, Gió Marconi, Milan, *Chapmanworld*, Institute of Contemporary Art, London, and Grazer Kunstverein, Graz, and Kunst-Werke, Berlin; 1995, *Jake & Dinos Chapamn*, Gavin Brown's Enterprise, New York, *Zygotic acceleration, biogenetic, de-sublimated model (enlarged x 1000)*, Victoria Miro Gallery, London, *Bring Me the Head of Franco Toselli*, Riding House Editions, London, *Jake & Dinos Chapman*, Andréhn-Schiptjenko Gallery, Stockholm; 1994, *Great Deeds Against the Dead*, Victoria Miro Gallery, London, *Mummy & Daddy*, Galleria Franco Toselli, Milan; 1993, *The Disasters of War*, Victoria Miro Gallery, London; 1992, *We Are Artists*, Hales Gallery, London, and Blue Coat Gallery, Liverpool.

CLEGG & GUTTMANN

(Live and work in New York, Berlin and Vienna)

Michael Clegg: Born, Dublin, 1957. Lives in Berlin.
Martin Guttmann: Born, Jerusalem, 1957. Lives in Vienna.
They began their collaboration in 1980.

TWO-PERSON EXHIBITIONS (selected): 2007, Revolution of the Poetic Language (Establishment of Correlation) – A Cognitive Exercise for a Group of Four, Performance by Clegg & Guttmann, Georg Kargl Fine Arts, Vienna; 2006 Social Sculptures, Community Portraits and Spontaneous Operas 1990 – 2006, Cornerhouse, Manchester, Mach vs. Boltzmann II, Kunstverein Braunschweig e.V - Haus Salve Hospes, Braunschweig, Mach vs. Boltzmann, Secession, Vienna; 2005 Social Sculptures, Community Portraits and Spontaneous Operas 1990–2005, Georg Kargl Fine Arts, Vienna; 2004 A Monument for Historical Change, permanently installed social sculpture, Rosa Luxemburg Platz e.V., Berlin, Sha'at'nez oder die verschobene Bibliothek, Sigmund-Freud-Museum, Vienna;

2003, Decomposition/Reconstitution Berlin – 1918: Anti Capitalism, Avant-Garde, Art, Atonal Music, Galerie Christian Nagel, Berlin; 2002 Negations of Strict Order: Anarchism, Cubism and Syncopated Music, American Fine Arts, New York; 2001 Minister und Senatoren – Politische Physiognomische Fragmente, Galerie Christian Nagel, Cologne, Knowledge Sculpture–False Perspective, Galleria Lia Rumma, Milan and the Valencia Biennial; 2000 The Historical Soccer Stadium, Proposal for a permanent public sculpture commissioned by the Deutsche Bank, Frankfurt/Main; 1999 Die sieben Brücken von Königsberg, a temporary public project installation in Duisburg; 1997 1897–The first Zionist Congress in Basel, Kunsthalle Basel, The Speaker's Platform of Grieskirchen, Grieskirchen; 1996 The Sick Soul III, Galerie Christian Nagel, Cologne, The Sick Soul II, American Fine Arts, New York, The Sick Soul–Morbid Fascination and Behavioral Research in Micro Sociology, Reality TV and Avant-Garde Art, Grazer Kunstverein, Graz; 1995 Breaking Down the Boundaries between Art and Life, The New School for Social Research, New York; 1993 The Firminy Music Library, a temporary public project, Unité, Firminy; 1991 The Open Public Library, Graz, Grazer Kunstverein, Graz, Nordanstad-Skarstedt Galleri, Stockholm; 1988 Galérie Hussenot, Paris; 1987 Jay Gorney Modern Art, New York, Galerie Achim Kubinski, Stuttgart; 1984 Galerie Tanja Grunert, Cologne; 1983 Allegories of Stock Exchange, Olsen Gallery, New York; 1982 Michelle Lachowsky, Antwerpen; 1981 Group Portraits of Executives, Annina Nosei Gallery, New York.

ELMGREEN & DRAGSET
(Live and work in Berlin)
Michael Elmgreen: Born, Copenhagen, 1961.
Ingar Dragset: Born, Trondheim, Norway, 1969.
They met in 1995 and their collaboration began soon thereafter.

TWO-PERSON EXHIBITIONS (selected): 2007, *Drama Queens*, Münster Sculpture Project, *This Is The First Day Of My Life*, Malmö Kunsthall, Malmo; 2006, *Disgrace*, Galerie Emmanuel Perrotin, Miami, *Would You Like Your Eggs A Little Different This Morning?*, Galleria Massimo De Carlo, Milan, *The Incidental Self*, Taka Ishii Gallery, Tokyo, *The Welfare Show*, Serpentine Gallery, London, and The Power Plant, Toronto; 2005, *Prada Marfa*, Art Production Fund/ Ballroom Marfa, Marfa, Texas, *The Brightness of Shady Lives*, Galeria Helga de Alvear, Madrid, *End Station*, Bohen Foundation, New York, *The Welfare Show*, Bergen Kunsthall, Bergen, and Bawag Foundation, Vienna; Wrong Gallery, New York, *Linienstrasse 160, Neue Mitte*, Galerie Klosterfelde, Berlin; 2004 *Intervention 37*, Sprengel Museum, Hanover, *Just a Single Wrong Move*, Tate Modern, London, *Moving Energies # 04. Aspekte der Sammlung Olbricht*, Museum Folkwang, Essen; 2003, *Short Cut*, Fondazione Trussardi, Milan, *Spaced Out*, Portikus, Frankfurt/M; *Paris Diaries*, Galerie Emmanuel Perrotin, Paris, *Phone Home*, Tanya Bonakdar Gallery, New York,

Constructed Catastrophes, CCA, Kitakyushu, *Please, Keep Silent !*, Galleri Nicolai Wallner, Copenhagen; 2002 *How are you today?*, Galleria Massimo de Carlo, Milan, *Powerless Structures, Fig. 229*, Gallerie Helga Aldevar, Madrid, *Museum*, Sala Montcada/Fondaciò La Caixa, Barcelona, *Suspended Space*, Taka Ishii Gallery, Tokyo; 2001, *Taking Place*, Kunsthalle Zürich, Zurich, *Opening Soon*, Gallery Tanya Bonakdar, New York, *A Room Defined by its Accessibility*, Statens Museum for Kunst, Copenhagen, Galleri Nicolai Wallner, Copenhagen, "Linienstr. 160", Klosterfelde, Berlin, *Powerless Structures, fig. 111*, Portikus, Frankfurt/M; 2000, *Zwischen anderen Ereignissen*, Galerie für Zeitgenössische Kunst, Leipzig, Roslyn Oxley9 Gallery, Sydney; 1999, Galleri Nicolai Wallner, Copenhagen, "Powerless Structures, Fig. 57-60", The Project, New York; 1998, *Dug Down Gallery/ Powerless Structures, Fig. 45*, Galleri I8 & Reykjavik Art Museum, Reykjavik; 1997, *Powerless Structures*, Gallery Campbells Occasionally, Copenhagen

EVA & ADELE
(Live and work in Berlin)
The biography of Eva & Adele constitutes itself as 'Coming out of the future'; Eva, height 176cm, Bust 101cm, Waist, 81cm, Hips 96cm. Adele, height 161cm, Bust 86cm, Waist, 68cm, Hips 96cm. Eva is Austrian and trained as a painter. Adele is German, and trained as a sculptor.

TWO-PERSON EXHIBITIONS (selected): 2008, *Tell it Like a Polaroid Picture*, Museum der Moderne Salzburg, Rupertinum, Salzburg; 2007, *Eva &Adele Dauergeil*, White Trash Contemporary, Hamburg, *Angels, Devils & Sex Monsters*, Claire Oliver, New York, *Eva & Adele*, Erik van Lieshout, Galerie Ron Mandos, Amsterdam; 2006, *NEON*, Galerie Kaj Forsblom, Helsinki, *Goldenes Manifest*, Galerie Brigitte March, Stuttgart, *Lasso*, Galerie Jérôme de Noirmont, Paris; 2005, *Death of Performance*, Claire Oliver, New York, *House of Futuring*, Sprengel Museum, Hanover; 2004, *ACT*, Galerie Brigitte March, Stuttgart, *Get on My Wings*, Les-Abattoirs, Musée, Centre d'art moderne et contemporaine, Toulouse, *FRU FRU*, Galerie Asbaek, Copenhagen, *Geschlossene Gesellschaft*, Galerie Michael Schultz, Berlin, The Goya Installation, Villa Aurora, Los Angeles; 2003, *Shy*, Galerie Jérôme de Noirmont, Paris, *Painting Queer*, Centro Cultural Andratx, Mallorca, *Sculpture in the Park*, Villa XPIRA, Zweibrücken, *Futuring Company*, Galerie Kaj Forsblom, Helsinki, *Watermusic*, Video Sculpture - Steirischer Herbts, Graz, *LOGO*, Galerie & Edition Artelier, Graz, *Day by Day Painting*, The Nordic Watercolour Museum, Skähamn; 2002, *Double Self-Portraits*, Galieri Stefan Andersson, Umea; 2001, *LOGO*, Neuer Sächsischer Kunstverein, Dresden; *Get on My Wings*, Paris Photo, Carrousel du Louvre, Paris, *Encore*, Galerie de l'E.E.B.A.N., Nantes; 2000, *LOGO*, Moderne Galerie Saarland Museum, Saarbrücken, *Close-Up & Blow-Up*, Galerie Jérôme de Noirmont, Paris, and Overbeck

Gesellschaft, Lübeck; 1999, *Wherever we are is Museum*, Neuer Berliner Kunstverein, Berlin; 1998, Generous Miracles Gallery (One-night Exibition), New York; *CUM*, Sprengel Museum, Hanover.

TERESA HUBBARD/ ALEXANDER BIRCHLER
(Live and work in Austin, Texas)
Teresa Hubbard: Born Dublin, Ireland, 1965. 1985-88, B.F.A., University of Texas, Austin. 1988, Yale School of Art, MFA Sculpture Program. 1987, Skowhegan School of Painting and Sculpture, Skowhegan. 1990-92, M.F.A., Nova Scotia College of Art and Design, Halifax. Since 2000, Professor, Department of Art & Art History, University of Texas, at Austin. 2004 – present, Core Faculty, Milton Avery Graduate School of the Arts, Bard College.
Alexander Birchler: Born Baden, Switzerland, 1962. 1985, University of Art and Design, Helsinki. 1983-87, Schule für Gestaltung, Basel. 1990-92, M.F.A., Nova Scotia College of Art and Design, Halifax. 1993-94, lecturer, University of Zürich. 2004 – present, Core Faculty, Milton Avery Graduate School of the Arts, Bard College.

Awards and Prizes (selected): 2006, Landis + Gyr Stiftung Foundation, Zug (residency grant in London); 2003, Kunstkredit Basel-Stadt Commission Award, Basel; 1999 National Prize of Fine Arts, Swiss Federal Office of Culture; 1998, Swiss Federal office of Culture, Residency Fellowship, Künstlerhaus Bethanien, Berlin, Kunstkredit Basel-Stadt, Basel (stipend); 1997, National Prize of Fine Arts, Swiss Federal Office of Culture, Residency Fellowship, Residency Fellowship Akademie Schloss Solitude, Stuttgart; 1996, Manor Art prize, Museum of Contemporary Art, Basel; Alexander Clavel Foundation Prize, Riehen, Yukon Arts Centre Residency Grant, Whitehorse, Basler Kunstverein Travel Prize, Kunsthalle Basel; 1994, Kunstkredit Basel. Stadt, Artist Stipend; 1990-92, Fellowship Nova Scotia College of Art and Design; 1989, Fellowship, Banff Centre for the Arts, Banff.

TWO-PERSON EXHIBITIONS (selected): 2008, *Teresa Hubbard/Alexander Birchler*, The Modern Museum, Fort Worth, Texas; 2006, *Teresa Hubbard/Alexander Birchler*, Galerie Barbara Thumm, Berlin, *House with Pool*, Miami Art Museum; 2005, *Teresa Hubbard/Alexander Birchler*, Museum Sammlung Goetz, München, *Little Pictures at Mrs. Owens House*, Centro Galego de Arte Contemporánea, Santiago de Compostela, *Troop*, Bob von Orsouw, Zürich, *Editing the Dark*, Kemper Museum of Contemporary Art, Kansas City, *Single Wide*, Kaiser Wilhelm Museum, Krefeld, *New Spaces*, Pinakothek der Moderne, München, *Single Wide*, Herzliya Museum of Contemporary Art, Israel; 2004, *Single Wide*, Whitmey Museum of American Art at Altria, USA, *House with Pool*, Tanya Bonakdar Gallery, New York, *House with Pool*, Museum für Gegenwartskunst, Basel; 2003, *Eight*, Centro Galego de Arte Contemporánea,

Santiago de Compostela, *Teresa Hubbard/Alexander Birchler*, Vera Munro Gallery, Hamburg, *County Line Road*, Galerie Barbara Thumm, Berlin; 2002, Art Pace Foundation for Contemporary Art, San Antonio, Kunsthalle zu Kiel, Kiel, Kunstmuseum St Gallen, Tanya Bonakdar Gallery, New York; 2001, Museum Haus Lange and Esters, Krefeld, Huis Marseille, Foundation for Photography, Amsterdam, Gallery Bob von Orsouw, Zürich; 2000, *Arsenal*, Bonakdar-Jancou Gallery, New York, 'Werk Raum' National Gallery in Hamburger Bahnhof, Museum of Contemporary Art (with Sophie Calle and Remy Markowitsch), Berlin; 1999, *Motion Pictures*, Galerie Barbara Thumm, Berlin, National Gallery of Modern and Contemporary Art, Prague, *Gregor's Room*, Gallery Bob von Orsouw, Zürich; 1998, Akademie Schloss Solitude, *Stripping*, Künstlerhaus Bethanien, Berlin; 1997, *Slow Place*, Museum für Gegenwartskunst, Basel, Gallery Bob von Orsouw, Zürich.

MUNTEAN/ROSENBLUM
(Live and work in Vienna and London)
Markus Muntean: Born in Graz, 1962
Adi Rosenblum: Born in Haifa, 1962.
They began their collaboration in 1992.

TWO-PERSON EXHIBITIONS (selected): 2008, Sammlung Essl Privatstiftung, Klosterneuberg, Vienna; 2007, Team Gallery, New York, Arario Gallery, Seoul, Galerie für Zeitgenössische Kunst, Leipzig, Museu CHIADO, Lisbon; 2006, *Make Death Listen*, MUSAC, Museo DE Arte Contemporánea, Léon, Centre d'Art Santa Mònica, CASM, Barcelona, Arndt & Partner, Zürich, MAK, Vienna, *We Live in Twilight*, Kunsthalle Budapest; 2005, *Disco*, Maureen Paley, London, Jack Hanley, Los Angeles, *Far Away From Why*, Galrie Arndt & Partner, Berlin, Viennale, Gartenbau, Vienna; 2004, *Being in and out of love too many times makes it harder to love*, Australian Centre for Contemporary Art, Melbourne, *How soon is now*, Georg Kargl, Vienna, *It never facts that tell*, Tate Britain (and Gloucester Road project), London; 2003, Maureen Paley, Interim Art, London, Galleria Franco Noero, Turin, *There is a silence to fill*, Salzberger Kunstverein, Salzburg, *Not to be. Not to be at all*, Porsche Hof, Salzburg, Art Unlimited, Basel; 2002, *To Die For*, De Appel, Amsterdam, *Billboards*, Kunsthaus Bregenz, Sommer Contemporary, Tel Aviv; 2001, *Lost in the savage wilderness if civil life*, Georg Kargl, Vienna, Maureen Paley, Interim Art, London, Art & Concept, Paris, Chicoprojectroom, Los Angeles; 2000, Susanne Kulli, St Gallen, Statements, Art Basel, Steirischer Herbst, Minoritengalerie, Graz, *Where else*, SECESSION, Vienna, *I always tell you the truth unless of course I am lying to you*, Kunsthaus Glarus, Minoritangalerie, Jack Tilton, New York, Magazin 4, Bregenz; 1999, Galleria Franco Noero, Turin, Georg Kargl, Vienna, Chicago Project Room, Chicago, MWMWM, Brooklyn, New York; 1998, *Lonely Facts*, Kunsthalle, Luckenwalde, *Slaymobil*, City Racing, London, *Slaymobil*, Galerie Shift, Berlin, *People Forever*,

Kunstverein, Ludwigsburg; 1996, *Body Shop*, Galerie Kidmat Eden, Tel Aviv.

TIM NOBLE & SUE WEBSTER
(Live and work in London)
Tim Noble: Born Stroud, Gloucestershire, 1966. 1985-86 Foundation College, Cheltenham Art College, 1986-89, Nottingham Trent University. 1989-92, Dean Clough, Halifax. 1992-94, Royal College of Art, London.
Sue Webster. Born Leicester, 1967. 1986-89 Nottingham Trent University. 1989-92, Dean Clough, Halifax. 1992-94, Audited (unofficially) Royal College of Art, London

TWO-PERSON EXHIBITIONS (selected): 2007, Serving Suggestion, The Wrong Gallery, Tate Modern, London, UK.; 2006, Polymorphous Perverse, The Freud Museum, London, UK.; 2005, *The Glory Hole*, Bortolami Dayan, New York, *The Joy of Sex*, Kukje Gallery, Seoul, *The New Barbarians*, CAC Málaga, Centro de Arte Contemporanea, Málaga; 2004, *Modern Art is Dead*, Modern Art, London, *Tim Noble & Sue Webster*, Museum of Fine Arts, Boston; 2003, *Tim Noble & Sue Webster*, P.S.1 Contemporary Art Center, New York; 2002, *Black Magic*, MW Projects, London, *Ghastly Arrangements*, Milton Keynes Gallery, Milton Keynes, *Real Life is Rubbish*, Statements at Art Basel; 2001, *Instant Gratification*, Gagosian Gallery, Beverley Hills, California; 2000, *British Wildlife*, Modern Art, London, *I YOU*, Deitch Projects, New York, *Masters of the Universe*, Deste Foundation, Athens; 1999, *The New Barbarians*, Chisenhale Gallery, London, *The New Barbarians*, Spacex Gallery, Exeter, UK; 1998, *Vogue Us*, Habitat, Kings Road, London, *WOW*, Modern Art, London; 1997, *Home Chance*, Rivington Street, London; 1996, *British Rubbish*, Independent Art Space, London.

PIERRE et GILLES
(Live and work in Paris)
Pierre Commoy: Born La Roche-sur-Yon, 1950. Studied Photography in Geneva (interrupted by military services)
Gilles Blanchard: Born, la Havre, 1953. Early 1970s, studied at the Ecole des Beaux-Arts, la Havre
Their collaboration began after meeting at a Kenzo boutique opening, in Autum 1976

TWO-PERSON EXHIBITIONS (selected): 2007, *Pierre et Gilles*, Galerie Andrea Caratsch, Zurich, *Correspondanves Musée D'Orsay/ Art Contemporain*, Musée D'Orsay, Paris, *Pierre et Gilles*, (touring exhibition) Moscow House of Photography, The Manege, Moscow, and Marble Palace, Russian Museum, St Petersburg, *Pierre et Gilles: Double-Je 1976 – 2007*, Galerie Nationale du Jeu de Paume, Paris; 2006/07, *Pierre et Gilles – Un monde parfait*, Galerie Jérôme de Noirmont, Paris; 2005 *Pierre et Gilles, Retrospective*, Museum of Contemporary Art, Shanghai; 2004, *Pierre et Gilles - Beautiful Dragon*, Seoul Museum

of Arts, Seoul, and Singapore Art Museum, Singapore (touring exhibition), *Pierre et Gilles - Le Grand Amour*, Galerie Jérôme de Noirmont, Paris; 2003, *Pierre et Gilles*, Botanique, Brussels, *Pierre et Gilles*, Robert Miller Gallery, New York; 2002, *Pierre et Gilles - Arrache mon coeur*, KunstHaus Wien, Vienna, and Galerie Jérôme de Noirmont, Paris, (touring exhibition); 2001, *Pierre et Gilles*, New Museum of Contemporary Art, New York, The Yerba Buena Center for The Arts, San Francisco (touring exhibition); *Pierre et Gilles*, Galerie Jérôme de Noirmont, Paris (2001); 1999-2000, *Pierre et Gilles*, Turun Taidemuseo, Turku; 1998-99, *Pierre et Gilles*, Museo de Bellas Artes de València, Valencia, *Pierre et Gilles, Mémoire de Voyage*, Shiseido Gallery Ginza Art Space, Tokyo, exhibition organized for the Year of France in Japan, *Pierre et Gilles - Douce Violence*, Galerie Jérôme de Noirmont, Paris; 1997, *Die Welt von Pierre et Gilles*, Fotomuseum, Munich, *Pierre & Gilles - Grit and Glitter*, Gallery of Modern Art, Glasgow; 1996-97, *Les Plaisirs de la Forêt - Jolis Voyous*, Galerie Max Hetzler, Berlin, *Pierre et Gilles, A.C.C.* Galerie, Weimar, *Pierre et Gilles, Vingt ans d'Amour (1976 - 1996)*, Maison Européenne de la Photographie, Paris; 1995 *Pierre et Gilles*, Roslyn Oxley Gallery, Sydney, and Australian Center for Contemporary Art, Melbourne, and Wellington City Art Gallery, Wellington, and Auckland City Art Gallery, Auckland, (touring exhibition), *Annual'95*, Shiseido Gallery Ginza Art Space, Tokyo; 1994 *Pierre et Gilles*, Chapelle du Méjan, Rencontres Internationales de la Photographie, Arles, *Pierre et Gilles*, Le Case d'Arte, Milan; 1993 *Absolut Peep-show*, Raab Gallery, London, Galerie du Salon, D.R.A.C. des Pays de la Loire, Nantes; *Pierre et Gilles*, Galerie Samia Saouma, Paris, March; *Pierre et Gilles*, Galleria Il Ponte, Rome; 1992, *Pierre et Gilles*, Raab Galerie, Berlin, *Pierre et Gilles*, Russisches Museum, Diaghilev Center of Modern Art, Saint-Petersburg, *Pierre et Gilles*, Raab Galerie, London; 1990-01, *Pierre et Gilles*, Hirschl & Adler Modern, New York; 1990, *Pierre et Gilles*, Parco Par II de Shibuya, Tokyo, and Osaka (touring exhibition); 1988, *Les Saints*, Galerie Samia Saouma, Paris; 1986, *Pierre et Gilles - Naufrage*, Galerie des Arènes, Nîmes, *Naufrage*, Galerie Samia Saouma, Paris; 1985, *Pierre et Gilles*, The Art Ginza Space, Tokyo, *Pierre et Gilles*, Galerie Saluces Art Contemporain, Avignon; 1983, *Pierre et Gilles*, Galerie Texbraun, Paris.

DOUG & MIKE STARN
(Live and Work, Brooklyn, New York)
Doug & Mike Starn: Born, New Jersey, 1961.
1982-85, School of the Museum of Fine Art, Boston.

Awards and Public Commissions: 2005/08, Metropolitan Transportation Authority (South Ferry Terminal) Mulri-media Installation. 2000, The Medal Award, School Museum of Fine Arts, Boston; 1995, National Endowment for the Arts Grant. 1992, International Center for Photography's Infinity Award for Fine Art Photography.

1986, Massachusetts Council of the Arts, Fellowship in Photography. 1987, National Endowment for the Arts Grant. 1985, Fifth Year Travelling Schlorship.

TWO-PERSON EXHIBITIONS (selected): 2007, *Doug and Mike Starn: Black Pulse 2000-2007*, The Print Center, Philadelphia, *alleverythingthatisyou*, Wetterling Gallery, Stockholm, *New Works* (working title), Weinstein Gallery, Minneapolis; 2006, *Absorption + Transmission*, Stedelijk Museum de Lakenhal, Leiden, *Opposition of Coincidents*, Torch Gallery, Amsterdam, *alleverythingthatisyou*, Baldwin Gallery, Aspen, Colorado, *Mike and Doug Starn*, Galeria Metta, Madrid; 2005, *Absorption + Transmission*, The National Academy of Sciences, Washington D.C. (travelling exhibition), *Impermanence*, Leo Castelli Gallery, New York; 2004, *Gravity of Light*, Färgfabriken Kunsthalle, Stockholm (travelling exhibition), *Behind Yor Eye*, The Neuberger Museum of Art at Purchase College, Purchase, New York (travelling exhibition), *I'm a negative falling down to the light a silhouette veins flowing with black visible to these useless blind eyes*, Bjorn Wetterling Gallery, Stockholm, *Toshodaiji*, Akira Ikeda Gallery, Taura, Japan, *Attracted to Light*, Baldwin Gallery, Aspen, Colorado, *Doug & Mike Starn*, Lehmann Maupin Gallery, New York; 2003, *Attracted to Light*, Stephen Wirtz Gallery, SanFrancisco, *Absorption of Light*, Lis Sette Gallery, Scottsdale, Arizona, and Galerie Bhak, Seoul, and Torch Gallery, Amsterdam, and Hans Mayer, Düsseldorf; 2001-02, *Absorption of Light*, Stephen Wirtz Gallery, San Francisco; 2001, *New Work*, Weinstein Gallery, Minneapolis; 2000, *Black Pulse*, Baldwin Gallery, Aspen, Colorado, *Doug and Mike Starn*, Grossman Gallery/School of the Museum of Fine Arts, Boston, *Permanent Collection*, Museum of Fine Arts, Boston: 1999, Fay Gold Gallery, Atlanta; 1998, *Blot Out The Sun*, Baldwin Gallery, Aspen, Colorado, *Black Sun Burned*, Leo Castelli, New York; 1997, *Size of the Earth*, The Friends of Photography/The Ansel Adams Center, San Francisco; 1996, *Doug and Mike Starn; Retrospective*, Overgaden Ministry of Culture, Copenhagen, *Helio Libri*, Fay Gold Gallery, Atlanta; 1995, Galerie Bhak, Seoul, *Helio Libri*, Pace/MacGill, New York; 1994, *Doug and Mike Starn: Sphere of Influence*, Portland Museum of Art, Portland, *Spectroheliographs*, Leo Castelli, New York; 1993, *Doug and Mike Starn*, Naoshima Contemporary Art Museum, Kagawa, Japan, *Marking Time: Doug and Mike Starn*, National Gallery of Victoria, Melbourne; 1992, *Yellow and Blue Louvre Floor – A Project*, Galerie Thaddeus Ropac, Paris, Leo Castelli, New York; 1991, *Multiples*, Pace/MacGill Gallery, New York (in co-operation with Leo Castelli, New York); 1990-91, *Doug and Mike Starn*, Baltimore Museum of Art, Baltimore, and Center for Fine Arts, Miami, and Blaffer Gallery, University of Houston, Texas, and Center for the Fine Arts, Cincinnati, and The Akron Museum of Art, Akron, Ohio; 1990, Fred Hoffman Gallery, Santa Monica, Mario Diacono Gallery, Boston, Stux Gallery, New York, Leo Castelli, New York, Galertie Antoine Candau, Paris; 1989, Akira Ikeda Gallery, Tokyo, *Anne Frank Group*,

Leo Castelli and Stux Gallery, New York; 1988, *Mike and Doug Starn: Selected Works 1985-87*, Honolulu Academy of Art, Honolulu, and University Art Museum, University of California at Berkeley, and Wadsworth Athenaeum, Hartford, and Museum of Contemporary Art, Chicago, 1988 cont. Stux Gallery, New York, Leo Castelli Gallery, New York; 1987-88, *The Christ Series*, Museum of Modern Art, San Francisco, and The John and Mable Ringling Museum of Art, Sarasota, Florida; 1987 Stux Gallery Boston; 1986, Stux Gallery, New York; 1985, Stux Gallery, Boston.

ALICE STEPANEK & STEVEN MASLIN
(Live and work in Cologne and Berlin)
Alice Stepanek. Born, 1954, Berlin. 1981-82 St Martin's School of Art, London. 1974-80 Akademie der bildenden Künste, Munchen.
Steven Maslin: Born, 1959, London. 1979-79 St Martin's School of Art, London. 1979-79, Kingston Polytechnic, Kingston-upon-Thames.

Awards and Prizes: 2001, Kunstpreis der Stadt Nordhorn, Städtische Galerie Nordhorn.

TWO-PERSON EXHIBITIONS (selected): 2007, Galerie Jean-Luc & Takako Richard, Paris, Galerie Volker Diehl, Berlin; 2006,Torch, Amsterdam, Galeria Leyendecker, Santa Cruz de Tenerife; 2005. Fabian & Claude Walter Galerie, Zürich, Purdy Hicks Gallery, London; 2004, Galerie Jean-Luc & Takako Richard, Paris; 2003, Aidan Gallery, Moscow, Galerie Thomas Rehbein, Köln; 2002, Galerie Volker Diehl, Berlin, Galeria Pedro Cera, Lisboa, Purdy Hicks Gallery, London; 2001, Kunstpreis der Stadt Nordhorn, Städtische Galerie Nordhorn, Nordhorn (with Beate Gütschow); 2000, Studio D'Arte Raffaelli, Trento, Aidan Gallery, Moscow, Stefan Stux Gallery, New York; 1999, Galeria Leyendecker, Santa Cruz de Tenerife, Laure Genillard Gallery, London, Museum Schloss Hardenberg, Velbert, Damasquine, Brussels; 1998, Galerie Axel Thieme, Darmstadt, Elizabeth Cherry Contemporary Art, Tucson, Stefan Stux Gallery, New York, Galerie Volker Diehl, Berlin, Torch, Amsterdam; 1997, Laure Genillard Gallery, London; 1996, Johnen & Schöttle, Köln, Rüdiger Schöttle, München, Galerie für Landschaftskunst, Hamburg, Galleri Tommy Lund, Odense; 1995, Torch, Amsterdam, Laure Genillard Gallery, London, Galeria Leyendecker, Santa Cruz de Tenerife; 1994, Daniel Newburg Gallery, New York, Forum Bildender Künstler, Essen, The Corridor, Reykjavik, Galleri Tommy Lund, Odense, Jan Mot & Oscar van den Boogaard, Brussels, Palmengarten, Frankfurt/ Main; 1993, Johnen & Schöttle, Köln, Galerie Volker Diehl, Berlin, Na Bidylku, Brno, Vera van Laer Gallery, Knokke, Galeria Leyendecker, Santa Cruz de Tenerife; 1992, Galeria Mar Estrada, Madrid, Galleri Tommy Lund, Odense, 1991, Galeria Leyendecker, Santa Cruz de Tenerife; 1990, Galeria Leyendecker, Santa Cruz de Tenerife, The Living Room, Amsterdam; 1989, Torch-Onrust Galerie, Köln; 1988, The

Living Room, Amsterdam, Galerie Six Friedrich, München, Daniel Newburg Gallery, New York; 1987, Daniel Newburg Gallery, New York, Anna Friebe Galerie, Köln; 1985, Galerie Six Friedrich, München, Anna Friebe Galerie, Köln

JANE AND LOUISE WILSON
(Live and Work in London)
Jane & Louise Wilson: Born 1967, Great Britain. 1986-89 Duncan of Jordanstone College of Art, Dundee, BA Fine Art (Louise), Newcastle Polytechnic, BA Fine Art (Jane). 1990-92 Goldsmiths College, London, MA Fine Art (Jane & Louise) 1993

Awards & Grants: 1993 Barclays Young Artist Award. 1996 DAAD Scholarship, Berlin - Hannover, Germany. 1997 Part time Professors at the Kunst Academy, Oslo. 1999 Nominated for the Turner Prize. 2000 IASPIS, International Artist's Studio Program in Sweden, Stockholm, Residency Fall. 2001– 2005 External Assessor For Glasgow M.F.A. 2002 Awarded Doctors of Civil Law, DCL, Northumberland University. 2004 Residency at the School of Fine Arts, SOFA Gallery, Christchurch, New Zealand.

TWO-PERSON EXHIBITIONS (selected): 2006 *Jane & Louise Wilson*, Haunch of Venison, Zurich, *The New Brutalists*, Lisson Gallery, London; 2005, *Erewhon*, Blaffer Gallery, Houston, *Broken time*, Hatton Gallery, Newcastle Upon Tyne, *The Knot Garden*, Collaboration on Michael Tippett opera, Royal Opera House 2, London; 2004 *Jane & Louise Wilson*, Bergen Art Museum, Bergen, Norway, *Erewhon – Jane & Louise Wilson*, 303 Gallery, New York, *Jane & Louise Wilson*, Fondazione Davide Halevim, *Jane & Louise Wilson*, De Appel, Amsterdam, *A Free & Anonymous Monument*, Pori Art Museum, Pori, Finland, *Jane & Louise Wilson*, Umea Bildmuseet, Umea, Sweden; 2003, *A Free & Anonymous Monument*, Baltic Centre for Contemporary Art, Gateshead, Centro de Fotografia, Salamanca, Lisson Gallery, London; 2002, Kunst-Werke, Berlin; 2000 *Star City*, 303 Gallery, New York, Bernier / Eliades, Athens, *Stasi City & Crawl Space*, MIT List Visual Arts Centre, Cambridge, MA; 1999/2000 *Turner Prize*, Tate Gallery, London; 1999 *Jane and Louise Wilson*, Serpentine Gallery, London, *Gamma*, Lisson Gallery, London, *Stasi City*, Hamburger Kunsthalle, Hamburg; 1998 *H&R Projects*, Brussels, *Stasi City*, 303 Gallery, New York, *Film Stills*, Aki-Ex Gallery, Tokyo; 1997 *Stasi City*, Kunstverein Hannover (Touring to Kunstraum Munich; Centre d'art Contemporain, Geneva; Kunstwerke, Berlin), *Jane and Louise Wilson*, LEA, London; 1996 Galleria S.A.L.E.S., Rome (part of the British Art Festival); 1995 "Normapaths", Chisenhale Gallery, London (touring to Berwick Gymnasium Gallery, Berwick-upon-Tweed); "Crawl Space", Milch Gallery, London; 1994 *Jane and Louise Wilson*, British Project II, Galerie Krinzinger, Vienna, Routes *1 & 9 North*, AC Project Room, New York.

ENDNOTES IIIIIII

🔲 - INTRODUCTION AND PSYCHOLOGICAL MOTIVES

[1] Rudi Fuchs (ed.), *Gilbert and George: The Complete Pictures*, 2 vols., London 2007

[2] Marco Livingstone et al. *Gilbert & George: Major Exhibition*, London 2007

[3] The Flanagan arches in question are almost certainly those of the railway arches around Liverpool Street, the large railway station in the East of London. In fact one of Gilbert & George's living sculpture performances took place under the arches in Cable Street, E1 (near to Limehouse Station) in 1970

[4] Bud Flanagan (born Chaim Reuven Weintrop) 1869-1968, Chesney Allen (1893-1982)

[5] Op cit., note 2, p. 47

[6] Ibid., p. 60

[7] 'What Our Art Means', Statement by the artists in *Gilbert & George: The Complete Pictures 1971-85*, reproduced in *The Words of Gilbert & George: With Portraits of the Artists from 1986 to 1997*, London 1997, p. 149

[8] Vitaly Komar, *Komar/Melamid: Two Soviet dissident artists*, London and New York 1979

[9] Carter Ratcliff, *Komar & Melamid*, New York 1988, p. 17

[10] The artist's critique of Western (notably American) forms of art patronage and consumption was developed later, see Joann Wypijewski (ed.), Aleksandr Melamid (author), Vitaly Komar (author), *Painting by Numbers: Komar & Melamid's Scientific Guide to Art*, New York 1997, and Berkeley and Los Angeles 1998

[11] Peter Wollen, *Komar and Melamid: History Painting*, Edinburgh 1985

[12] *Ulay/Abramovic: Performances 1976–1988*, exhib. cat., Stedlijk Van Abbemuseum, Eindhoven, 1997

[13] Paul Kokke, 'An Interview with Ulay and Abramovic, *ibid*, p. 119

[14] Thomas McEvilley, 'Ethics, Esthetics, and Relation in the work of Marina Abramovic and Ulay' in *Modus Vivendi: Works 1980–85*, exhib. cat., Stedelijk Van Abbemuseum, Eindhoven, 1985

[15] The series of descriptive quotes for their works is from *Ulay/Abramovic: Performances 1976–1988* which presents the performances in individual sections that are not paginated

[16] Op cit., note 13, p. 117

[17] Susanne Lange, *Was wir tun, ist letztlich Geschichte erzählen: Bernd und Hilla Becher, Einführung in das Leben und Werk*, Munich, 2005

[18] Fredric Jameson, *Postmodernism, or the Cultural Logic of Late Capitalism*, Durham, NC. 1991. Jameson may be seen in some respects and a late devotee of the traditional Frankfurt School, Benjamin, Adorno, Horkheimer, who similarly sought to revise Marxism

🔲 - TRANSGRESSION, PROHIBITION AND TABOO

[1] Jacques Derrida, 'Force and Signification' in *Writing and Difference*, Alan Bass (transl.), Chicago and London 1978: reprinted, London 1993, p. 3

[2] George Bataille, 'The Festival, or the Transgression of Prohibitions' in *The Accursed Share*, Robert Hurley (transl.), vol. II, 'The History of Eroticism', New York 1991, pp. 89–94. The text originates from *L'Erotisme*, Paris, 1957

[3] Bataille, 'The Schema of Sovereignty' in *The Accursed Share*, Robert Hurley (transl.), vol. III, New York 1991, pp. 213–23 Though originally intended as the third volume of *La part maudite*, the text was written as early as 1953, but only published in 1976

[4] Bataille, 'Preface' and 'The Meaning of the General Economy' in *The Accursed Share*, Robert Hurley (transl.), vol. I, New York 1991, pp. 9–14, 19–26. "I have tried in vain to make clear the notion of the 'general economy' in which the 'expenditure' (the 'consumption') of wealth, rather than production, was the primary object," p. 9

[5] Bataille's influence on the visual arts has been enormous, not only with regard to the so-called 'dark side of Surrealism', but also to many contemporary art practitioners, see *Undercover Surrealism: George Bataille and DOCUMENTS*, exhib. cat., South Bank Centre Publications, London 2006

[6] Interview with Sarah Kent 'Gender Blenders', *Time Out*, May 1-8, 1996, pp. 18-19 (p. 18)

[7] See: Douglas Fogle, 'A Scatological Aesthetics for the Tired of Seeing' in *Chapmanworld*, exhib. cat., London 1996. The show travelled to the Grazer Kunstverein, Graz, and Kunst-Werke, Berlin, in 1997

[8] In terms of implicit references to Bataille, see *George Bataille: Visions of Excess, Selected Writings 1927–1939*, Allan Stoekl (ed. and intro.), Allan Stoekl with Carl R. Lovitt and Donald M. Leslie, Jr, (transl.), Theory and History of Literature, vol. 14, Minnesota 1985

[9] 'Revelations: A Conversation between Robert Rosenblum and Dinos & Jake Chapman', *Holy Libel* (Six Feet Under), exhib. cat., New York 1997, pp. 147–53. The catalogue with its doubled skull and crossbones and gold-leaf edged pages is a deliberate parody of the Holy Bible

[10] Copraphagia (excrement eating) and copraphilia (excrement loving) has a long literary and visual arts history. It is described in the Marquis de Sade's *Justine* and, in Surrealism, we are reminded of it in Salvador Dali's painting *The Lugubrious Game*, 1929, diagrammatically illustrated in Bataille's *Documents*, December 1929. See Dawn Ades, *Dalí*, London 1982, p. 69. There is also Piero Manzoni's *Merde d'artista* (90 cans, 1961), see Germano Celant, *Piero Manzoni*, exhib. cat., London 1998, p. 274. The contemporary artist Marc Quinn also used his own excrement in a series of 'Shit Paintings', see *Marc Quinn: Incarnate* (essays by Will Self, David Thorp and Mark Gisbourne), London 1998. Reference has already been made with regard to the series on this subject by Gilbert & George

[11] It may be coincidental (but nonetheless appropriate) that Dominique Laporte's *History of Shit* was published in English at this time by Cambridge, Mass. 1993. Originally written in Paris in 1968, it was published in France as the *Histoire de la Merde (Prologue)* in 1978. It dealt extensively with the buried (a pun) history of bodily waste and effluents.

[12] The use of the mannequin has a long, twentieth-century history of use in the visual arts, beginning with De Chirico, the French Surrealist International exhibition using mannequins in 1938, and in the post-war period artists like Duane Hanson, John de Andrea and more recent contemporary artists Charles Ray and Ron Mueck.

[13] See David Falconer, 'Doctorin' the Retardis', in *Chapmanworld*, (op. cit.), n. p. There is a deliberate pun on Dr Who (a popular British TV science fiction series that has lasted some forty years in which the Doctor has changed many times), and the non-word 'Retardis' which plays upon 'retard' and the 'Tardis' the Police Box time travel machine used by the Doctor.

[14] George Louis Leclerc, Comte de Buffon (1707–78) was a French naturalist who developed devolutionary theories of mutation to explain the diversification of types within species and the sexual origin of species. His relevance here may be due only to the the fact that his ideas were expounded by Percy Bysshe Shelley (1792–1822) and Mary Shelley (1797–1851) and formed an influential background to her creation of Frankenstein. The catalogue *Chapmanworld* is introduced in pseudo-Gothic script associated with the Gothic horror tradition.

[15] In their catalogue *Holy Libel* the Chapman's extended text (written by Jake but collaboratively agreed) is a simulacrum of a book or epistle from the Bible, as is the general appearance of the book. It is littered with such hallucinatory language and titled 'Pleasurable Disgust in the Theatre of Abhorrence: Spastic Though, Terminal Tics and Hyperbolic Ambivalance', pp. 5–76; "But Fuckface is neither a boy nor a girl. No.

Fuckface is just plain fuckface. By birthright Fuckface is a disavowel organ, a loosely spotted cockanalcunt," p. 28

[16] The decollated or headless body was the cover illustration (designed by André Masson) for Bataille's esoteric review *Acéphale* which ran from 1936–39

[17] There are Freudian references throughout the early literature and a Freud epigraph begins the Chapman text in *Holy Libel*. See also Leo Bersani, whose book *The Freudian Body Psychoanalysis and Art*, New York 1990, is a telling early influence on their work

[18] Bataille, 'From Erotic Laughter to Prohibition', in *The Tears of Eros*, San Francisco 1989, p. 66. "In considering eroticism, the human mind is faced with its most fundamental difficulty. Eroticism, in a sense, is laughable … Allusion to the erotic is always capable of arousing irony." It should not be missed either that Eros was a God, frequently represented and depicted as a 'puerile child'. Original French text, *Les Larmes de Eros*, Paris 1961

[19] Their initial exhibition as 'Blue Noses' took place as *The New Holy Fools, or the Pathology of Performance* at the Yverev Center of Contemporary Art, Moscow in 1999. At this time they were an ensemble that included Dmitry Bulnygin, Konstantin Shotnikov, and several others. From time to time they still second other artist-participants for the purposes of specific projects or manifestations

[20] *Blue Noses*, exhib. cat., Tretyakov Gallery/ Martin Guelman Art Foundation, 2006, p. 5

[21] Beatrix Ruf ,'Taking Place' in *Taking Place: The Works of Michael Elmgreen & Ingar Dragset*, exhib. cat., Ostfilderen, pp. 12–32

[22] Henri Lefèbvre, *The Production of Space*, London and Oxford 1991, French original, 1974

[23] Dorothea von Hantelmann, 'Production of Space – Space of Production' in *Spaced Out (Powerless Structures)*, exhib. cat., Frankfurt-am-Main 2003, pp. 59–63

[24] In this, Elmgreen & Dragset are indebted to earlier positions vis-à-vis space adopted by artists like Dan Graham, Gordon Matta-Clark and Lawrence Weiner. See Dan Graham, 'Theater, Cinema, Power', in *Rock My Religion: Writings and Projects, 1965–1990*, Cambridge, Mass. and London 1993, pp. 170–89

[25] An exhibition of an empty space is not without precedence – save that two painters laboured in the Elmgreen & Dragset space. Yves Klein exhibited an empty gallery space and vitrine as *Le vide* (The Void), at Iris Clert Gallery, Paris, from 28 April–12 May, 1958. See, Siidra Stich (ed.), *Yves Klein*, exhib. cat., Ostfildern 1995, pp. 134–35. (The exhibition was also shown at the Museum Ludwig Cologne, Kunstammlug Nordrhein Westfalen, and Museo

Nacional Centro de Arte Reina Sofia, Madrid 1994/5)

[26] Brian O'Doherty (a.k.a. Patrick Ireland), *Inside the White Cube: The Ideology of the Gallery Space*, Berkeley, Los Angeles, London 1976, expanded edition 1986

[27] Elmgreen & Dragset: Interview with Jens Hoffman, *Spaced Out (Powerless Structures)*, pp. 32–37

[28] Mark Fletcher (curator), 'Love in the Late Capitalist Dystopia: Coming Together is Divine' in *The Joy of Sex*, exhib. cat., Seoul 2005, pp. 10–12

[29] Alex Comfort, *The Joy of Sex*, London 2002. The book has been in continuous publication since its release in 1972

[30] The term was coined by the famous British critic Herbert Read in relation to the award winning sculpture in the British Pavilion at the Venice Biennale in 1952. An important aspect of Lynn Chadwick's early work was the use of welding and assemblage. The group included Reg Butler, Lynn Chadwick, Bernard Meadows, Kenneth Armitage, John Hoskin, Robert Adams, Elizabeth Frink, Eduardo Paolozzi and, marginally, Henry Moore. See Dennis Farr and Eva Chadwick, *Lynn Chadwick Sculptor: With a Complete Illustrated Catalogue, 1947–2005*, Lund Humphries 2006

[31] Jeffrey Deitch, 'Black Magic' in *Tim Noble & Sue Webster: Wasted Youth*, New York 2006, n. p.

[32] Another seemingly spontaneous art work exists called *Untitled Stone Formation. Death Valley* (1998). It is a circle of stones the artist executed in Death Valley, USA, shaped as a heart and having the letters T & S centrally placed, *Tim Noble and Sue Webster: The New Barbarians*, London 1999, illus. p. 4

[33] David Barrett, 'How to be Young British Artists for Fun and Profit', *Tim Noble and Sue Webster: The New Barbarians*, pp. 5–7

III – GENDER AND DESIRE

[1] Judith Butler 'II. The Compulsory Order of Sex/Gender/Desire' in *Gender Troubles*, London 1999, pp. 9–11: "… the distinction between sex and gender serves the argument that whatever biological intractability sex appears to have, gender is culturally constructed: hence gender is neither the causal result of sex nor as seemingly fixed as sex."

[2] Susan Stewart, 'Objects of Desire' in *On Longing*, Durham and London 1993, pp. 132–69: "Within the development of culture within the exchange economy, the search for authentic experience and, correlatively, the search for the authentic object become critical."

[3] What constitutes kitsch is difficult to define but, in its origin,

refers to an inferior copy of an existing style. In the nineteenth century it inferred sentimentality and melodrama, but in the twentieth century has taken on many different theoretical implications. See: Clement Greenberg, 'The Avant Garde and Kitsch' in *Art and Culture*, New York 1971; Hermann Broch and John Hargraves, *Geist and Zeitgeist: The Spirit in an Unspiritual Age*, New York, repr. 2003; Theodor Adorno, *Culture Industry*, Oxford, repr. 2001. The above authors would seem to agree on the position (albeit differently argued) of a form of false consciousness. Postmodernism with its eclectic inclusiveness and with appropriation artists like Jeff Koons has made a secure definition even more difficult. As a result literature on the subject over the last twenty-five years has become enormous.

[4] Markus Muntean and Adi Rosenblum in conversation with Cerith Wyn Evans, *To Die For Muntean/ Rosenblum*, exhib. cat., Amsterdam 2002 , p. 55. The quotation used was stated by Rosenblum.

[5] Leon Battista Alberti, *On Painting* (1434), (Vol. II, 43), London, repr. 1991, pp. 78–79: "There should be some bodies that face towards us, and others going away, to right and left. Of these some parts should be shown towards the spectators, and others should be turned away; some should be raised upwards and other directed downwards."

[6] Op. cit., note 4, p. 53

[7] Cesare Ripa *Iconologia*, Rome 1593. An enormously influential emblem book for the depiction of figures, forms and poses in the 17th and 18th centuries. As an historical, standard text it has been translated and reprinted many times.

[8] See: Dave Hickey, 'The Delicacy of Rock-And-Roll' in *Air Guitar: Essays on Art and Democracy*, Los Angeles 1997, pp. 96–101. The curator and critic Dave Hickey was a rock music critic and writer of pop songs in the late '60s and early '70s. His essay gives a sense of the tone of the period and the music scene in the United States at that time.

[9] See: *Abetz/Drescher: Paint it Black*, exhib. cat., Galerie Volker Diehl, Berlin, and Galerie Suzanne Tarasiève, Paris, 2004

[10] Max Ernst frequently referred to himself in the third person and the third eye was the 'eye of the unconscious self'. Cyclops-like, single-eyed figures appear frequently in works, particularly in the 1920s. See: *Max Ernst*, Barcelona 1984, ill. pp. 156–57. George Bataille called the same third eye 'the pineal eye' as the eye of immediate existence. See: 'III Pineal Eye', *Visions of Excess: Selected Writings 1927–39*, Theory and History of Literature, vol. 14, Minnesota 1994, p 82

[11] "There was an old woman who lived in a shoe. She had so many children, she didn't know what to do. She gave them some broth without any bread; she whipped them all soundly, and sent them to bed." The German or English origins of this nursery rhyme are still much debated. One of the earliest illustrations

is by Joseph Martin Kronheim (1810–96), made in 1875. Born in Magdeburg, Kronheim was an enormously influential coloured printmaker who moved to Edinburgh, then finally to London, c. 1846. His colour prints were distributed throughout Europe.

[12] Robert Fleck, 'Eva & Adele', exhib. cat., *Eva & Adele: Where Ever We Are is Museum*, Ostfilden 1999, p. 67

[13] *Eva & Adele: Logo Mediaplastik-Wings-Lingerie*, exhib. cat., Ostfilden 2000; (see essays by Thea Herold and Gesine Last)

[14] Paolo Bianchi, 'Art as the Invention of Life', exhib. cat., *CUM Eva & Adele*, (Coming Out of the Future), Hannover 1997, pp. 28–35

[15] See: Mark Gisbourne 'Life in the Pink', *Geschlossene Gesellschaft Eva & Adele*, exhib. cat., Berlin 2004, pp. 5–15

[16] See: Sabine Kampmann, 'Gender Identity and Authorship EVA & ADELE – just about "Over the Boundaries of Gender"' in *EVA & ADELE: Day By Day Painting*, Nordic Watercolour Museum, Ostfilden 2003, pp. 52–62

[17] Dan Cameron and Bernard Marcadé, *Pierre et Gilles, l'œuvre complète 1976–96*, Cologne 1996

[18] Odon Vallet, *PIERRE ET GILLES Göttliche Körper*, Munich 2006 ; (from the French *Les corps divin – Pierre et Gilles*, Paris 2006

[19] Eric Troncy, *Pierre et Gilles. Sailors and the Sea*, Cologne 2005

[20] Dan Cameron, *Pierre et Gilles*, London 2000. See also: *Pierre et Gilles – Retrospective*, Museum of Contemporary Art, Shanghai, 2005, *Pierre et Gilles - Beautiful Dragon*, Seoul Museum of Art, 2005 and Singapore Art Museum, 2004

[21] Michel Beltrami, *Pierre et Gilles: L'Odyssée Imaginaire*, Contrejour (Centre National des Arts Plastiques FIACRE), Paris 1988

IV – WAR, CRIME, POWER AND SOCIAL SCULPTURE

[1] Christopher Turner, 'Great Deeds Against Dead Artists: How the Chapman Brothers Nearly Changed Their Name to Goya', exhib. cat., Jake & Dinos Chapman: Bad Art for Bad People, Tate Liverpool, 2006, pp. 37–53

[2] The Goya series of etchings was created c. 1810–15, but due to their horrific visual contents were not published until 1863, long after the artist's death. The order in which the plates were subsequently printed was therefore beyond the control of the artist and some speculation remains. See Francisco Jose de Goya, The Disasters of War, London and New York 1968; Anthony Griffiths, Juliet Wilson-Bareau and John Willett,

Disasters of War: Callot Goya Dix, exhib. cat., London 1998; Robert Hughes, Goya, London and New York 2003

[3] "The corpse (or cadaver: cadere to fall), that which irremediably comes a cropper, is cesspool and death; it upsets even more violently the one who confronts it as fragile and fallacious chance," Julia Kristeva, 'Approaching Abjection' in Powers of Horror: An Essay on Abjection, Leon S Roudiez (transl.), New York 1982, p. 3

[4] The theory of the rhizome has been a considerable influence, since it speaks to the post-modern or late capitalist idea of a lateral rather than the vertical model of discourse. It is a decentred concept that many be seen as being analogous with interconnectivity and the internet and the spread of globalisation. See Gilles Deleuze, 'Introduction Rhizome' in A Thousand Plateaus: Capitalism and Schizophrenia, Brian Massumi (transl.), London 1987, pp. 3–25

[5] Walker Art Center, Brilliant! New Art From London, exhib. cat., Minneapolis and Houston, 1995. The catalogue took the form of a British tabloid newspaper

[6] Sir Edwin Landseer (1892-73) was one of the favourite painters of Queen Victoria, and the fact that the work was first shown in an Brilliant exhibition of yBa art in the United States was not lost on the Chapman Brothers. See, Sir Edwin Landseer, ex. cat., Tate Gallery, London, and Philadelphia Museum of Art, Philadelphia, 1982, pp. 174-175. A nostalgic image of Britishness familiar through many simulacra of labels found on certain Scottish whisky bottles.

[7] Kelly Oliver, 'Nietzsche and Kristeva on the politics of poetry' in Social Theory and Practice 5, 3, Fall 1989, pp. 305–20; Gilles Deleuze, Nietzsche & Philosophy, Hugh Tomlinson (transl.), London 1996; Georges Bataille, On Nietzsche, republ. London 2004

[8] Hal Foster, Compulsive Beauty, Cambridge Mass. and London 1993

[9] "Beauty will be convulsive or will not be at all," is a quotation taken from André Breton's famous novel Nadja, 1928

[10] The title derives from Freud's 'Introductory Lectures on Psychoanalysis'; James Strachey (ed.) in The Standard Edition of the Complete Psychological Works of Sigmund Freud, London 1986

[11] It is another word-play. In the UK and the United States large charitable fundraising projects on television are often called a 'Telethon', derived no doubt from 'Marathon'. Children's programming at different times of the years follows the same pattern. The use of etch-a-sketch-thon satirises the use of children in this way, while also 'etching' often has in English a set of sensual associations. Childhood and sexuality are never far apart in the works of Jake & Dinos Chapman.

[12] Jake & Dinos Chapman, Insult to Injury, Göttingen 2004

[13] The defence also included a reference to Robert Rauschenberg's work called Erased De Kooning Drawing of 1953. See Jake & Dinos Chapman: Bad Art for Bad People, ill. p.50

[14] The effects of both shock and laughter, and the fact that in a state of shock our human reaction is often that of laughter, has been extensively discussed in relation to Jake and Dinos Chapmans work. See Tanya Barson, 'Powers of Laughter', and Dave Beech, 'Shock: A Report on Contemporary Art' in Jake & Dinos Chapman: Bad Art for Bad People, Tate Liverpool, 2006, pp. 67–85, pp. 99–110 respectively

[15] Norman Kleeblatt (ed.), Mirroring Evil: Nazi Imagery/Recent Art, New York 2002. The book also served as an exhibition catalogue at the same time at the Jewish Museum, New York.

[16] Torben Christensen, 'The Young London Art Scene of the 90s' in Corpus Delicti, exhib. cat., Copenhagen 1995, pp. 48–51

[17] Peter Schjeldahl, 'V.I. Jane & Louise Wilson', exhib. cat., Jane & Louise Wilson, London 1999, pp. 3–6

[18] Ibid., p. 3

[19] Lisa Corrin, in an interview with Jane and Louise Wilson, Jane & Louise Wilson, Serpentine Gallery, p. 6

[20] Michel Foucault, 'Panopticism' in Disciple and Punish, London 1991, pp. 195–228. Jane and Louise Wilson further emphasised their interest in the Panopticon in a project in Las Vegas in the Optimax Cinema in Caesar's Palace, also in 1999.

[21] Lisa Corrin, op. cit., p. 8

[22] Ibid., p. 10

[23] A 'Mobius strip' or 'Mobius band', is a surface with only one side and only one boundary component. It has the mathematical property of being non-orientable. It is also a ruled surface. It was discovered independently by the German mathematicians August Ferdinand Mobius and Johann Bededict Lessing in 1858.

[24] For a general overview of the development of Teresa Hubbard and Alexander Birchler's work see Teresa Hubbard/Alexander Birchler: Wild Walls, Bielefeld 2001. The publication served as the catalogue for the artists' exhibition in 2001/2002 that travelled to the Haus Lange/Haus Estes, Krefeld, the Huis Marseille, Amsterdam, the Foundation for Photography, Amsterdam, the Kunstverein St. Gallen Kunstmuseum and the Kunsthalle, Kiel.

[25] Teresa Hubbard/Alexander Birchler, House With Pool, Kunstmuseum Basel, Museum für Gegenwartskunst, 2004

[26] E. Schlebrügge (ed.), Clegg & Guttmann:

Monument For Historical Change and Other Social Sculptures, Community Portraits And Spontaneous Operas 1990–2005, Berlin and Vienna 2005

V – PERFORMANCE, SEXUAL AND SOCIAL ANARCHY

[1] For different positions on stage performance, see Janella G. Reinelt and Joseph R. Roach (eds.), *Critical Theory and Performance*, Ann Arbor and London 1992

[2] RoseLee Goldberg, *Performance Art: From Futurism to the Present*, London 2001 (revised edition); also *Out of Actions: Between Performance Art and the Object, 1949–1979*, London 1998 and *Hors limites: l'art et la vie 1952–1994*, Musée national d'art moderne, Centre Georges Pompidou, Paris 1994

[3] Urolagnia (also known as urophilia or undinism) is a sexual fetish with participants deriving pleasure from urine – by drinking urine, urinating in public, urinating on someone else or being urinated upon. Common euphemisms are 'golden showers' or 'water sports.'

[4] The tradition of British hunting pictures is long. For a contemporary publication, see Malcolm Cormack, *Country Pursuits: British, American, and French Sporting Art from the Mellon Collections in the Virginia Museum of Fine Art*, 2007. The work is a tribute to Tim Noble's father and family associations with taxidermy, as well as to the British traditions and the nation's love of bird-watching and hunting.

[5] The term is the same as their large monograph *Wasted Youth*, New York and London 2006

[6] The work *The Original Sinners* uses kinetics and an electric pump mechanism. See *Wasted Youth* for illustration (not paginated), where Sue is lactating and Tim urinating.

[7] For an overview of the work of Jean Tinguely, see *Museum Jean Tinguely Basel: The Collection*, Berne 1996

[8] See *Performance Art, Out of Actions*, and *Hors Limites* (op. cit.) for current definitions of performance art.

[9] Kippenberger's *Subway Station, Lord Jim*, (1993) was first conceived for the Kthma Canné, on the Greek Island of Syros. A subsequent but different version appeared in the United States (1995) and the concept was used again at documenta X in 1997. See *Kippenberger*, Cologne and London, p.11 for illustration.

[10] Beatrix Ruf, *Taking Place*, Zurich 2001, p. 32. The questions posed are: What kind of spaces does art need? Who decides what form they take? Who uses them? What is an installation? What is work? And what is an exhibition?

[11] Coco Fusco (in conversation with Dragset and Elmgreen), 'Transformational Acts' in *Taking Place*, p. 37. Here, Elmgreen is speaking.

[12] For Allan Kaprow, see *Child's Play: The Art of Allan Kaprow*, Berkeley and London 2004, Benjamin H.D. Buchloh (et al.), *Experiments in the Everyday, Allan Kaprow and Robert Watts – Events, Objects, Documents*, Washington and London 2000, and Allan Kaprow and Jeff Kelley, *Essays of the Blurring of Art and Life*, Berkeley and London 2003. On Carolee Schneemann, see *Carolee Schneemann: Imaging her Erotics – Essays, Interviews, Projects*, Cambridge and London 2002, and for a near contemporary account, see *More Than Meat Joy: Complete Performance Works and Selected Writings*, New York 1979

[13] Ingar Dragset, *Taking Place*, p. 38

[14] Yvonne Villareal, Doreen Remen, Elmgreen & Dragset, *Prada Marfa, Elmgreen & Dragset*, Cologne 2007

[15] For general overviews on Land Art, see Jeffrey Kastner and Brian Wallis (eds.), *Land and Environmental Art*, London 1998, and Gilles A. Tiberghien, *Land Art*, Paris 1995. For monographs, see *Robert Smithson Retrospective: Works 1955–1973*, exhib. cat. 1999, *James Turrell: The Other Horizon*, Stuttgart 1999, and Germano Celant, *Michael Heizer*, Milan 1997

[16] They constitute (in part with Heidegger) the father figures with regard to modern theories on phenomenology. The concepts are elaborated at length by Edmund Husserl (1859–1938), in a number of books on intuition and introspection. For Maurice Merleau-Ponty (1908–61), see *The Phenomenology of Perception* (1946) and his series of collected essays *The Primacy of Perception*, first transl. in 1963. Both have been published in numerous editions.

[17] For an introduction to their individual work before 1998/99, see *Blue Noses* (State Tretyakov Gallery/Marat Guelman Art Foundation), Moscow 2006

[18] Art Moscow Workshop, '25 Contemporary Russian Artists', Central House of the Artists, Moscow 2001

[19] The Blue Noses, *Kitchen Suprematism*, 6th Photo Biennial, House of Journalists, Moscow 2006

[20] *Gender Troubles*, 1st Moscow Biennial, Museum of Modern Art, Moscow 2005, *The Dialectics of Hope*, 1st Moscow Biennial, Former Lenin Museum, Moscow 2005, *Accomplices. Collective and Interactive Works in the Russian Art of the 1960-2000s*, 1st Moscow Biennial, State Tretyakov Gallery, Moscow 2005, Art Digital-2004 I Click Therefore I Am, 1st Moscow Biennial, M'ARS Gallery, Moscow 2005, Art Kliazma–2005, International Contemporary Art Open-Air Festival, *The Winter Factor, or Snow Maidens do not Die*, 1st Moscow Biennial, Boarding House 'Kliazma Water Reservoir', 2005. See also *Always a Little Further*, 51st Venice Biennale, 2005, and *Expanded Painting*, 2nd Prague Biennial, 2005

[21] The Blue Noses, *Two Against the Russian Mafia*, Moscow and Kiev, 2003

[22] Mark Gisbourne, 'Life in the Pink', *Eve & Adele: Geschlossene Gesellschaft*, exhib. cat., Galerie Michael Schultz, 2004, pp. 11–15

VI – HISTORY, MEMORY AND NOSTALGIA

[1] Søren Kierkegaard, 'Recollection is a discarded garment' in *The Treasure Chests of Mnemosyne: Selected texts on memory theory from Plato to Derrida*, Dresden 1998, p. 128

[2] Agustin Pérez Rubio, 'Noli me tangere: Spectres in a system of Ambiguity' in *Muntean and Rosenblum: Make Death Listen*, Zurich 2006, pp. 89–91

[3] The term modernity, from which flows the traditional art critical beginnings of Modernism, stems from Charles Baudelaire's famous essay of 1863 'The Painter of Modern Life' in *Baudelaire: Selected Writings on Art and Artists*, transl. P.E. Charvet, Cambridge and London 1972, pp. 391–435. Coincidently, although probably written around 1859/60, it appeared in publications at exactly in same time as Manet's Le *Déjeuner sur l'herbe* was first exhibited.

[4] For the development and history of Géricault's subject matter, see Albert Alhadeff, *The Raft of the Medusa, Géricault, Art and Race*, Munich/London/New York 2002

[5] Alice Stepanek was a DAAD scholarship student at St Martin's School of Art, London

[6] Hans Irrek, 'Passage' in *Alice Stepanek/Steven Maslin*, exhib. cat., Volker Diehl Gallery, Berlin; Laure Genillard Gallery, London; Johnen & Schöttle, Cologne; Torch, Amsterdam, 1997, n.p.

[7] Christiana Perella, 'A technological sublime' in *Alice Stepanek/Steven Maslin*, exhib. cat., Studio d'arte Raffaelli, Trento, 2000, n.p.

[8] Early examples are found in *Stepanek & Maslin: Kunstpreis der Stadt Nordhorn*, exhib. cat., Städtische Galerie Nordhorn, 2001

[9] For John Constable's treatments of skies and clouds, see *Constable's Clouds: Paintings and Cloud Studies by John Constable*, Edinburgh 2002

[10] Andreas Honneth, 'Arcadia Panic: Contemplation of "Views of the Sky" by Alice Stepanek and Steven Maslin' in *Stepanek & Maslin. Peintres du XXIe siècle/Painters of the 21st century/Maler des 21. Jahrhunderts*, exhib. cat., Galerie Jean-Luc & Takako Richard, Paris, 2004, pp. 2–4, 21. Honneth is a literary theorist and philosopher

who has written extensively on Nietzsche; references to
Friedrch Nietzsche's 'eternal return' frequently appear
in the bibliographic literature of Stepanek & Maslin.

[11] Andy Lim (ed.), *Stepanek & Maslin: Skyviews*, Cologne 2006

[12] *Doug & Mike Starn* (with essays by Robert Rosenblum and
Andy Grunberg), New York 1990. The monograph served
as a catalogue for their exhibition at the Baltimore
Museum of Art in the same year; the show travelled
to the Center of Fine Arts, Miami, Blaffer Gallery,
University of Houston, The Contemporary Arts Centre,
Cincinnati and the Akron Museum of Art, Akron, Ohio

[13] *The Christ Series*, MoMA, San Francisco and The John and
Mable Ringling Museum, Sarasota, Florida, 1987/88.
Also, the exhibition *Mike and Doug Starn: Selected
Works 1985–87*, Honolulu Academy of Art, Honolulu
University Art Museum, University of California at
Berkeley, California Wadsworth Athenaeim, Hartford,
Connecticut, Museum of Contemporary art, Chicago, 1988

[14] Doug & Mike Starn, *Attracted to Light*, New York 2004, n.p.

[15] The silver-gelatin process was originally invented by
R.L. Maddox in 1871 and, by 1878, was substantially
stabilised by Charles Harper Bennet

[16] *Behind Your Eye: Doug and Mike Starn*, exhib. cat.,
Neuberger Museum, SUNY, New York, 2004, n.p.

[17] *Absorption of Light* was the title given to a series of
commercial gallery exhibitions that took place at
the Lisa Sette Gallery, Scottsdale, Arizona, Galerie
Bhak, Seoul, South Korea, Torch Gallery, Amsterdam,
and Galerie Hans Mayer, Düsseldorf, in 2003

[18] *Gravity of Light: Doug & Mike Starn*, Färgfabrikan Kunsthalle,
Stockholm 2004. The exhibition – in part – travelled
to several venues. They had used the title used earlier
(1995–1998): "It is a sculptural book that emits fiber optics
in an organic flow of lines that link the open acetate pages
on the floor to a dark orb suspended like a planet in the air
fifteen feet away. In *Gravity of Light*, the artists investigate
the physical world and the way that light – from the sun
to black holes – behaves in the universe. Although there
is more than one scientific model to explain the existence
of black holes in the universe, all of them are based on the
absorption of light." Dede Young, *Behind Your Eye*, n. p. 3

[19] See Andrew Solomon, 'From Imaging to Image' in
Absorption + Transmission, exhib. cat., National
Academy of Sciences, Washington D.C., 2005, n.p.

[20] From Doug and Mike Starn's journals, cited
in Dede Young, op. cit., note 18

[21] *Doug & Mike Starn, alleverythingthatisyou*, exhib. cat., Wetterling
Gallery, Stockholm, 2007. The idea was inspired by the
work of Wilson A. Bentley, a self-taught nineteenth-century
natural scientist who developed a system for photographing
snowflakes and created five thousand images of snow
crystals, revealing that no two were ever alike. See
Jacqueline Briggs and Mary Azarian, *'Snowflake' Bentley*,
Boston 1998, and Duncan C. Blanchard, *Snowflake Man:
A Biography of Wilson A. Bentley*, Granville, Ohio 1998

[22] Barry Barker, '(re)imaging the world, the work of jane and louise
wilson' in *Jane & Louise Wilson*, Sala de Exposiciones
Abrantes, Universidad de Salamanca, 2003, pp. 6–15

[23] F. Javier Panera, 'retro-futuristic melancholy: thoughts on the
photographs of jane and louise wilson', *ibid.*, pp. 48–55

[24] Carlos Trigueros, "ghosts of the future or the presence of a double
narrator (videos of jane and louise wilson', ibid., pp. 82–94

[25] *Jane & Louise Wilson: A Free and Anonymous Monument*, exhib.
cat., Film and Video Umbrella, BALTIC/Centre for Contemporary
Art, Gateshead, and Lisson Gallery, London, 2003

[26] Alan Bowness and Luigi Lambertini, *Victor Pasmore: With a
Catalogue Raisonne of Paintings, Constructions and Graphics
1926–79*, London 1980. See also Norbert Lynton, *Victor
Pasmore: Paintings and Graphics, 1980–92*, London 1992

[27] An excellent analysis of the entire project is provided by Giuliana,
Bruno, 'Modernist Ruins: Filmic Archaeologies' in *Jane &
Louise Wilson: A Free and Anonymous Monument*, pp. 7–24

[28] For Abetz and Drescher, the title derives – in the first instance
– from Aldous Huxley (1894–1963) and his novel *Brave New
World* (1932). The actual expression, however, comes from
Prospero's daughter Miranda: "O wonder! How many goodly
creatures are there here! How beautious mankind is! O brave
new world, That has such people in't!" (William Shakespeare,
The Tempest, Act V, Scene I). It is also worth mentioning
that Huxley's experience with psychedelic drugs (mescalin)
which led to his writing his famous book *Doors of Perception*
(1954), was iconic literature to the 1960s and early '70s.

VII – CONCLUSION: THE END OF SINCERITY

[1] *Allora & Calzadilla: LAND MARK*, exhib. cat.,
Palais de Tokyo, Paris, 2006

[2] *Common Wealth*, Tate Modern, London, 2003, *How Latitudes
Become Forms of Art in a Global Age*, Walker Art
Center, Minneapolis, 2003, *Dak'Art: The Biennial
of African Contemporary Art* (2004), *Always a Little
Further*, 51st Biennale di Venezia, Venice, 2005

[3] Op. cit., note 1, p. 5

[4] The work also echoes *Charcoal Dance Floor* of 1997,
a delicate and expressive drawing that becomes
increasingly abstract and blurred as people walk
across it, leaving traces of the soles of their shoes.

[5] Their video project *Unrealisable Goals* (2007) was shown in
Zurich and deals with Japan's claims to islands lost but
to which they originally had title, and how this fits in with
the Japanese pacifist constitution. See *Allora & Calzadilla*,
Kunsthalle, Zurich, 2007. The exhibition also showed
Under Discussion, Clamor, and *Wake Up* (2007), a work
commissioned by the Renaissance Society, Chicago, in
which ten of the world's leading trumpet players reinterpret
the 'reveille', opening up what is military music to a whole
new series of interpretations and understandings.

[6] For an overview of Allora & Calzadilla's recent works and
development, the following published sources should be
consulted: Tom Morton, 'Turning the Tables' (a review of
Common Wealth at the Tate Modern) in *Tate*, no. 8, December,
2003, pp. 74–78, Yates Mc Kee, 'Allora & Calzadilla, The
Monstrous Dimension of Art' (an interview) in *Flash Art*,
January/February, 2005, pp. 96–99, 'Allora and Calzadilla:
Talk about three pieces in Vieques' in *Art Forum International*,
March, 2005, pp. 204–05, Adrian Dannatt, 'Artist Interview:
Clamor, Allora & Calzadilla' (The Moore Space, Miami) in
The Art Newspaper, December, 2006, p. 175, Yates McKee,
'The Ends of Art and the Right of Survival', The Hugo Boss
Prize 2006, Solomon R. Guggenheim Museum, New York,
2006, pp. 19–23, John B. Ravenal, 'Growth (Survival)' in
Artificial Light, exhib. cat., Virginia Museum of Fine Arts
and Museum of Contemporary Art, Miami, 2006, pp. 11–17,
Terry R. Myers, 'Allora & Calzadilla' (The Moore Space,
Miami) in *Modern Painters*, March, 2007, Alan G. Artner,
'Intersection of minimalism, politics' (a review of the show
'Wake Up' at The Renaissance Society) in the *Chicago Tribune*
(*Tempo*), 22 March, 2007, Rachel Campell-Johnson, 'Oh!
What a lively War' in *The Times*, 10 April, 2007, Hannah
Feldman, 'Sound Tracks: The Art of Jennifer Allora and
Guillermo Calzadilla' in *Artforum*, May 2007, pp. 336–40,
Sally O'Reilly, 'Trumpets and Turtles' in *Frieze*, no. 108,
June/July/August, 2007, Stella Santacaterina, 'A Lateral
Gaze on the Real' in *Portfolio #45*, June, 2007, pp. 56–59